HOW TO DRAW
ANIME & GAME CHARACTERS

Mastering Battle & Action Moves

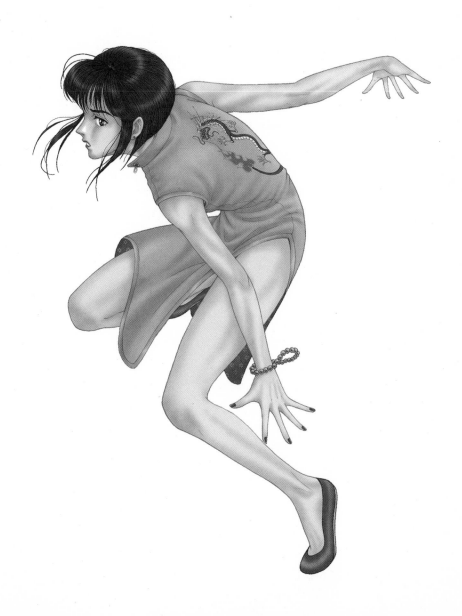

VOL. 4

INTRODUCTION

Can you effortlessly draw the curve the back makes when depicting a movement like a jump kick, or the length between strides a character makes when jogging along? How should you appropriately depict moves that are elaborate and help build excitement? Normally, this requires carefully studying the movements made by the body. This is why people constantly say "sketching and balance are critical" to game animation, animated films, and manga. These words are repeatedly uttered like a mantra. Many falter, and ultimately give up, worrying that this is not all there is to it. However, "sketching and balance" are absolute necessities to creating an interesting or outstanding work. It is regarded as common sense amongst those already in the industry.

Some claim to be aware that sketching is important, but say they do not know exactly how to learn sketching, or where the line between sketching talent and lack thereof lies. Then again, is this actually the case? If you open your eyes and look around, you should find that the games and manga you accumulated yourself serve well as fertile learning materials. In other words, the real issue is "Where are you looking?" In this volume, you will learn to master movements used frequently in game animation and animated films.

HOW TO DRAW ANIME & GAME CHARACTERS Vol. 4
Mastering Battle & Action Moves
by Tadashi Ozawa

Copyright © 2001 Tadashi Ozawa
Copyright © 2001 Graphic-sha Publishing Co., Ltd.

First published in 2001 by Graphic-sha Publishing Co., Ltd.
This English edition was published in 2002 by
Graphic-sha Publishing Co., Ltd.
1-9-12 Kudan-kita, Chiyoda-ku, Tokyo 102-0073 Japan

Contributions to illustrations:	Yoriko Mochizuki and Chika Majima
Contributions to text:	Chika Majima
Design:	Kazuo Matsui
Photography:	Izumi Saito
English edition layout:	Shinichi Ishioka
English translation:	Língua fránca, Inc. (an3y-skmt@asahi-net.or.jp)
Japanese edition editor:	Sahoko Hyakutake (Graphic-sha Publishing Co., Ltd.)
Foreign language edition project coordinator:	Kumiko Sakamoto (Graphic-sha Publishing Co., Ltd.)

Distributed by
NIPPAN IPS
11-6, 3chome, Iidabashi,
Chiyoda-ku, Tokyo
102-0073 Japan
Tel: +81-(0)3-3238-0676
Fax: +81-(0)3-3238-0996
E-mail: ips03@nippan-ips.co.jp

Distributed Exclusively
In North America by
Digital Manga Distribution
1123 Dominguez St., Unit "K"
Carson, CA 90746, U.S.A.
Tel: (310) 604-9701
Fax: (310) 604-1134
E-mail: distribution@emanga.com
URL:http://www.emanga.com/dmd/

First printing: April 2002

ISBN: 4-7661-1254-7
Printed and bound in China

TABLE OF CONTENTS

Know the Basics

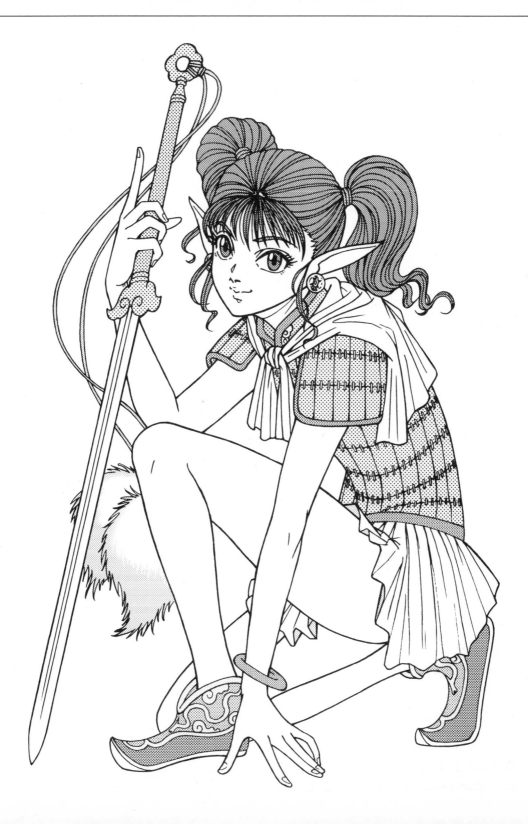

What is motion?

Flashy action moves are the highpoint of a story. For some animated works, the focus of the story is the action itself. There are likely countless prospective artists who were first attracted to the industry by action scenes. However, common sense of professionals in the industry dictates that the entire movement in any given pose or action must be drawn. This poses a stumbling block for the prospective artist. Setting that aside for now, let's move on to what exactly motion is.

1 | Create an imaginary 3-dimensional space in your mind

What exactly is an "imaginary space"? To give an example, the latest 3-D games have the feel of being in a totally separate world. Characters walk and jump around, engage in combat and in many other forms of action in this world. Think of this world as an "imaginary space."

Artists able to draw characters in motion can do so, because they have created a space with depth and height inside their minds.

A computer system that transfers movements made by a human being to those made by an animated character used in making 3-D games is called "Motion Capture." Unfortunately, with only this system you are limited to those movements actually made by human beings-rather dry, don't you think? Action requires exaggerated, dynamic movements. In order to produce such movements, you need to understand 3-dimensional form. In other words, it is essential that you practice drawing characters from various angles.

2 | How many stills are needed to create one work?

Whether it be animated films, games, or manga, if all you draw are the main action scenes, then you end up with a series of still scenes. For example, a scene showing a roundhouse consists of...

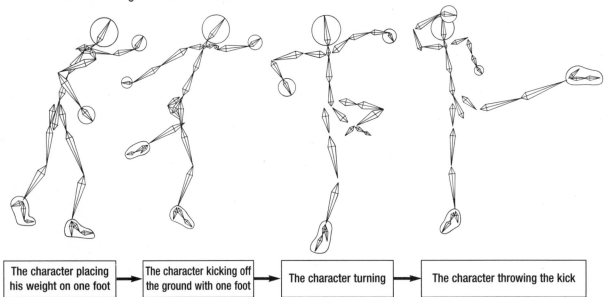

| The character placing his weight on one foot | The character kicking off the ground with one foot | The character turning | The character throwing the kick |

These moves in sequence form the motion. Characters appearing to move naturally that we see on TV are actually made up of a huge number of motion stills (i.e. drawings). Now let's take a close look at how many drawings it does take.

Cell Animation

- 30-minute program: 3,500 to 5,000 cells
- Cinematic film: 30,000 to 100,000 cells

A tremendous number of cells are used. In other words, artists have to produce 5 to 20 cells (drawings) for each second of film.

Games

Games use about the same number of images, but most people don't notice. Take for example a 2-D combat game. Pushing different combinations of buttons causes the characters to move in various attack patterns, and that is also where the fun of the game lies. How many different moves can your favorite game character perform? This is not just limited to when your character is attacking, but includes when he is baiting the opponent. Reacting to injury, guarding, celebrating a victory, and other such movements are all actions we take for granted when we play a game, but they are actually composed of complicated movement. The following drawings demonstrate this point.

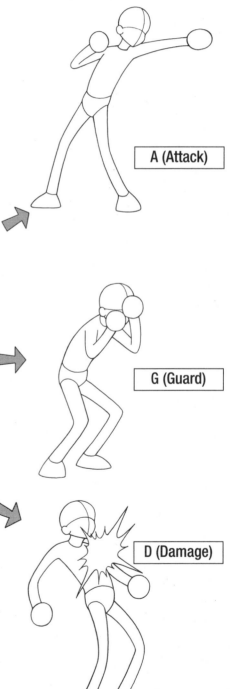

A (Attack)

G (Guard)

D (Damage)

Basic Standing Pose	Aggressive Pose
Before the game starts	The game starts! This is the character in "idling" mode, waiting to receive an action command.

"Idling," a term derived from a car idling, refers to the pose used for the character while waiting for the next action command. So, we have seen 5 examples of motions used already, and the character has not even started fighting.

Now, let's move on to the attack. How should we attack first? Punch? Kick? No. What we really need to do first is approach the enemy. Regardless of whether we attack from above or below, the game has already started.

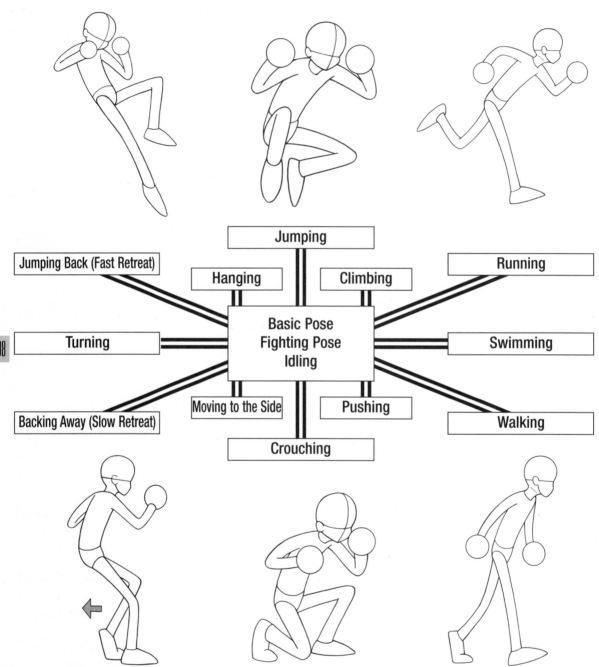

The following will be familiar ground to you, if you play games frequently.

- **The difference in power between a weak, medium, and strong punch or kick**
- **The distance between you (your character) and the enemy**

These are the elements that determine victory. Oh, and let's not forget throwing. Moreover, if you include effects, such as fire or explosions and the like to add a little drama, a single character could have more than 100 different animated segments.

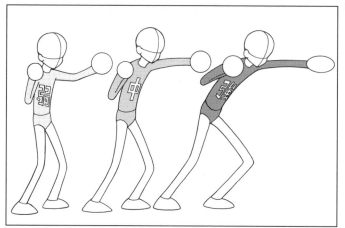

If each animated segment requires about 7 images, then

100 animated segments x 7 images = 700 images

The newer games tend to have about 14 characters.

14 characters x 700 images = 9,800 images

Those images sure do add up quickly, don't they?

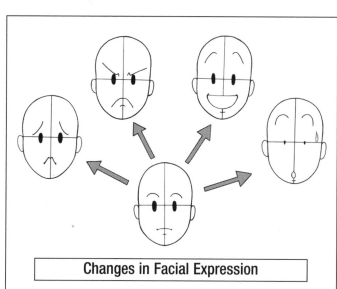

Changes in Facial Expression

Let's take a look next at adventure games and romance simulation games, which seem to have less movement. No matter how beautiful the girl on the screen appears, what fun is it if only one drawing is used, and her facial expression never changes? The main point of this game genre is dialogue with the characters. What makes the game fun-really come alive-is when the character shows his/her reactions through crying, laughing, or becoming angry.

Moreover, having a multitude of facial expressions is required for making an appealing character seem "alive." The bare minimum is likely 3 images per emotion. The most basic emotions consist of contentment, anger, sadness, and joy.

4 emotions x 3 images x 2 (eye blinking and mouth movements) = 24 images

Adding optional touches such as seasonal clothing or special scenes, making 20 options for each variation, then

24 images x 20 options = 480 images

About 12 characters appear in each game of this genre.

480 images x 12 characters = 5,760 images

Furthermore, if you want to add subtle changes in facial expression to make the character more individualistic or add animation to special scenes, then the sky is the limit.

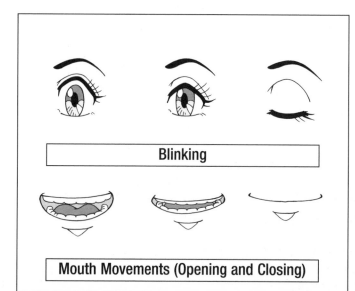

Blinking

Mouth Movements (Opening and Closing)

Manga

Well, what about manga? Each artist has his or her own style, but 16 pages seem to be the norm for printing purposes. So, how many drawings are there on one page? Taking a look at comic books, normally a page is divided into 7 to 8 panels.

16 pages x 8 panels = 128 panels

Panel 3	Panel 2	Panel 1

x 16 Pages

Panel 4

Panel 6	Panel 5
Panel 7	

Of course, your story can't keep going with only 1 character, so you should have at least 4.

128 panels x 4 characters = 512 character drawings

Since all four characters won't be appearing in every single panel, this number is quite an exaggeration, but if this manga were to continue as a weekly published series...

512 character drawings x 4 weeks = 2,048 character drawings

If you draw the background separately from the characters, then this number may climb even higher.

"Drawing motion" involves being able to draw freely using various angles and compositions. It is the presenting of multiple drawings and linking of moments to capture movement.
This is essential to game or film animation, manga, illustration, or any other art form involving graphics (drawing or painting).

Well, enough with the introduction. Let's start drawing.

Structure of the Human Form

It is not necessary to base all of your drawings on the skeletal structure. However, knowing skeletal structure will determine your level of improvement. Knowing the skeletal structure is the starting point of sketching. Once you are familiar with the skeletal structure, you can exaggerate and manipulate the character's form according to your own style. This is character design.

Parts of the Torso and Arms

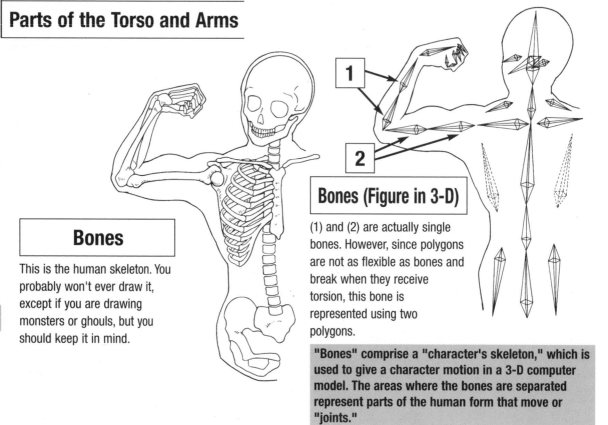

Bones

This is the human skeleton. You probably won't ever draw it, except if you are drawing monsters or ghouls, but you should keep it in mind.

Bones (Figure in 3-D)

(1) and (2) are actually single bones. However, since polygons are not as flexible as bones and break when they receive torsion, this bone is represented using two polygons.

"Bones" comprise a "character's skeleton," which is used to give a character motion in a 3-D computer model. The areas where the bones are separated represent parts of the human form that move or "joints."

Box Figure

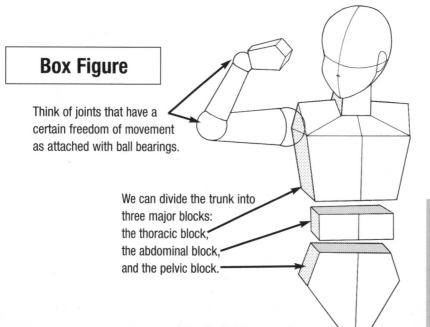

Think of joints that have a certain freedom of movement as attached with ball bearings.

We can divide the trunk into three major blocks: the thoracic block, the abdominal block, and the pelvic block.

No matter how good you are at sketching, converting the supple, round human form to a three dimensional figure is no easy task. Visualizing this block figure will make this task easier.

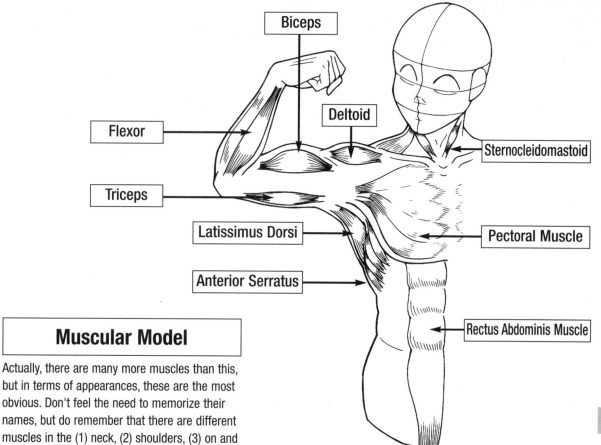

Biceps

Deltoid

Flexor

Sternocleidomastoid

Triceps

Latissimus Dorsi

Pectoral Muscle

Anterior Serratus

Rectus Abdominis Muscle

Muscular Model

Actually, there are many more muscles than this, but in terms of appearances, these are the most obvious. Don't feel the need to memorize their names, but do remember that there are different muscles in the (1) neck, (2) shoulders, (3) on and (4) underneath the upper arms, (5) from the elbow to the wrist, (6) the side of the torso, (7) ribs, (8) chest, and (9) stomach.

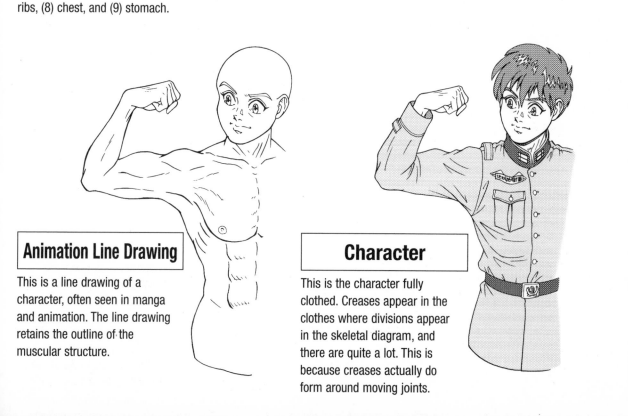

Animation Line Drawing

This is a line drawing of a character, often seen in manga and animation. The line drawing retains the outline of the muscular structure.

Character

This is the character fully clothed. Creases appear in the clothes where divisions appear in the skeletal diagram, and there are quite a lot. This is because creases actually do form around moving joints.

Parts of the Legs

Kicking is an action that creates an impressive image and is used frequently to punctuate the action in a scene. Furthermore, since the position and angle of the leg express the center of gravity, they also define the balance of a composition. It is important that you have a general sense of the positions of the muscles and bones.

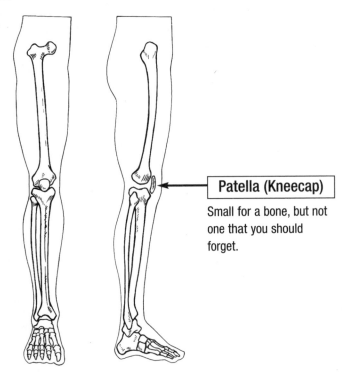

Patella (Kneecap)

Small for a bone, but not one that you should forget.

1

Parts of the Bones

If you aren't familiar with the kneecap, you may end up drawing unnaturally pointed knees. As a result of the kneecap, the knee tends to be flat.

Bones (Figure in 3-D)

A small polygon appears in (1) to represent the kneecap. In 2-dimensional drawings as well as 3, without the kneecap the leg would bend at a sharp angle and look mechanical.

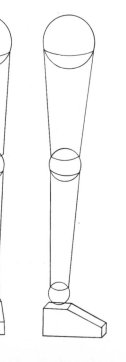

Box Figure

Circles represent the joints. Picture the thighs and calves as cylinders. Using a semi-wedged shaped box for the feet makes them easy to visualize.

Muscular Model

Remember that for the thigh, muscles are attached to the front, side, and back, while for the calf, muscles are attached to only two sides.

Rectus Femoris Muscle

Vastus Lateralis Muscle

Biceps Femoris Muscle

Gastrocnemial Muscle

015

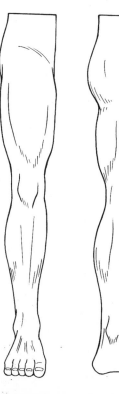

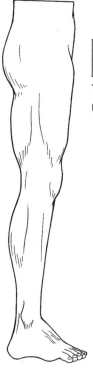

Animation Line Drawing

The line drawing shows the undulations of the leg muscles.

Character

On the fully clothed character, the skeletal structure seems even more apparent as a result of creases forming around the knees and other joints.

Head Movements

Keeping your character facing forward in an action scene would look absurd. If the head does not move along with the body, then the poses you can use become limited. These pages introduce head movements you can apply to your artwork, provided you master them.

Standard Head

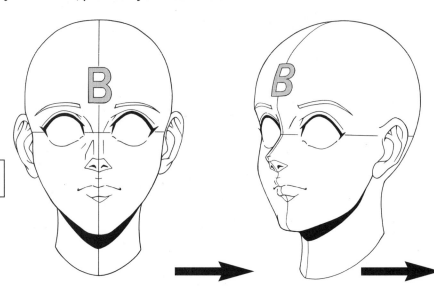

Basic: Front and Profile

This head has somewhat stylized features: the eyes are centrally located and are considerably enlarged. The head is shown turning to the side.

The forehead jutting out hides the eyelids, and the eyebrows and eyelashes overlap.

The ear protruding obscures the back of the head.

Notice where the line of the cheek swells and recesses.

Upward Movement of the Head

POINT!

The end of the eyebrow and corner of the eye appear closer.

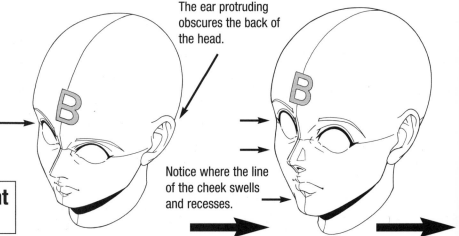

The eyebrow and the eye appear closer.

The nostril on the further end.

Downward Perspective

Side View

Upward Perspective

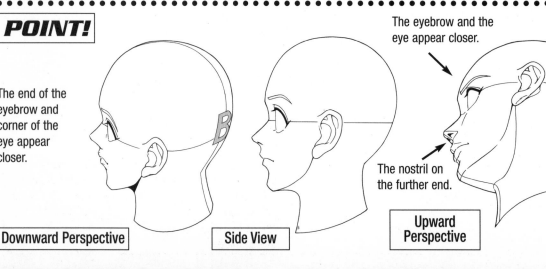

The protrusion of the nose and lips disrupt the silhouette line of the face. Don't neglect the swelling of the cheek.

Side view. The upper lip extends over and covers the lower.

The height of the eye is the same as the frontal view. The eye itself should not extend beyond the bridge line.

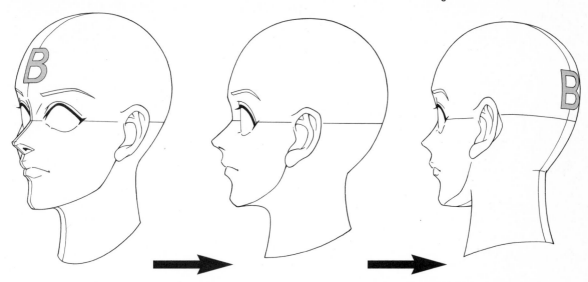

The eyebrows trace along the same line as the head.

The eyebrows follow the curve of the forehead.

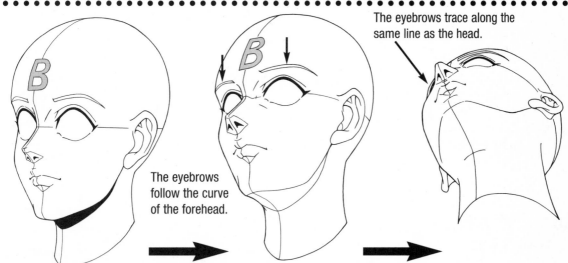

Remember! - Upward Perspective: 3 Styles

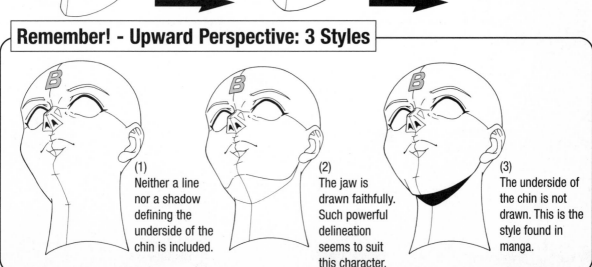

(1) Neither a line nor a shadow defining the underside of the chin is included.

(2) The jaw is drawn faithfully. Such powerful delineation seems to suit this character.

(3) The underside of the chin is not drawn. This is the style found in manga.

Character Head

Although the character has a manga flavor, it has an overall roundness that gives it a realistic feel. The eyes are different from the characteristically exaggerated eyes used in anime, and care should be taken to ensure that if the eyes have clearly delineated eyebrows and eyelashes, these should correctly move with the head.

Note the distance between the eye and eyebrow. This changes according to the head's angle.

Pay attention to level of the ear on the head.

Only at the same level of the eye can the upper portion of the ear on the far side of the head be seen.

Basic: Front and Profile

This is the angle at which the ear disappears behind the head. If it appears extraneous, leave it out.

The distance between the mouth and nose is very short.

The distance between the mouth and nose is somewhat short.

Upward Movement of the Head

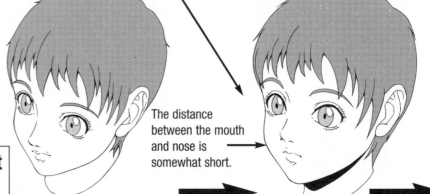

POINT!

The nostril on the further end might better omitted.

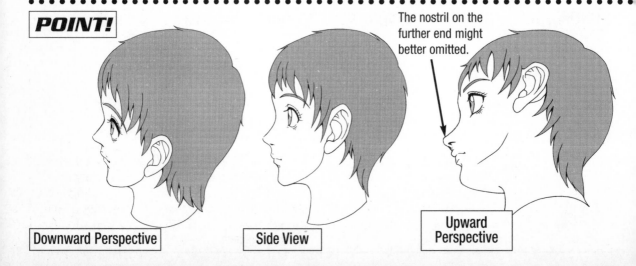

Downward Perspective

Side View

Upward Perspective

Connect the recess of the eyes and swell of the cheeks with a gently undulating line.

Keep the line defining projections such as the tip of the nose and swell of the lips thin. Allowing breaks in the line at the tip will create a soft feel.

Keep the protrusion of the forehead gentle. Take care that the jaw does not become too sharp.

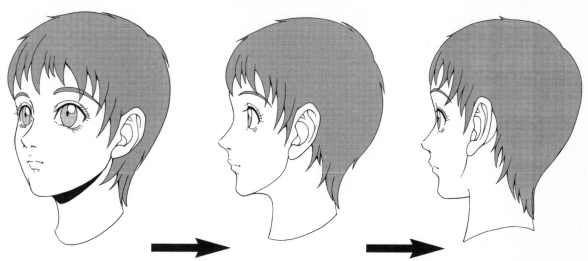

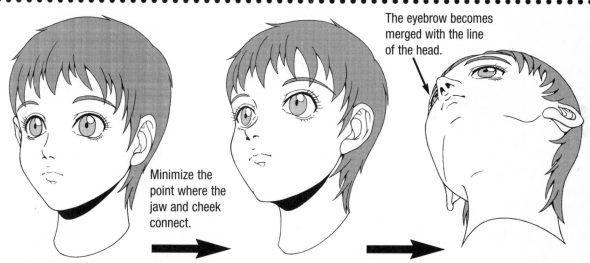

The eyebrow becomes merged with the line of the head.

Minimize the point where the jaw and cheek connect.

Remember! - Upward Perspective: 3 Styles

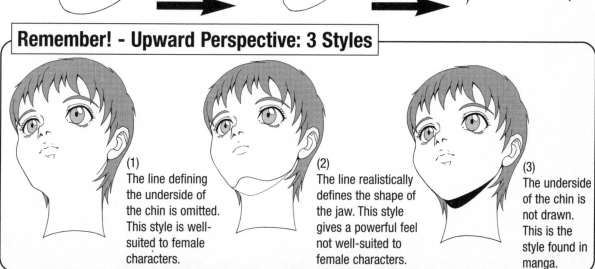

(1) The line defining the underside of the chin is omitted. This style is well-suited to female characters.

(2) The line realistically defines the shape of the jaw. This style gives a powerful feel not well-suited to female characters.

(3) The underside of the chin is not drawn. This is the style found in manga.

Crash Course, Part 1

Drawing by Eriko Nakano, Kanagawa Prefecture

The sword makes an interesting prop, but it wasn't fully exploited. Including the hilt would have balanced the left and right sides of the composition. Also, add a little playfulness to detailing of her vest clasp.

Almost there! This is an excellent drawing; however, it would have been a bit better if more care had been taken with the positioning of the hands and other details. In addition, make it a habit to use cleaner lines in the future.

Let's take another look using a box figure. Remember that keeping the hands in view is basic to good character design, unless you have a particular reason to hide them.

The angle of the knees and ankles don't match.

The positioning of the hand matches the expression in her eyes. Excellent effort!

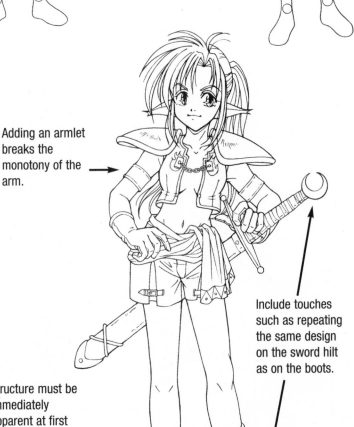

Adding an armlet breaks the monotony of the arm.

Include touches such as repeating the same design on the sword hilt as on the boots.

Structure must be immediately apparent at first sight in good character design.

Before

After

CHAPTER 2

Running and Walking: The Basics of Movement

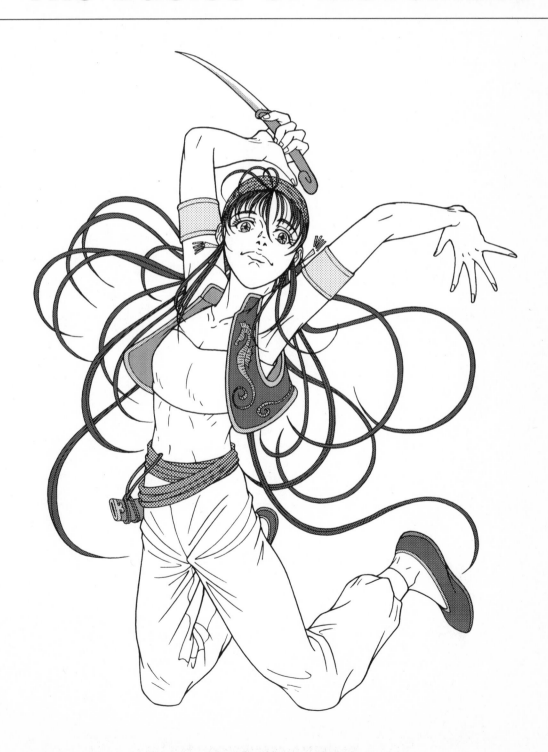

CHAPTER 2-1 | Walking

An artist must be able to produce from memory images of a character walking or running before moving on to more elaborate actions. These may seem lackluster actions, but you should master them completely before progressing.

Basic Movements in Walking: Starting with the Right Foot

First, let's start with the most fundamental of all, the key frames of an action sequence (in this case, walking). Take note of 4. This final pose determines the success of the whole sequence.

Our heads move up and down as we walk. As a result, even showing only the upper body can create the illusion of walking.

The hand does not have to be in a fist when walking; however, it should be when running, so try to master drawing a fist.

The basic pose for adding movement. Have your figure start in this pose before giving him motion.

Show torsion in the upper body by gradually minimizing the back, step after step.

The higher up the position of the heel, the more speed is suggested.

1

2

3

4

Basic Movements in Walking: Starting with the Left Foot

This is the opposite motion of that presented on the previous page. Naturally, you should practice learning both.

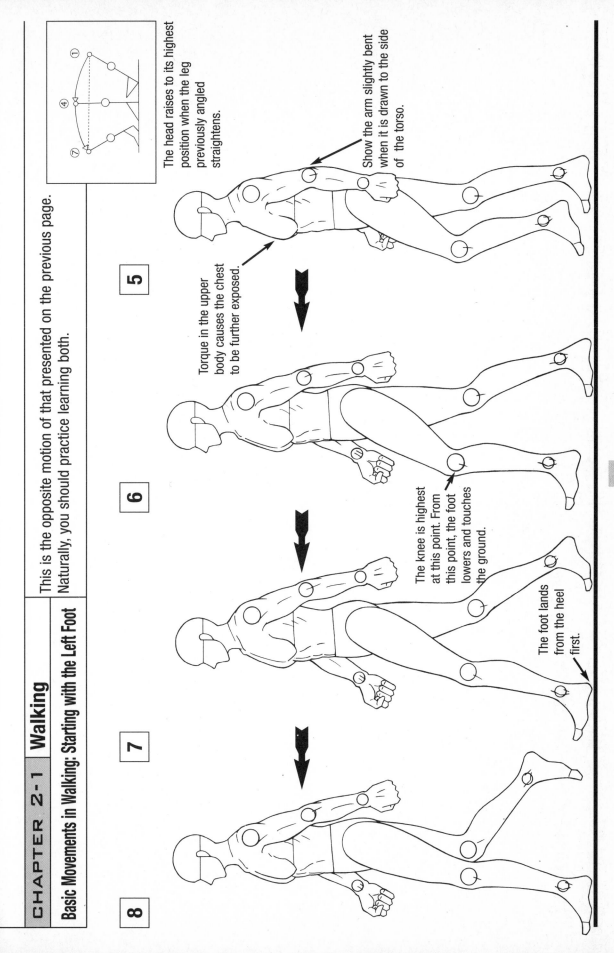

The head raises to its highest position when the leg previously angled straightens.

Show the arm slightly bent when it is drawn to the side of the torso.

Torque in the upper body causes the chest to be further exposed.

The knee is highest at this point. From this point, the foot lowers and touches the ground.

The foot lands from the heel first.

5

6

7

8

023

Intermediate Movements

Now try to draw the intermediate movements falling between the key frames. Pay careful attention to the subtle movements of the left foot as the body's weight shifts from it.

Sequence continued from the previous page.

8

9

Weight is completely on the left foot.

10

The figure seems unbalanced, but weight is still on the left foot.

11

12

This shows the distribution of weight just before switching to the right foot. It is the most difficult moment in walking to capture. Note the angle of the knees.

Making a Character Walk: Starting with the Right Foot

Once you gained a fair idea using the sketch model of where the body extends and bends, try to make your character walk. Remember that creases appear near the joints following the body's contours.

The basic pose for adding movement. Have your character start in this pose before giving him motion.

The swing of the arms and the distance between the feet are greatest in this frame.

1

This is the moment where the foot leaves the ground. The angle of the heel to the ground should be around 45°.

The body's weight is concentrated on this foot.

2

The foot is completely elevated from the ground. Because the ankle pivots, causing the foot to brush the ground, the toe should be angled back further than when the foot is in a standing position. Drawing of the ankle shifting heightens the sense of realism.

3

This is the frame where the knee is the straightest and the head, highest. This position sets the tone for whether your character will continue walking or stop.

4

025

CHAPTER 2-1 | Walking

Making a Character Walk: Starting with the Left Foot

Practice drawing your character starting to walk both with the right foot as well as the left foot as you did with the sketch model. The first frame picks up from the last frame on page 25. Note that in addition to the legs, the upper body's movements have also reversed.

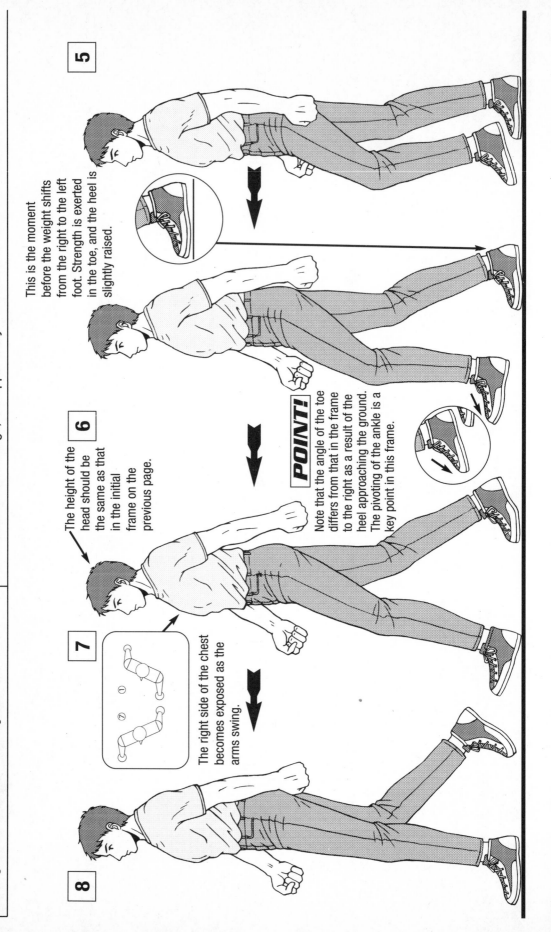

5

This is the moment before the weight shifts from the right to the left foot. Strength is exerted in the toe, and the heel is slightly raised.

POINT!

Note that the angle of the toe differs from that in the frame to the right as a result of the heel approaching the ground. The pivoting of the ankle is a key point in this frame.

6

The height of the head should be the same as that in the initial frame on the previous page.

7

The right side of the chest becomes exposed as the arms swing.

8

Making a Character Walk: Intermediate Movements

Examine the frames showing the intermediate stages from moment that the character's right foot is raised to the time that it returns to the ground. Pay careful attention not only to the legs, but also to the shifting positions of the arms.

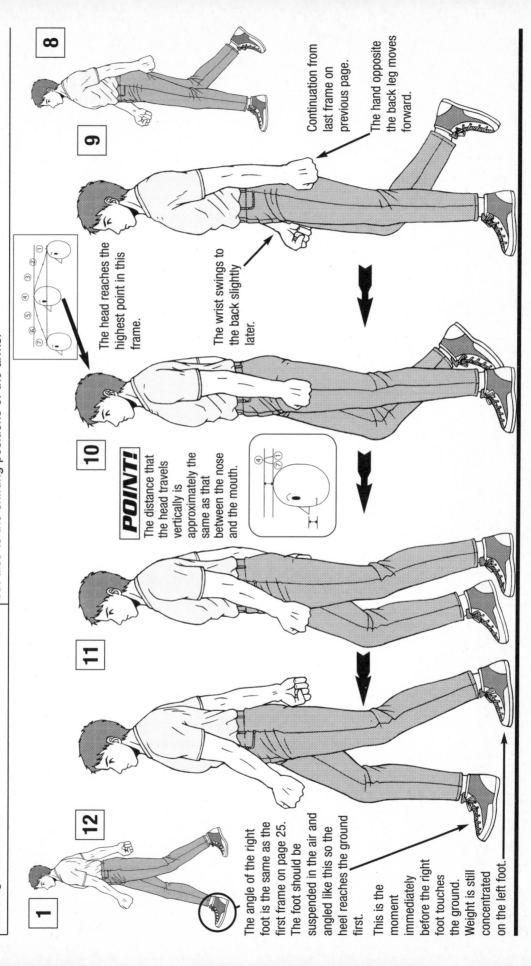

Continuation from last frame on previous page.

The hand opposite the back leg moves forward.

The head reaches the highest point in this frame.

The wrist swings to the back slightly later.

POINT!

The distance that the head travels vertically is approximately the same as that between the nose and the mouth.

The angle of the right foot is the same as the first frame on page 25. The foot should be suspended in the air and angled like this so the heel reaches the ground first.

This is the moment immediately before the right foot touches the ground. Weight is still concentrated on the left foot.

CHAPTER 2-2 | Running

Basic Movements in Running: Starting with the Right Foot

Next comes running. What is presented on these pages is "animation-style running," which means that it appears more exaggerated than running in real life. The elbow is drawn at a very high position.

1 Breaking into the run

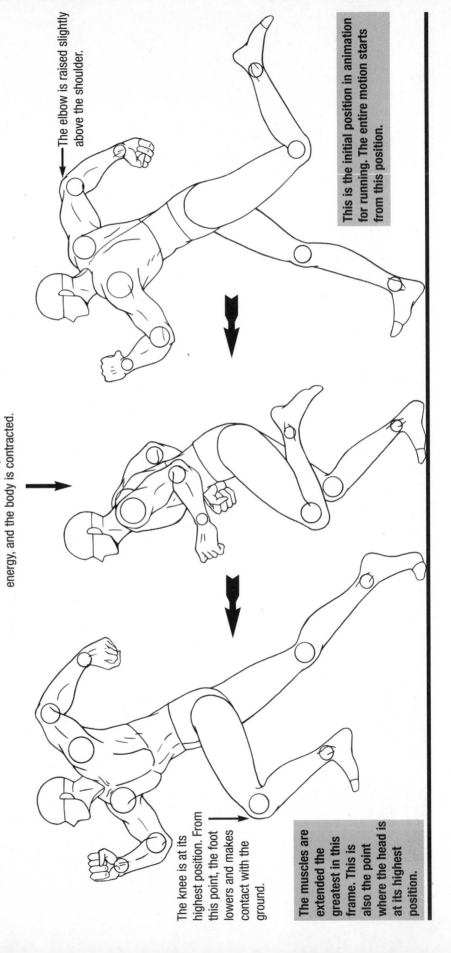

The elbow is raised slightly above the shoulder.

This is the initial position in animation for running. The entire motion starts from this position.

2 Muscles coiling

The knees are bent with potential energy, and the body is contracted.

3 Springing off the ground

The knee is at its highest position. From this point, the foot lowers and makes contact with the ground.

The muscles are extended the greatest in this frame. This is also the point where the head is at its highest position.

Basic Movements in Running: Starting with the Left Foot

Although this page presents running from the left foot, it is actually a continuation of the previous page. Note that in running, movements become more exaggerated as speed increases. Motion changes as the character breaks into a run and picks up speed.

Pace increased | **Character breaking into a run**

The heights of the arms and legs change according to speed.

Add lines to suggest ribs in the figure's side.

Draw the ankle at an angle greater than 90° to show the foot straightening.

4

The heel should approach the figure's lower back as speed increases.

5

The back becomes exposed due to torsion.

Keep the hands at different positions so the figure will not appear mechanical.

6

Having the flat of the foot touch the ground will lose a sense of speed.

029

CHAPTER 2-2 | Running

Making a Character Run: Starting with the Right Foot

Pay careful attention to where creases appear when the character is running, as this will have tremendous bearing on your ability to show speed.

1 | Breaking into the run

Undulations caused by the scapula (shoulder blade) and backbone should be translated to creases in the clothing.

Showing clothing lifting in the opposite direction of the character's motion will heighten the sense of speed.

This is the common running pose in animation. Torsion in the upper body should be exaggerated the most in this frame.

2 | Muscles coiling

Creases should radiate from areas where clothing is bunched.

3 | Springing off the ground

The creases should follow the torque of the body.

This is the moment where the tip of the foot lifts off, moving into the next step. Since this is also the moment where the body concentrates its power on advancing, exaggerate the body stepping into a forward movement.

This is a continuation of the previous page with the character starting on the opposite foot. Note the directions of the heels and wrists.

Making a Character Run: Starting with the Left Foot

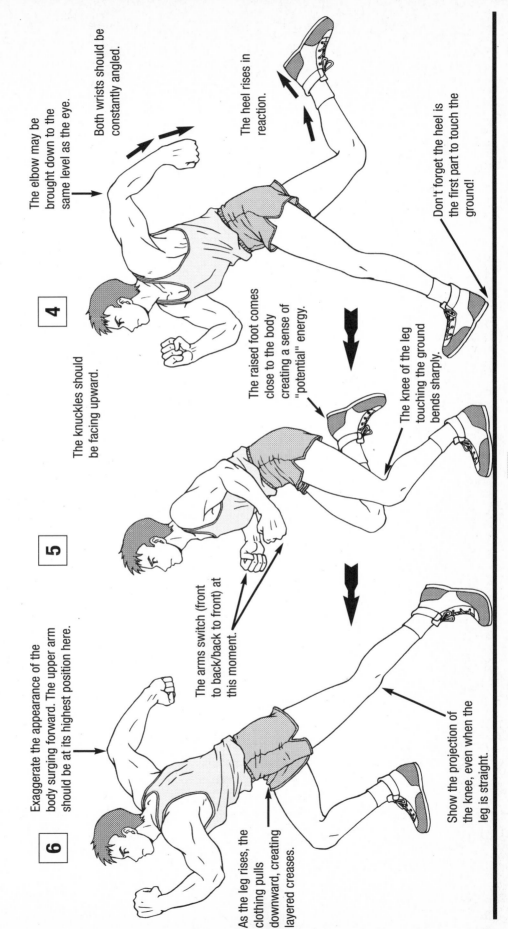

4

The elbow may be brought down to the same level as the eye.

Both wrists should be constantly angled.

The heel rises in reaction.

Don't forget the heel is the first part to touch the ground!

The knuckles should be facing upward.

The raised foot comes close to the body creating a sense of "potential" energy.

The knee of the leg touching the ground bends sharply.

5

Exaggerate the appearance of the body surging forward. The upper arm should be at its highest position here.

The arms switch (front to back/back to front) at this moment.

6

As the leg rises, the clothing pulls downward, creating layered creases.

Show the projection of the knee, even when the leg is straight.

031

Basic Movements in Running towards the Viewer: Starting with the Right Foot

Scenes of a character running towards the viewer often appear in animated films and games. Note that unlike the side view, the perspective requires foreshortening, so the right and left arms and legs are drawn in different sizes.

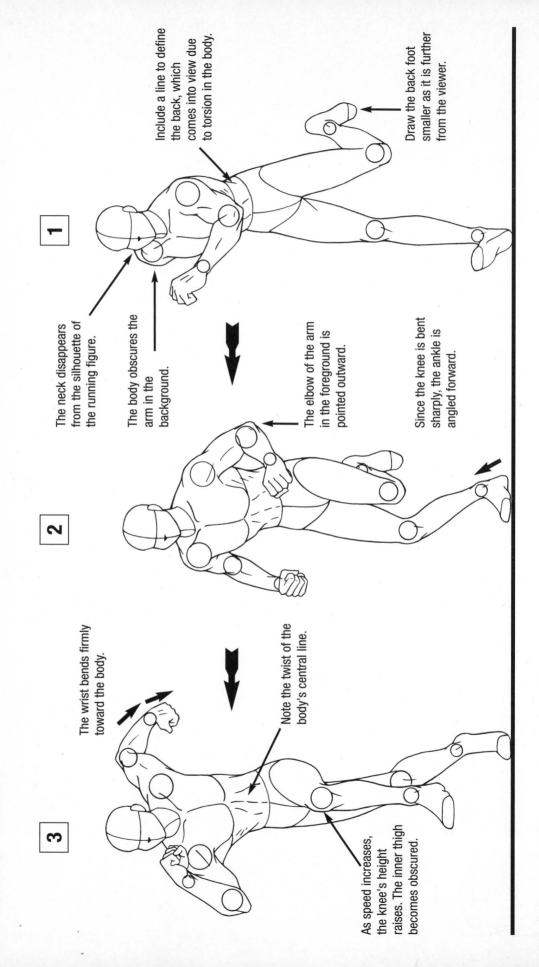

1

Include a line to define the back, which comes into view due to torsion in the body.

Draw the back foot smaller as it is further from the viewer.

2

The neck disappears from the silhouette of the running figure.

The body obscures the arm in the background.

The elbow of the arm in the foreground is pointed outward.

Since the knee is bent sharply, the ankle is angled forward.

3

The wrist bends firmly toward the body.

Note the twist of the body's central line.

As speed increases, the knee's height raises. The inner thigh becomes obscured.

Basic Movements in Running towards the Viewer: Starting with the Left Foot

This is a continuation from the previous page. The runner has upped the pace causing the swing of the arms become more exaggerated. Drawing the back foot smaller will make it appear further away, allowing you to emphasize the distance between the feet.

4

The arm swung away from the viewer appears smaller.

Avoid using a straight line to define the thigh. Opt for a curved line to express the muscles.

5

The arms switch (front to back/back to front) at this moment. Drawing the arms close to the trunk will lose a sense of speed.

6

Remember!

The height of the fist is proportionate to the runner's speed. As the pace increases, the fist may rise to the level of the face.

The tip of the foot rises. The base of the toes disappears.

Sprint!

CHAPTER 2-3 | Running towards the Viewer

Character Running towards the Viewer:
Starting with the Right Foot

When drawing a character, it is important that you select a fixed perspective. While this may not be that noticeable with one frame, a sequence drawn without a consistent perspective will result in the movement appearing imperfect and without purpose.

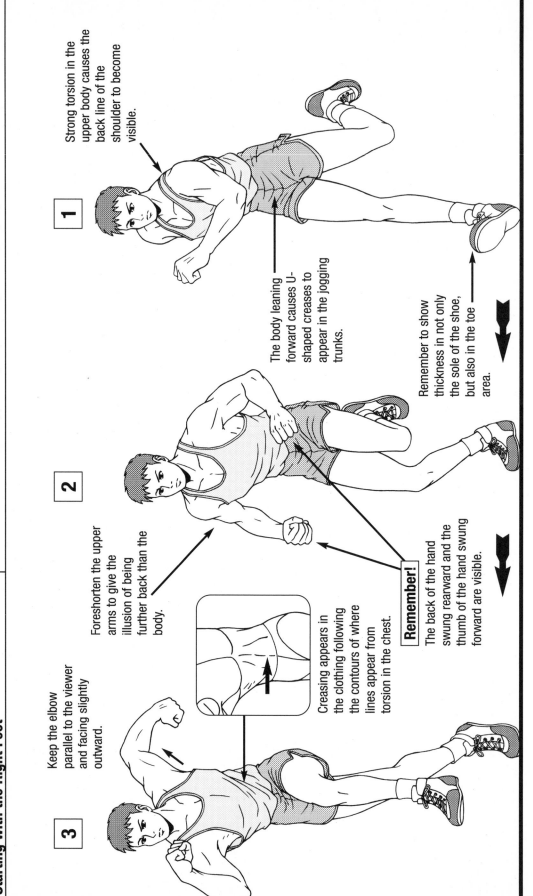

1

Strong torsion in the upper body causes the back line of the shoulder to become visible.

The body leaning forward causes U-shaped creases to appear in the jogging trunks.

Remember to show thickness in not only the sole of the shoe, but also in the toe area.

2

Foreshorten the upper arms to give the illusion of being further back than the body.

Remember!

The back of the hand swung rearward and the thumb of the hand swung forward are visible.

Creasing appears in the clothing following the contours of where lines appear from torsion in the chest.

3

Keep the elbow parallel to the viewer and facing slightly outward.

Character Running towards the Viewer: Starting with the Left Foot

This is a continuation of the preceding page. Since the limbs of the runner in the foreground have switched, pay close attention to the direction of the creases appearing in the clothing on the upper body.

4

Creases in previously bunched areas of clothing lighten, while new wrinkles form on the opposite side.

Lines drawn in the sides of clothing such as these are effective in illustrating the direction in which the body moves.

POINT!

The curve of the hem of the near leg should dip up. The far foot should face downward.

5

Drawing creases over lines appearing in the body's muscle will give a natural feel.

The knee is not composed of solely one curving line. Rather, the contour first curves in and then out again to define the kneecap.

6

Use lines following the contours of the pant leg's hem to illustrate creases gathering.

CHAPTER 2-4 Running away from the Viewer

Basic Movements in Running away from the Viewer: Starting with the Right Foot

This action, which is used as often as that of the character running toward the viewer, is common to scenes where the runs away (escapes) or engages in hot pursuit, exposing his back. Note the changing sizes of the hands and feet as they move from front to back.

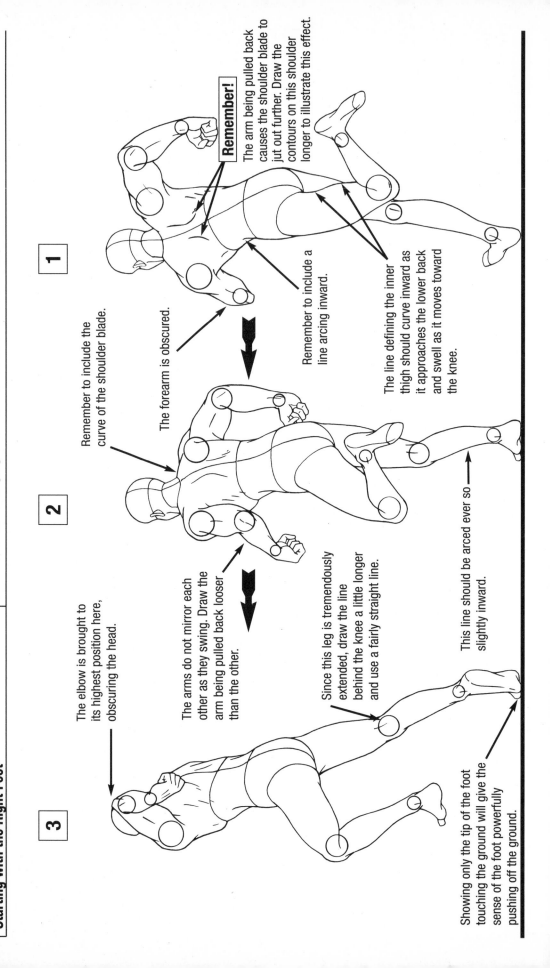

1

Remember!

The arm being pulled back causes the shoulder blade to jut out further. Draw the contours on this shoulder longer to illustrate this effect.

Remember to include a line arcing inward.

The line defining the inner thigh should curve inward as it approaches the lower back and swell as it moves toward the knee.

2

Remember to include the curve of the shoulder blade.

The forearm is obscured.

3

The elbow is brought to its highest position here, obscuring the head.

The arms do not mirror each other as they swing. Draw the arm being pulled back looser than the other.

Since this leg is tremendously extended, draw the line behind the knee a little longer and use a fairly straight line.

This line should be arced ever so slightly inward.

Showing only the tip of the foot touching the ground will give the sense of the foot powerfully pushing off the ground.

Basic Movements in Running away from the Viewer: Starting with the Left Foot

This is a continuation of the preceding page. Note that the figure's movements become more exaggerated as the pace increases. A key point is the movement of the shoulder blade.

4

Draw contour lines cutting into both sides of the lower back to define the upper body's torque.

The heel is the first to touch the ground in all body movements.

5

Shoulder contour

Deltoid

The calf begins to swell from this point.

The thoracic block starts here. Muscle contours swell from this line.

6

Draw the outer contour of the back cutting into the underarm contour to define the side.

Remember!

The ankle should not be at a right angle. Rather, the tip of the foot should be pointed downward.

Character Running away from the Viewer: Starting with the Right Foot

Next, let's look at drawing a character running away from the viewer. To add shading, shade the area highest on the posterior the lightest, gradually darkening the shading following the rounded slope of the posterior to produce a 3-dimensional feel. Creases in clothing should be drawn according to the sketch model.

038

1

This crease follows the contours of the shoulder blade.

This crease follows the contours of the posterior.

This crease follows the contours of the inner thigh.

The wrist should be facing the body. Adding lines defining the muscles inside the wrist increases the sense of tension.

2

This line defines the elbow.

In a head facing away, represent the eye with a line curving inward.

Bend the wrist in the same direction in which the arm is swinging.

3

Creases radiate from clothing bunching as the hip bends.

This is a continuation of the preceding page. Pay attention to the direction of the curves made by creases in the jogging trunks as well as the motion of the legs.

Character Running away from the Viewer: Starting with the Left Foot

4

Having the hem of the trunks flip up in the opposite direction enhances the sense of speed.

Having the contour line of the calf cut into the back of the knee defines the knee's tendon.

5

Including lines to define the bones of the back of the hand enhances the sense of a clenched fist.

6

The arm pulling back should be somewhat further from the body.

The arm swinging forward should be somewhat closer to the body.

Make sure the far side of the toe visible.

039

CHAPTER 2-5
Downward Perspective of a Running Figure

Figure in Full Run: Starting with the Right Foot

Next is a "'full run" as seen looking down at an oblique angle. When drawing from such an angle, first set the character in a box. This then defines the boundaries of your character's movements. Draw lines at the bottom of the box for your character to follow.

1

The shoulder blade comes into view as a result of torsion in the upper body.

2

The figure will appear deformed if it does not fit within the boundaries of these lines.

The upper part of the far arm is obscured.

Include a concave contour to define where the shoulder meets the chest.

Have the figure run along these lines to prevent it from appearing to be floating in space.

Figure in Full Run: Starting with the Left Foot

Next, let's continue by breaking down a single stride into four frames. After establishing drawings for (1) the moment the figure launches into the stride and (2) the moment that the left foot touches the ground, divide the sequence further for (3) the moment the leg extends in full stride and (4) the moment the leg contracts.

3

The moment that the elbow is at the highest point, the wrist is also at the highest point while the fist is the furthest from the body.

Since the point of view is a downward angle, this line curves down as well.

This line defines torsion in the body caused by the lowering of the shoulder.

4

Including the swell of mounds in the palm's heel adds a 3-dimensional feel.

5

The leg extended in front and the opposing shoulder (the shoulder extended in front) are angled downward.

At this angle, draw the contour of the shoulder from near the eye.

The arm in the foreground obscures the greater part of the abdomen.

6

041

Character in Full Run: Starting with the Right Foot

As when drawing the sketch model, imagine the character running within set boundaries. Since there is a fixed perspective, pay careful attention to the direction of creases in clothing.

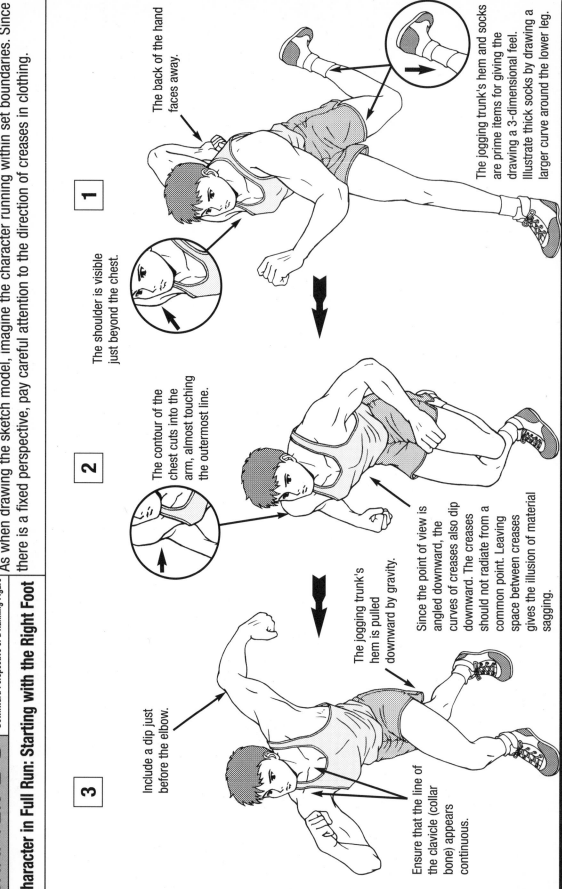

1

The back of the hand faces away.

The jogging trunk's hem and socks are prime items for giving the drawing a 3-dimensional feel. Illustrate thick socks by drawing a larger curve around the lower leg.

The shoulder is visible just beyond the chest.

2

The contour of the chest cuts into the arm, almost touching the outermost line.

Since the point of view is angled downward, the curves of creases also dip downward. The creases should not radiate from a common point. Leaving space between creases gives the illusion of material sagging.

The jogging trunk's hem is pulled downward by gravity.

3

Include a dip just before the elbow.

Ensure that the line of the clavicle (collar bone) appears continuous.

Character in Full Run: Starting with the Left Foot

The downward perspective means that there are more parts hidden from view. Maintain consistency in the positioning of the hands and feet.

4

(1) The shoulder, (2) the muscles of the upper arm, and (3) the elbow create three separate mounds.

The upper thigh is obscured, and the leg is only viewable below the knee.

Define the contour of the leg using creases in the trunks.

Include the bulge of the shoulder muscle.

Creases appear where the upper leg connects to the hip.

5

Having the strap of the tank top rise slightly above instead of resting on the shoulder gives a 3-dimension feel to the material.

The posterior becomes almost completely flattened from this angle.

These are creases caused by the leg rising. Use a bold, horizontal, and somewhat straight line.

6

CHAPTER 2-6 | Running at a Slower Gait

Basic Movements in a Trot: Starting with the Right Foot

To conclude, let's take a look at drawing a character in a trot. This is a motion used more commonly than one might expect, such as when the character is unrushed, when approaching something, when running at a slower gait. Bring the arms closer to the body when drawing a female character.

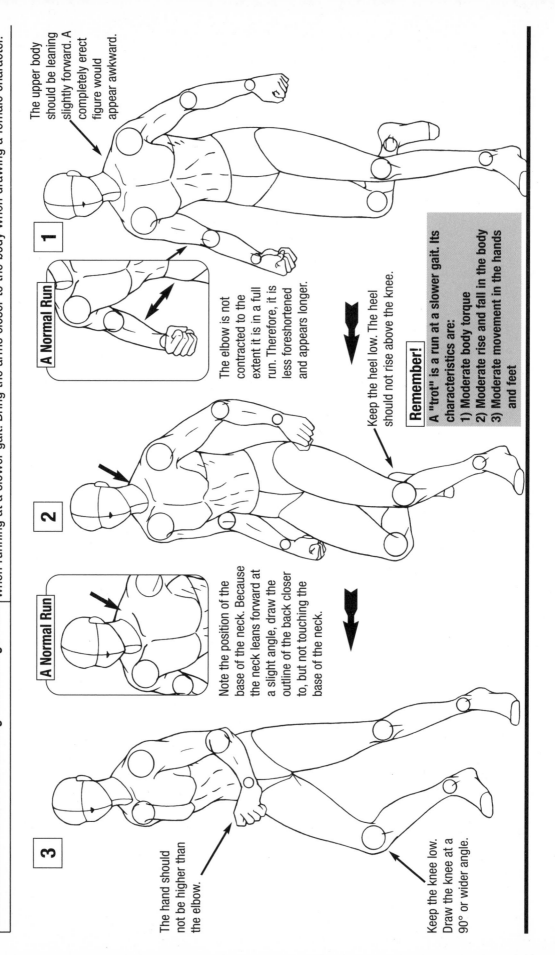

1

The upper body should be leaning slightly forward. A completely erect figure would appear awkward.

A Normal Run

The elbow is not contracted to the extent it is in a full run. Therefore, it is less foreshortened and appears longer.

Keep the heel low. The heel should not rise above the knee.

Remember!

A "trot" is a run at a slower gait. Its characteristics are:
1) Moderate body torque
2) Moderate rise and fall in the body
3) Moderate movement in the hands and feet

2

A Normal Run

Note the position of the base of the neck. Because the neck leans forward at a slight angle, draw the outline of the back closer to, but not touching the base of the neck.

3

The hand should not be higher than the elbow.

Keep the knee low. Draw the knee at a 90° or wider angle.

These are the movements between the moments that the right foot touches the ground and the left foot moves into the next step. The key point in showing leisure in the gait is not adding drama to the frame where the foot touches the ground and where the foot is suspended in mid-stride.

Basic Movements in a Trot: Starting with the Left Foot

4

Maximize upper body torque in this frame. The side of the trunk is exposed.

Maintain the shoulder in view.

5

Do not bend the wrist more inward than this.

This line is almost perpendicular to the ground line.

Unlike in a full run, the wrist bends slightly outward.

The leg touching the ground is extending and standing on the tip of the foot, but not angled as much as with the full run.

6

Because the wrist is not bent inward, the fingers are in view rather than the back of the fist. Draw three ridges to define the knuckles and add lines from the dips in between for the fingers.

CHAPTER 2-6 | Running at a Slower Gait

Clothing creases should not be drawn the same as when depicting a full run. The sizes of the creases affect how exaggerated movements appear.

Character in a Trot: Starting with the Right Foot

1

The shoulder is slouched forward slightly, exposing part of the back.

Because torsion is the strongest here, depict the creases using straighter lines.

Since the leg is not that significantly raised, be conservative with adding creases.

Remember!

Loose creases:
(1) Are not as detailed
(2) Have greater space between them
(3) Are drawn straighter

2

Maximize the character leaning forward in this frame. Because the arm is swinging, draw the distance between the shoulder seam and back wider than in the previous frame.

Give the shirt the appearance of sagging by having the creases run parallel.

Adding creases where the chest muscles meet makes the character's movements more apparent.

Adding a line here defines the inside of the elbow.

Although the step is made from the tip of the foot, the heel does not raise greatly.

3

The toe lowers automatically.

This is a continuation of the preceding page. The pace is increased somewhat over the previous page, so the swinging of the arms is more exaggerated; however, keep it conservative, or you will create the effect of a full run.

Character in a Trot: Starting with the Left Foot

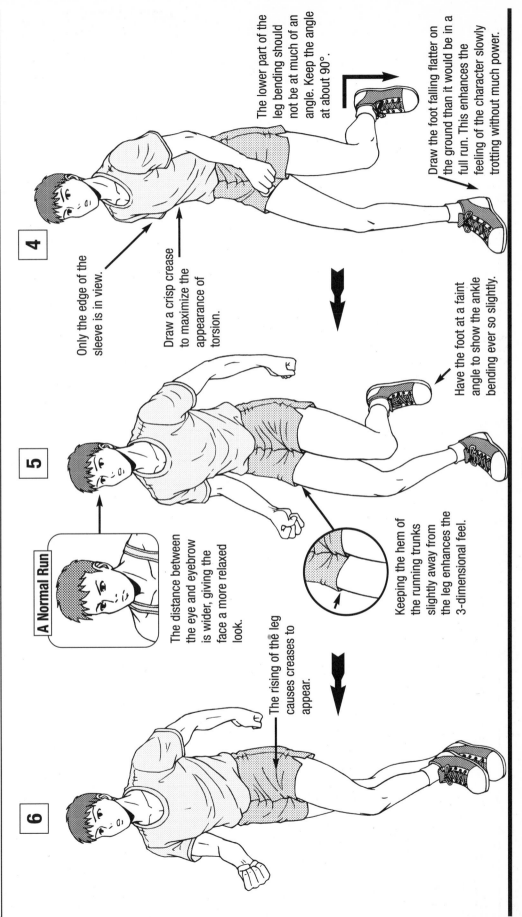

4

Only the edge of the sleeve is in view.

Draw a crisp crease to maximize the appearance of torsion.

The lower part of the leg bending should not be at much of an angle. Keep the angle at about 90°.

Draw the foot falling flatter on the ground than it would be in a full run. This enhances the feeling of the character slowly trotting without much power.

5

A Normal Run

The distance between the eye and eyebrow is wider, giving the face a more relaxed look.

Keeping the hem of the running trunks slightly away from the leg enhances the 3-dimensional feel.

Have the foot at a faint angle to show the ankle bending ever so slightly.

6

The rising of the leg causes creases to appear.

047

The drawing conveys a sense of gentleness, but the balance seems weighted more to the upper half of the composition. Since this image is supposed to be atmospheric and fantastic, my advice would be to stylize her features.

Since the upper half of the figure is already brimming over with the face, hair and other details, try adding interesting elements to the lower half, such as extending her staff down further or adding a pattern to her skirt.

The neck would appear more natural when positioned back further.

Bending the wrists would make her seem more alive.

Making the head a little larger would be appropriate for this type of character and would help balance the composition. I lengthened her staff and hair to give better balance to the composition.

Compare the two axial lines.

Adding a broach bearing a coat of arms or other such touch gives the character a cultural flavor.

Shorter boots would give her a sweeter, more charming feel.

Adornments are terrific items for enhancing the character's personality.

Before

After

048

CHAPTER 3

Action

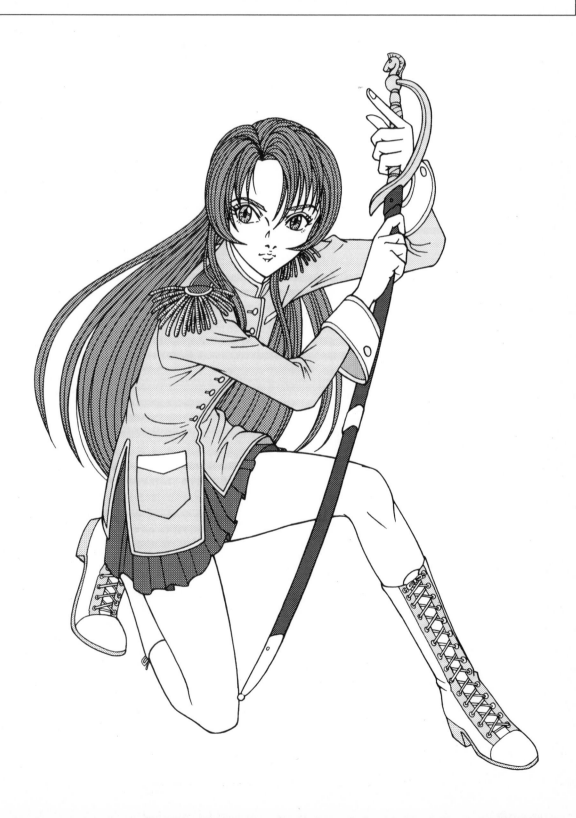

Arm Action

The most frequent form of attack in fight scenes is hand combat. The moves involved are highly varied, not stopping at just the arm, but including upper body movement, torque, and using the fist like a sword or knife. Conversely, you will need to pay close attention to the "connection" between arm movements and the body as a whole. A punch loses half of its power without the body to back it up.

Straight Punch	Basic Form

In this punch, the character takes a large step forward and uses the force of stepping forward in the punch's delivery. Just like the name says, the punch is delivered straight on. The figure is drawn here in manga-style, imagining that the fist is coming into contact with an opponent. Exaggerate the key move.

① Taking a large step forward.

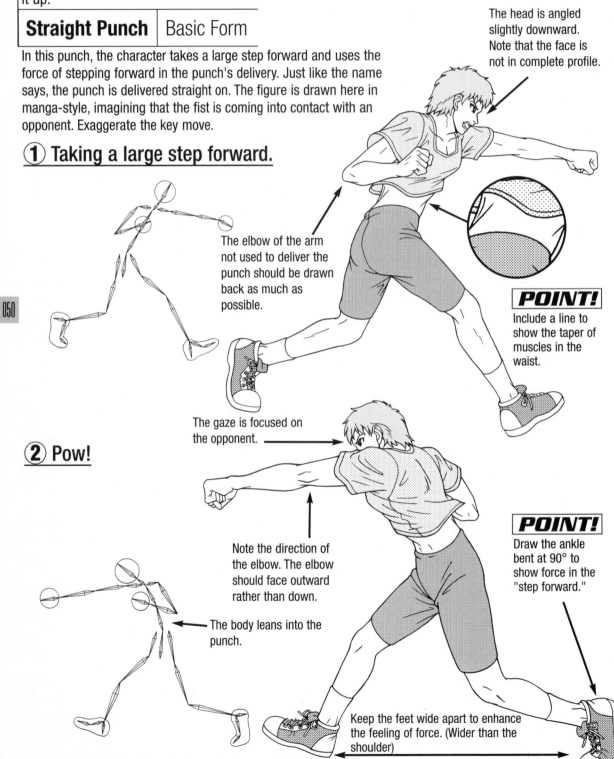

The head is angled slightly downward. Note that the face is not in complete profile.

The elbow of the arm not used to deliver the punch should be drawn back as much as possible.

POINT!
Include a line to show the taper of muscles in the waist.

The gaze is focused on the opponent.

② Pow!

Note the direction of the elbow. The elbow should face outward rather than down.

The body leans into the punch.

POINT!
Draw the ankle bent at 90° to show force in the "step forward."

Keep the feet wide apart to enhance the feeling of force. (Wider than the shoulder)

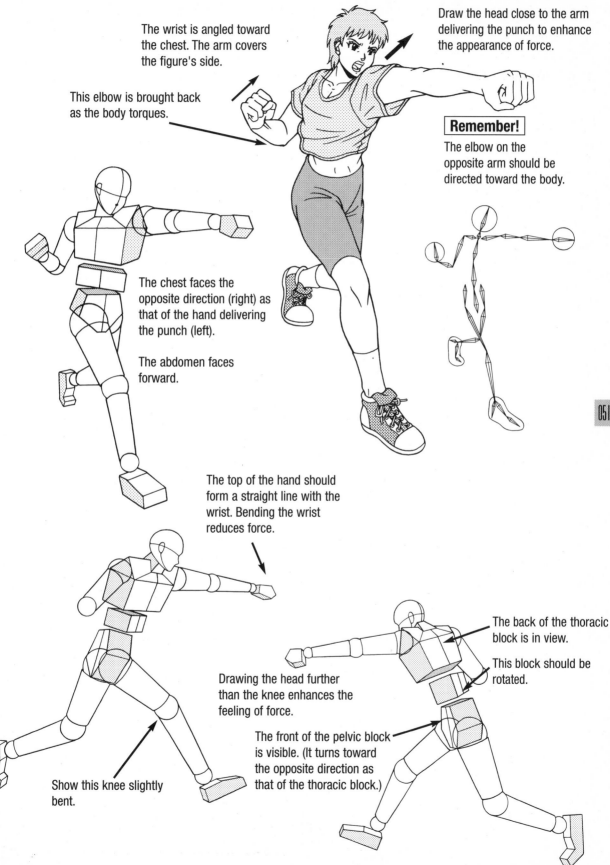

The wrist is angled toward the chest. The arm covers the figure's side.

This elbow is brought back as the body torques.

Draw the head close to the arm delivering the punch to enhance the appearance of force.

Remember!

The elbow on the opposite arm should be directed toward the body.

The chest faces the opposite direction (right) as that of the hand delivering the punch (left).

The abdomen faces forward.

The top of the hand should form a straight line with the wrist. Bending the wrist reduces force.

The back of the thoracic block is in view.

This block should be rotated.

Drawing the head further than the knee enhances the feeling of force.

The front of the pelvic block is visible. (It turns toward the opposite direction as that of the thoracic block.)

Show this knee slightly bent.

Downward Perspective

The elbow is always faced outward. Include contour lines to represent the inside of the elbows.

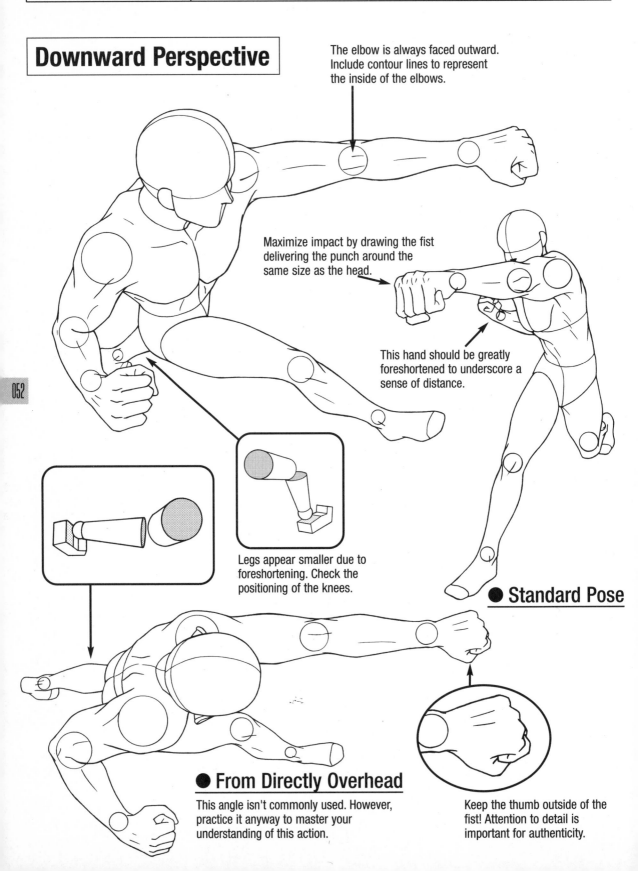

Maximize impact by drawing the fist delivering the punch around the same size as the head.

This hand should be greatly foreshortened to underscore a sense of distance.

Legs appear smaller due to foreshortening. Check the positioning of the knees.

● Standard Pose

● From Directly Overhead

This angle isn't commonly used. However, practice it anyway to master your understanding of this action.

Keep the thumb outside of the fist! Attention to detail is important for authenticity.

052

Upward Perspective

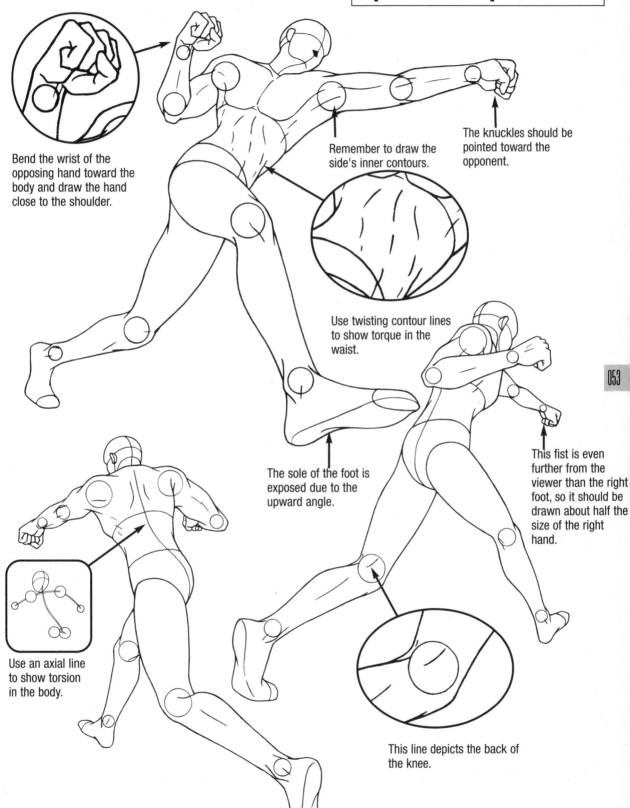

Bend the wrist of the opposing hand toward the body and draw the hand close to the shoulder.

Remember to draw the side's inner contours.

The knuckles should be pointed toward the opponent.

Use twisting contour lines to show torque in the waist.

The sole of the foot is exposed due to the upward angle.

This fist is even further from the viewer than the right foot, so it should be drawn about half the size of the right hand.

Use an axial line to show torsion in the body.

This line depicts the back of the knee.

053

Jab | Basic Form

An orthodox form of punch, this move is often used to keep an opponent in check and appears in almost every fighting game.

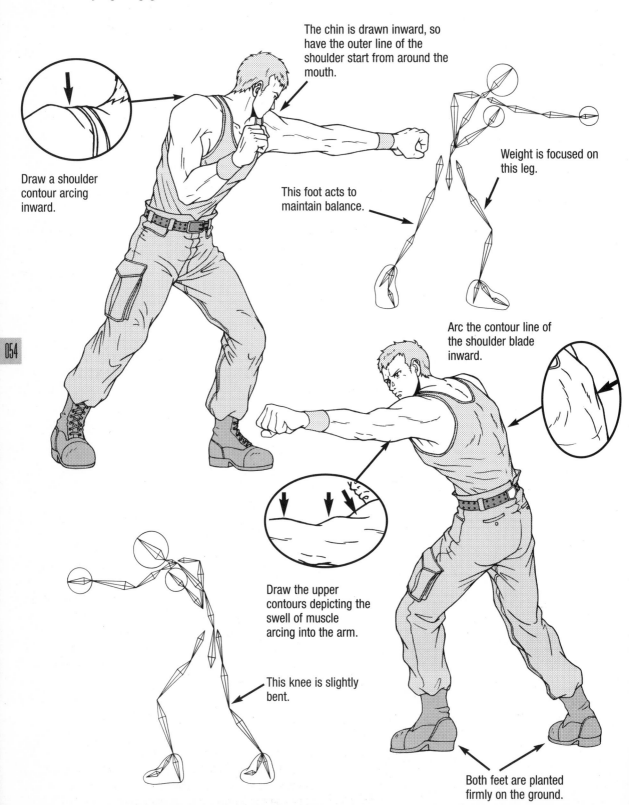

The chin is drawn inward, so have the outer line of the shoulder start from around the mouth.

Draw a shoulder contour arcing inward.

Weight is focused on this leg.

This foot acts to maintain balance.

Arc the contour line of the shoulder blade inward.

Draw the upper contours depicting the swell of muscle arcing into the arm.

This knee is slightly bent.

Both feet are planted firmly on the ground.

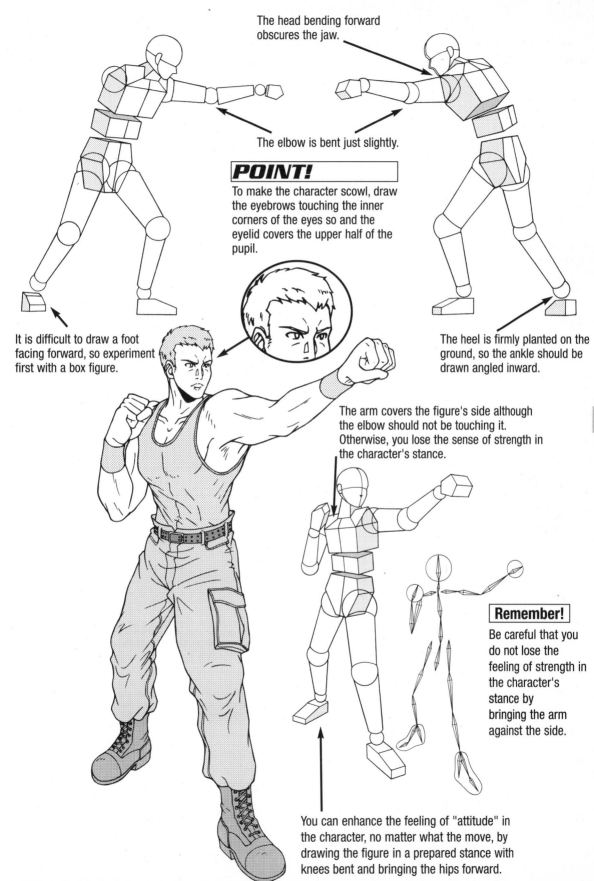

The head bending forward obscures the jaw.

The elbow is bent just slightly.

POINT!

To make the character scowl, draw the eyebrows touching the inner corners of the eyes so and the eyelid covers the upper half of the pupil.

It is difficult to draw a foot facing forward, so experiment first with a box figure.

The heel is firmly planted on the ground, so the ankle should be drawn angled inward.

The arm covers the figure's side although the elbow should not be touching it. Otherwise, you lose the sense of strength in the character's stance.

Remember!

Be careful that you do not lose the feeling of strength in the character's stance by bringing the arm against the side.

You can enhance the feeling of "attitude" in the character, no matter what the move, by drawing the figure in a prepared stance with knees bent and bringing the hips forward.

055

Jab | Perspectives with Foreshortening

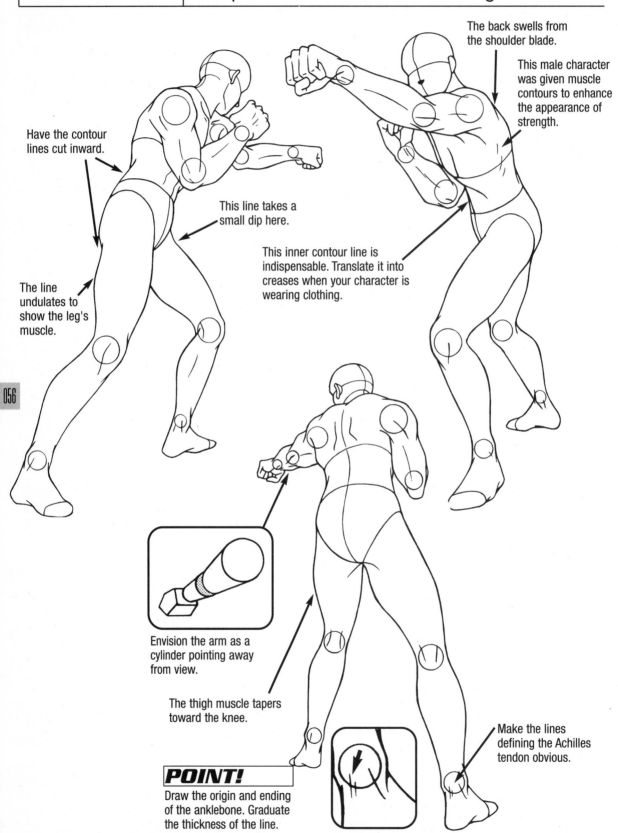

The back swells from the shoulder blade.

This male character was given muscle contours to enhance the appearance of strength.

Have the contour lines cut inward.

This line takes a small dip here.

This inner contour line is indispensable. Translate it into creases when your character is wearing clothing.

The line undulates to show the leg's muscle.

Envision the arm as a cylinder pointing away from view.

The thigh muscle tapers toward the knee.

Make the lines defining the Achilles tendon obvious.

POINT!
Draw the origin and ending of the anklebone. Graduate the thickness of the line.

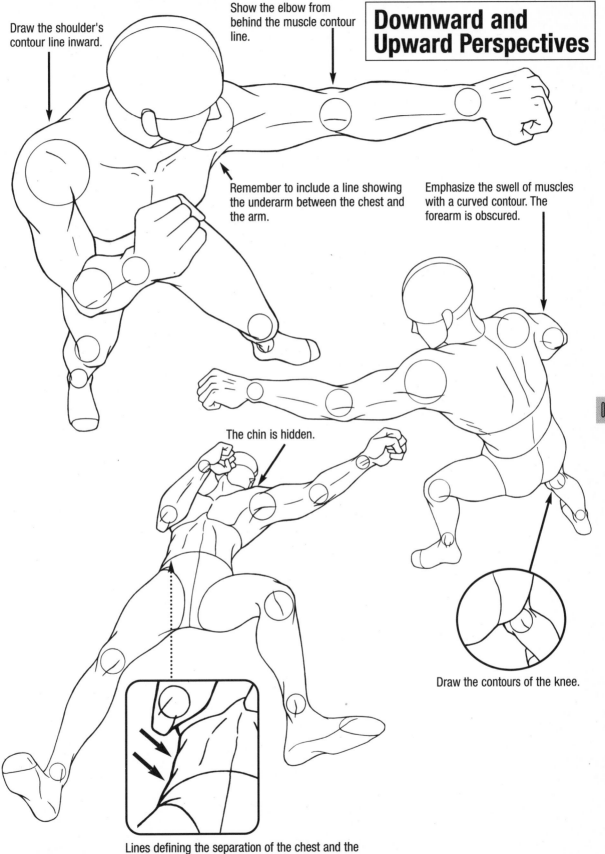

Downward and Upward Perspectives

Draw the shoulder's contour line inward.

Show the elbow from behind the muscle contour line.

Remember to include a line showing the underarm between the chest and the arm.

Emphasize the swell of muscles with a curved contour. The forearm is obscured.

The chin is hidden.

Draw the contours of the knee.

Lines defining the separation of the chest and the abdomen, and then the abdomen and pelvis. Depict these as creases in a clothed character.

057

Hook | Basic Form

The hook is not a strike made with the arm straight, but rather is delivered from the side with the arm arcing across the body. Since this form of strike is often used in combination with other moves, just remember what you see on these pages as one variation.

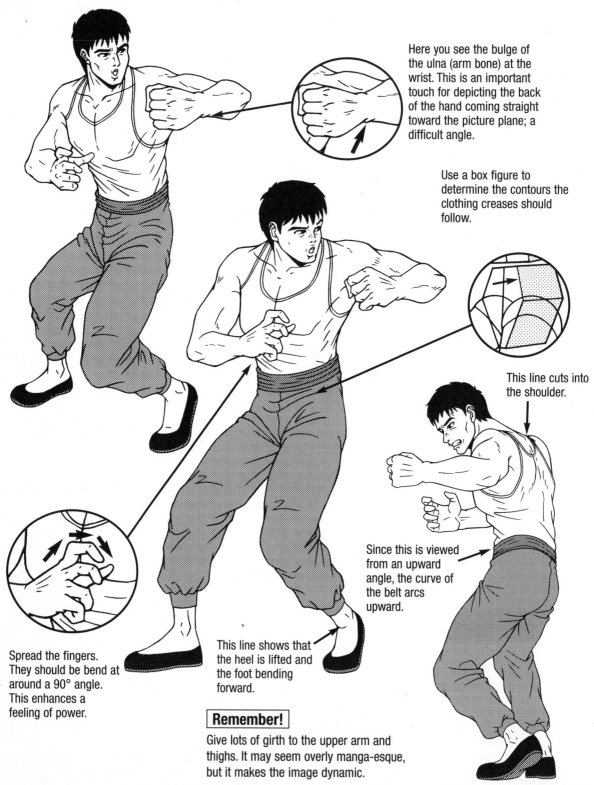

Here you see the bulge of the ulna (arm bone) at the wrist. This is an important touch for depicting the back of the hand coming straight toward the picture plane; a difficult angle.

Use a box figure to determine the contours the clothing creases should follow.

This line cuts into the shoulder.

Since this is viewed from an upward angle, the curve of the belt arcs upward.

Spread the fingers. They should be bend at around a 90° angle. This enhances a feeling of power.

This line shows that the heel is lifted and the foot bending forward.

Remember!

Give lots of girth to the upper arm and thighs. It may seem overly manga-esque, but it makes the image dynamic.

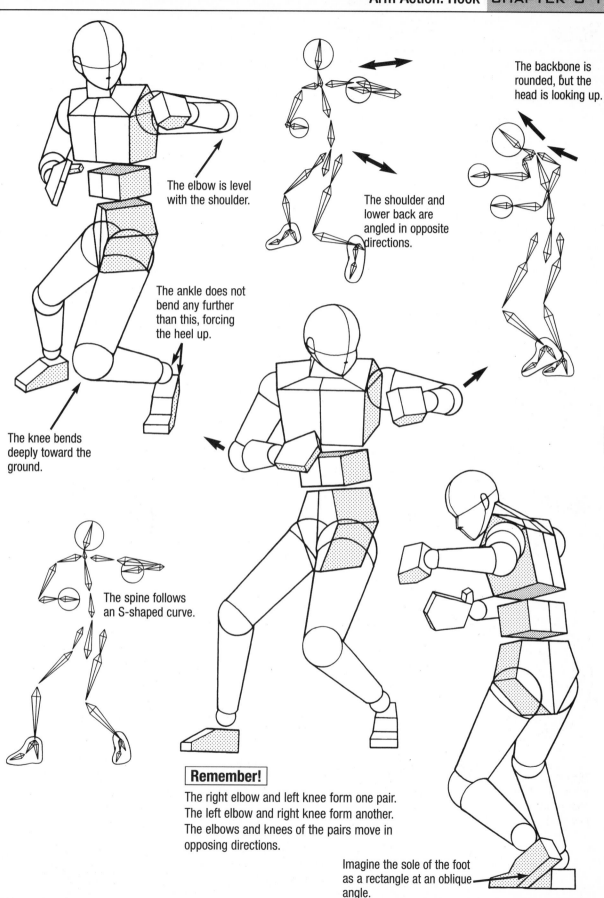

The elbow is level with the shoulder.

The backbone is rounded, but the head is looking up.

The shoulder and lower back are angled in opposite directions.

The ankle does not bend any further than this, forcing the heel up.

The knee bends deeply toward the ground.

The spine follows an S-shaped curve.

Remember!

The right elbow and left knee form one pair.
The left elbow and right knee form another.
The elbows and knees of the pairs move in opposing directions.

Imagine the sole of the foot as a rectangle at an oblique angle.

059

Downward Perspective

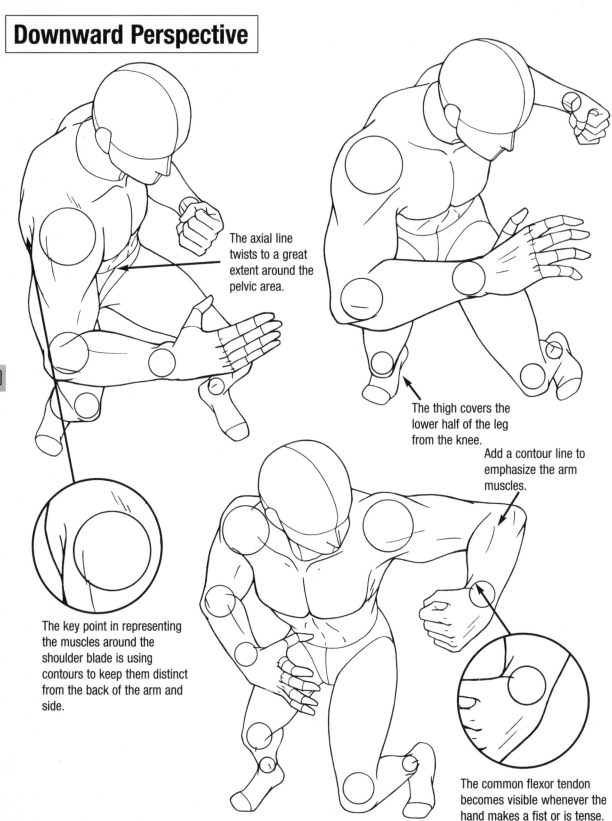

The axial line twists to a great extent around the pelvic area.

The thigh covers the lower half of the leg from the knee.

Add a contour line to emphasize the arm muscles.

The key point in representing the muscles around the shoulder blade is using contours to keep them distinct from the back of the arm and side.

The common flexor tendon becomes visible whenever the hand makes a fist or is tense.

Upward Perspective

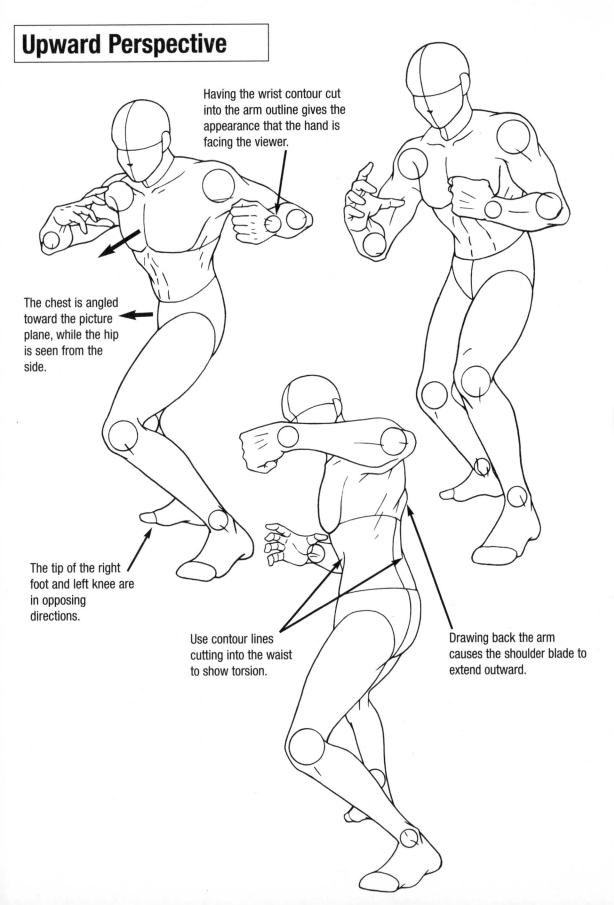

Having the wrist contour cut into the arm outline gives the appearance that the hand is facing the viewer.

The chest is angled toward the picture plane, while the hip is seen from the side.

The tip of the right foot and left knee are in opposing directions.

Use contour lines cutting into the waist to show torsion.

Drawing back the arm causes the shoulder blade to extend outward.

061

Strikes | Basic Form

An open hand with extended fingers, rather than a fist, is used to strike the opponent. This type of strike is favored by enemies (villains), nemeses, and other bad characters in manga and animated games and seems less suited for the hero.

Include the upper contour of the back behind the shoulder's muscles.

The belt should be shown streaming in the opposite direction of the hand striking to get the right effect.

Have the head tilt in the direction of the hand striking.

The second joints of the fingers should face downward.

The four fingers should be completely straight. The thumb should be bent at 90° and tucked inside the palm.

Close-up of the palm

Add gear for an effective touch.

Use foreshortening and draw this foot smaller.

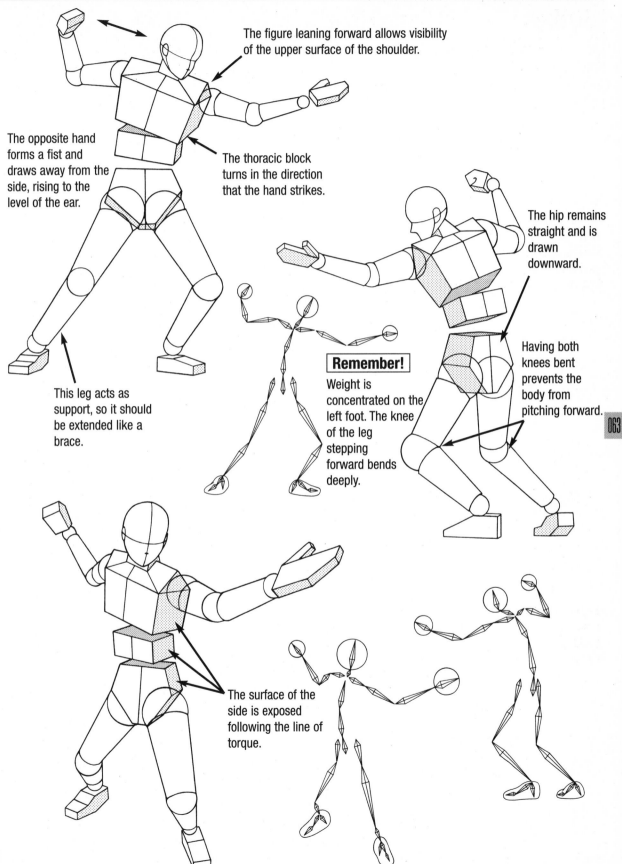

The figure leaning forward allows visibility of the upper surface of the shoulder.

The opposite hand forms a fist and draws away from the side, rising to the level of the ear.

The thoracic block turns in the direction that the hand strikes.

The hip remains straight and is drawn downward.

This leg acts as support, so it should be extended like a brace.

Remember!

Weight is concentrated on the left foot. The knee of the leg stepping forward bends deeply.

Having both knees bent prevents the body from pitching forward.

The surface of the side is exposed following the line of torque.

Downward Perspective

Developed chest muscles. The chest muscles bulge to the extent that they become part of the silhouette line.

The axial line turns at the edge of the neck.

Remember!

When making a fist, the folds of skin created by the first and second joints of the index finger form a Y.

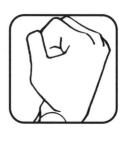

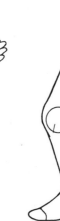

POINT!

Showing the bulge of the muscle in the back of the knee (semitendinosus muscle) adds to the feeling of tense muscles.

Having the outer leg contour curve inward enhances the sense of musculature.

Back View

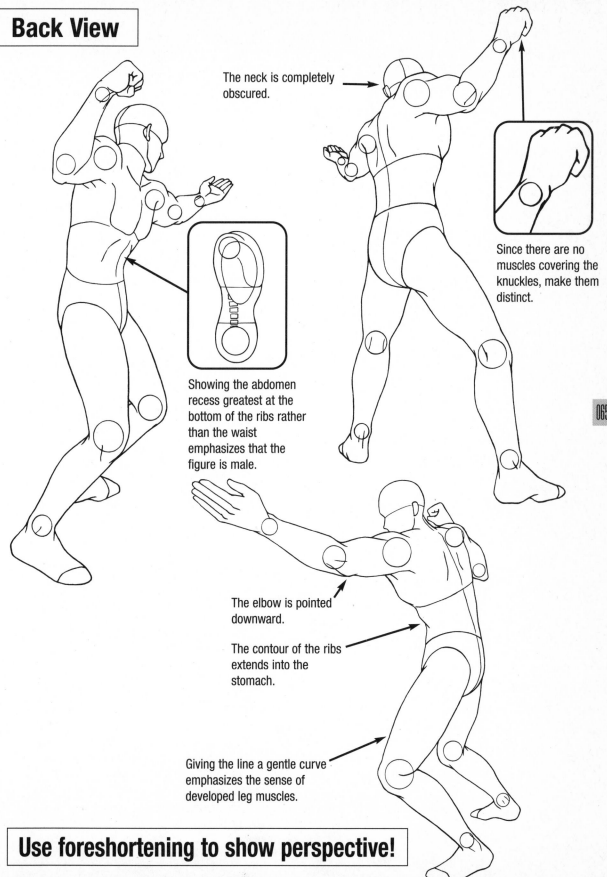

The neck is completely obscured.

Showing the abdomen recess greatest at the bottom of the ribs rather than the waist emphasizes that the figure is male.

Since there are no muscles covering the knuckles, make them distinct.

The elbow is pointed downward.

The contour of the ribs extends into the stomach.

Giving the line a gentle curve emphasizes the sense of developed leg muscles.

Use foreshortening to show perspective!

Palm-Heel Strike | Basic Form

For this move, the heel of the hand rather than the fist is used to strike the opponent. Since this move is specific to koppo [literally, "bone method": a special series of strikes designed to break bone], the figure should be oriented accordingly.

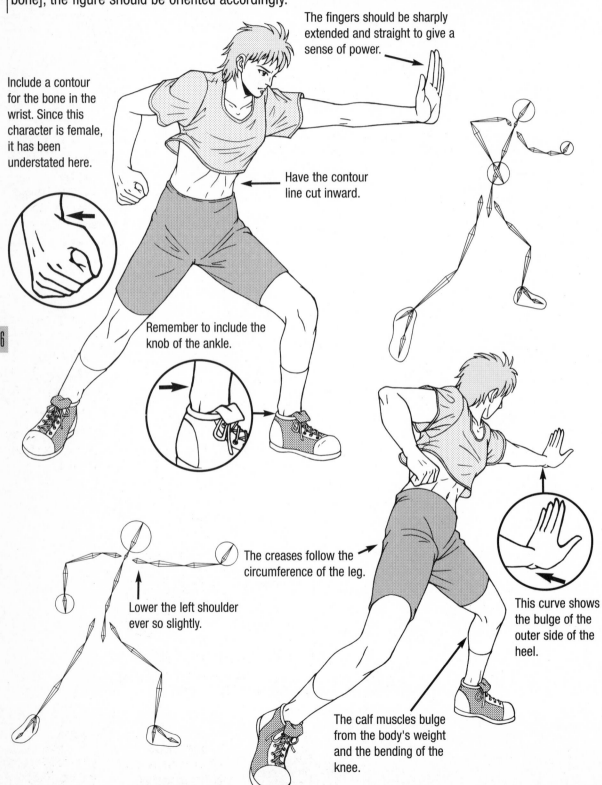

The fingers should be sharply extended and straight to give a sense of power.

Include a contour for the bone in the wrist. Since this character is female, it has been understated here.

Have the contour line cut inward.

Remember to include the knob of the ankle.

The creases follow the circumference of the leg.

Lower the left shoulder ever so slightly.

This curve shows the bulge of the outer side of the heel.

The calf muscles bulge from the body's weight and the bending of the knee.

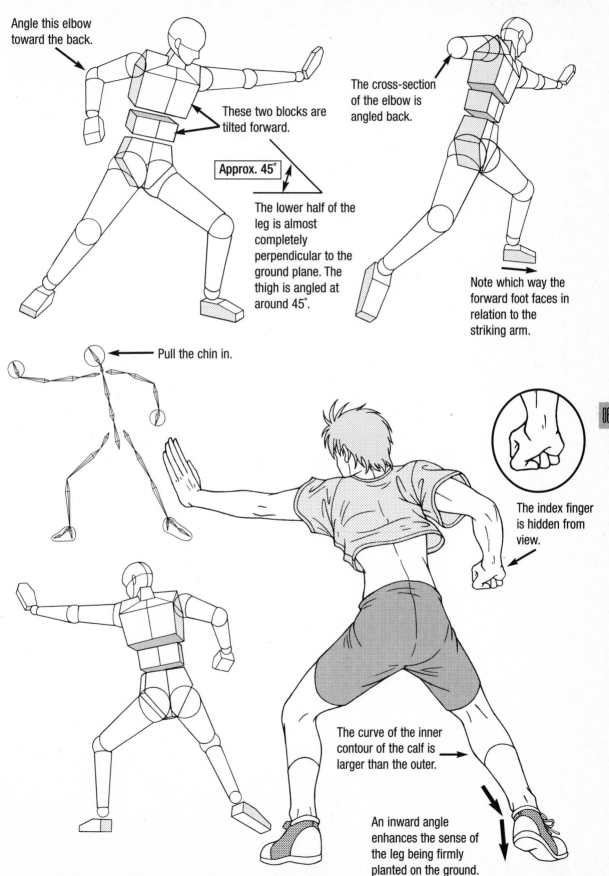

Angle this elbow toward the back.

These two blocks are tilted forward.

The cross-section of the elbow is angled back.

Approx. 45°

The lower half of the leg is almost completely perpendicular to the ground plane. The thigh is angled at around 45°.

Note which way the forward foot faces in relation to the striking arm.

Pull the chin in.

The index finger is hidden from view.

The curve of the inner contour of the calf is larger than the outer.

An inward angle enhances the sense of the leg being firmly planted on the ground.

067

Palm-Heel Strike | Perspectives with Foreshortening

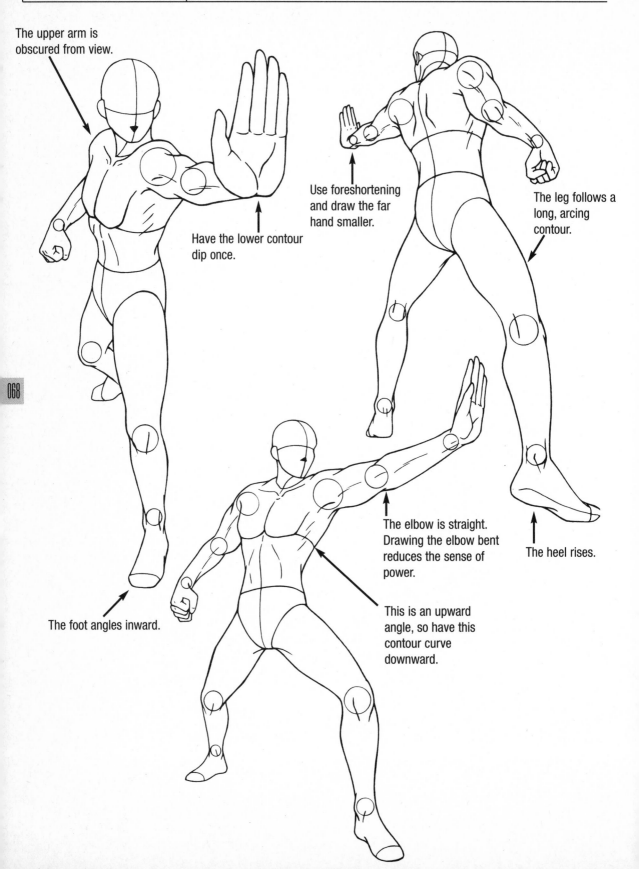

The upper arm is obscured from view.

Have the lower contour dip once.

Use foreshortening and draw the far hand smaller.

The leg follows a long, arcing contour.

The heel rises.

The elbow is straight. Drawing the elbow bent reduces the sense of power.

This is an upward angle, so have this contour curve downward.

The foot angles inward.

068

Downward and Upward Perspectives

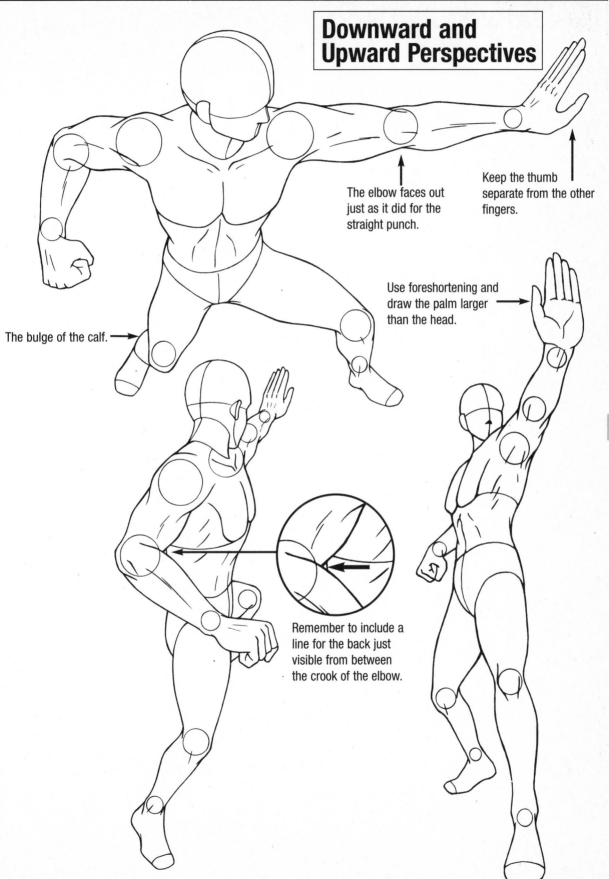

The elbow faces out just as it did for the straight punch.

Keep the thumb separate from the other fingers.

Use foreshortening and draw the palm larger than the head.

The bulge of the calf.

Remember to include a line for the back just visible from between the crook of the elbow.

Back Fist | Basic Form

For this move, the arm is drawn across the body and swung out. The blow is delivered with the back of the fist. More than the typical punch, this strike gives the character the impression of having knowledge in the martial arts and being experienced in fighting.

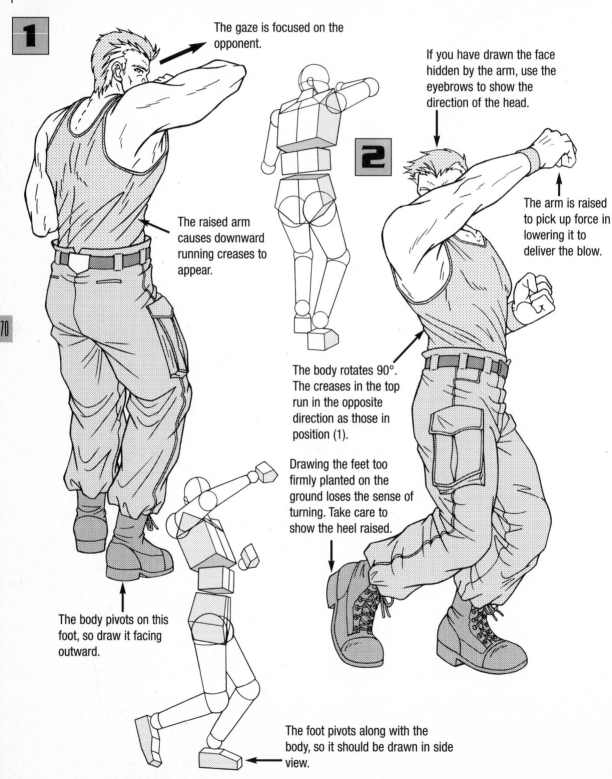

The gaze is focused on the opponent.

If you have drawn the face hidden by the arm, use the eyebrows to show the direction of the head.

The arm is raised to pick up force in lowering it to deliver the blow.

The raised arm causes downward running creases to appear.

The body rotates 90°. The creases in the top run in the opposite direction as those in position (1).

Drawing the feet too firmly planted on the ground loses the sense of turning. Take care to show the heel raised.

The body pivots on this foot, so draw it facing outward.

The foot pivots along with the body, so it should be drawn in side view.

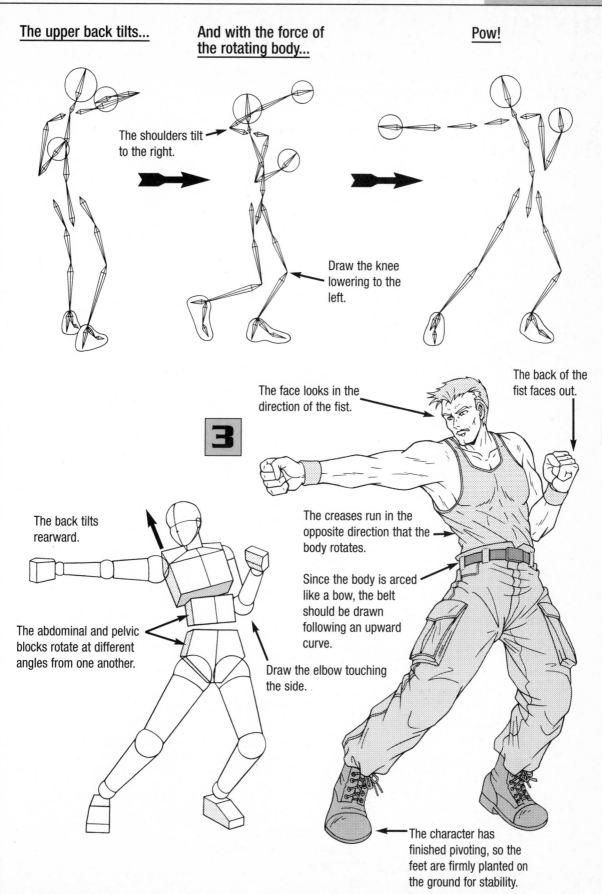

The upper back tilts...

And with the force of the rotating body...

Pow!

The shoulders tilt to the right.

Draw the knee lowering to the left.

3

The face looks in the direction of the fist.

The back of the fist faces out.

The back tilts rearward.

The creases run in the opposite direction that the body rotates.

Since the body is arced like a bow, the belt should be drawn following an upward curve.

The abdominal and pelvic blocks rotate at different angles from one another.

Draw the elbow touching the side.

The character has finished pivoting, so the feet are firmly planted on the ground for stability.

071

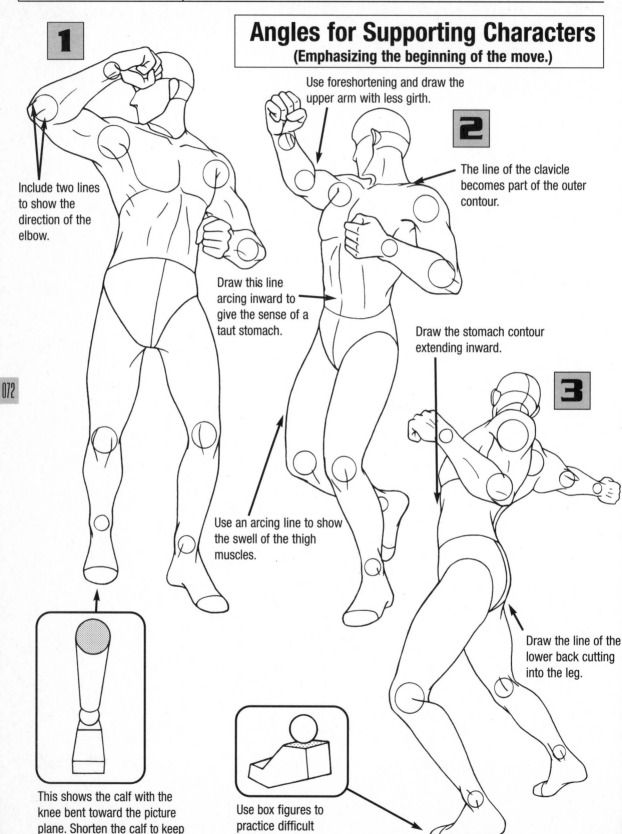

1

Include two lines to show the direction of the elbow.

Angles for Supporting Characters
(Emphasizing the beginning of the move.)

Use foreshortening and draw the upper arm with less girth.

2

The line of the clavicle becomes part of the outer contour.

Draw this line arcing inward to give the sense of a taut stomach.

Draw the stomach contour extending inward.

3

Use an arcing line to show the swell of the thigh muscles.

Draw the line of the lower back cutting into the leg.

This shows the calf with the knee bent toward the picture plane. Shorten the calf to keep the perspective consistent.

Use box figures to practice difficult positions.

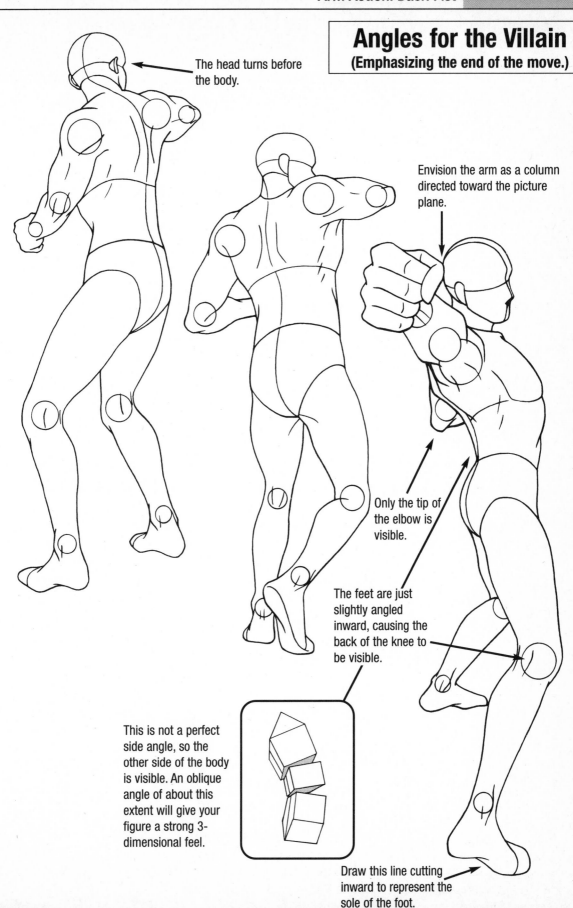

The head turns before the body.

Angles for the Villain
(Emphasizing the end of the move.)

Envision the arm as a column directed toward the picture plane.

Only the tip of the elbow is visible.

The feet are just slightly angled inward, causing the back of the knee to be visible.

This is not a perfect side angle, so the other side of the body is visible. An oblique angle of about this extent will give your figure a strong 3-dimensional feel.

Draw this line cutting inward to represent the sole of the foot.

073

Knife-Hand Strike | Basic Form

For this move, the strike is delivered using the side of an open hand. In manga, this can also be shown, as the name suggests, with the character delivering a slicing blow to the opponent.

Preparatory Stance

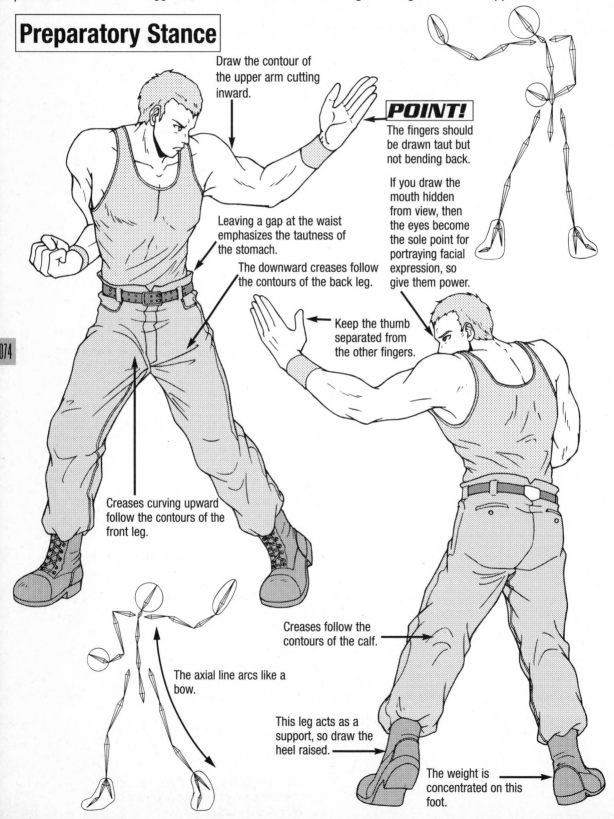

Draw the contour of the upper arm cutting inward.

POINT!
The fingers should be drawn taut but not bending back.

If you draw the mouth hidden from view, then the eyes become the sole point for portraying facial expression, so give them power.

Leaving a gap at the waist emphasizes the tautness of the stomach.

The downward creases follow the contours of the back leg.

Keep the thumb separated from the other fingers.

Creases curving upward follow the contours of the front leg.

Creases follow the contours of the calf.

The axial line arcs like a bow.

This leg acts as a support, so draw the heel raised.

The weight is concentrated on this foot.

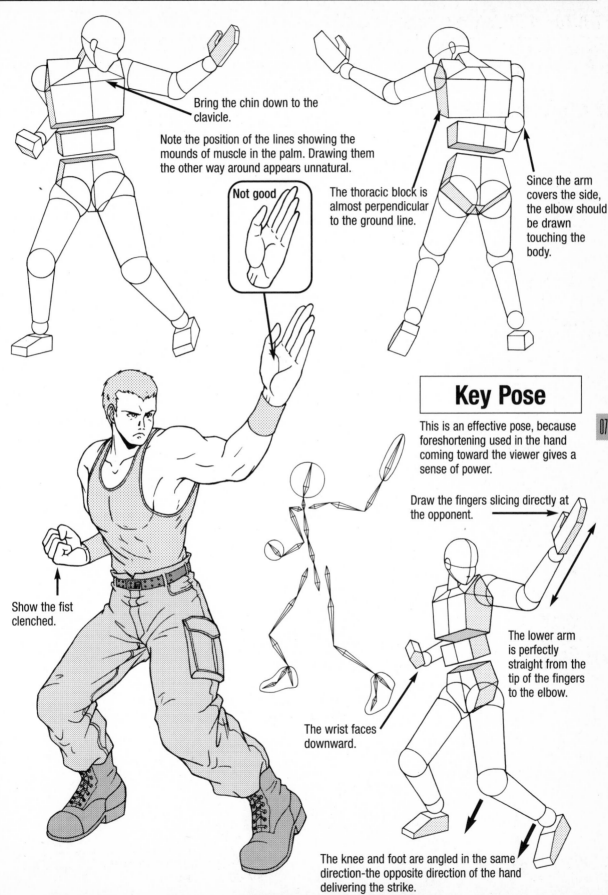

Bring the chin down to the clavicle.

Note the position of the lines showing the mounds of muscle in the palm. Drawing them the other way around appears unnatural.

Not good

The thoracic block is almost perpendicular to the ground line.

Since the arm covers the side, the elbow should be drawn touching the body.

Show the fist clenched.

Key Pose

This is an effective pose, because foreshortening used in the hand coming toward the viewer gives a sense of power.

Draw the fingers slicing directly at the opponent.

The lower arm is perfectly straight from the tip of the fingers to the elbow.

The wrist faces downward.

The knee and foot are angled in the same direction-the opposite direction of the hand delivering the strike.

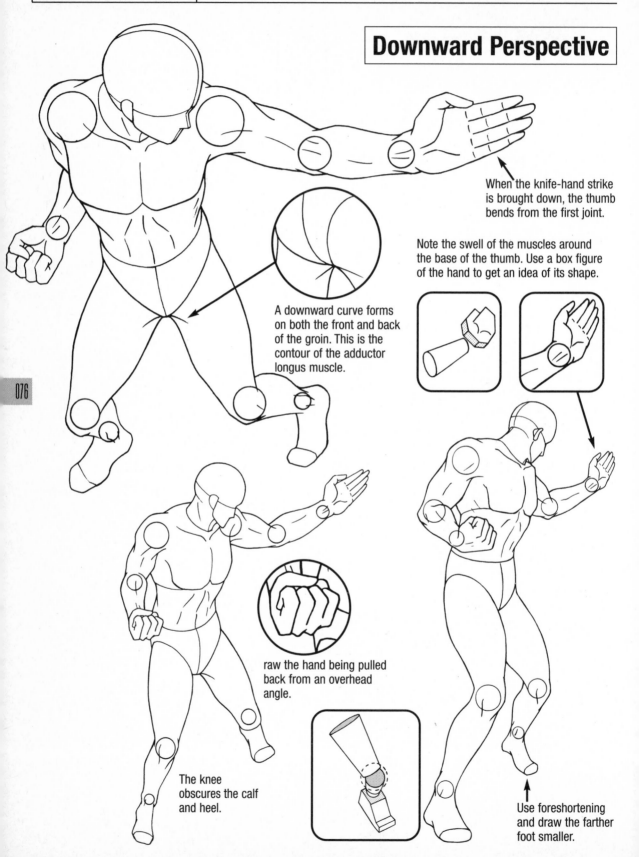

Downward Perspective

When the knife-hand strike is brought down, the thumb bends from the first joint.

Note the swell of the muscles around the base of the thumb. Use a box figure of the hand to get an idea of its shape.

A downward curve forms on both the front and back of the groin. This is the contour of the adductor longus muscle.

raw the hand being pulled back from an overhead angle.

The knee obscures the calf and heel.

Use foreshortening and draw the farther foot smaller.

076

Upward Perspective

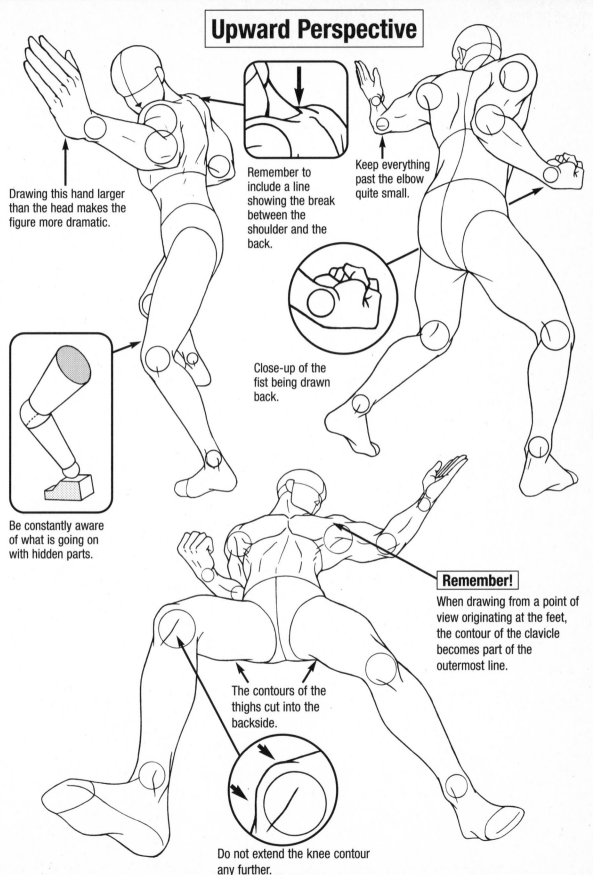

Drawing this hand larger than the head makes the figure more dramatic.

Remember to include a line showing the break between the shoulder and the back.

Keep everything past the elbow quite small.

Close-up of the fist being drawn back.

Be constantly aware of what is going on with hidden parts.

Remember!

When drawing from a point of view originating at the feet, the contour of the clavicle becomes part of the outermost line.

The contours of the thighs cut into the backside.

Do not extend the knee contour any further.

Lariat | Basic Form

This is a move where the arm is clenched and swung down in a motion as if wielding an ax with the blow delivered to the opponent's neck. This is a common pro-wrestling move and seems to suit big, brawny characters.

1

Making the character a skinhead enhances his "tough" look.

The blow will be delivered using the return force of the body, so the shoulders are pulled back here.

Adding contour lines enhances the look of bones in a clenched fist.

The elbow rotates.

Drawing the line separated from the wrist shows the sinews in the wrist and enhances the sense of force.

The outer seam of the fatigues work quite well to show which direction the character's leg faces.

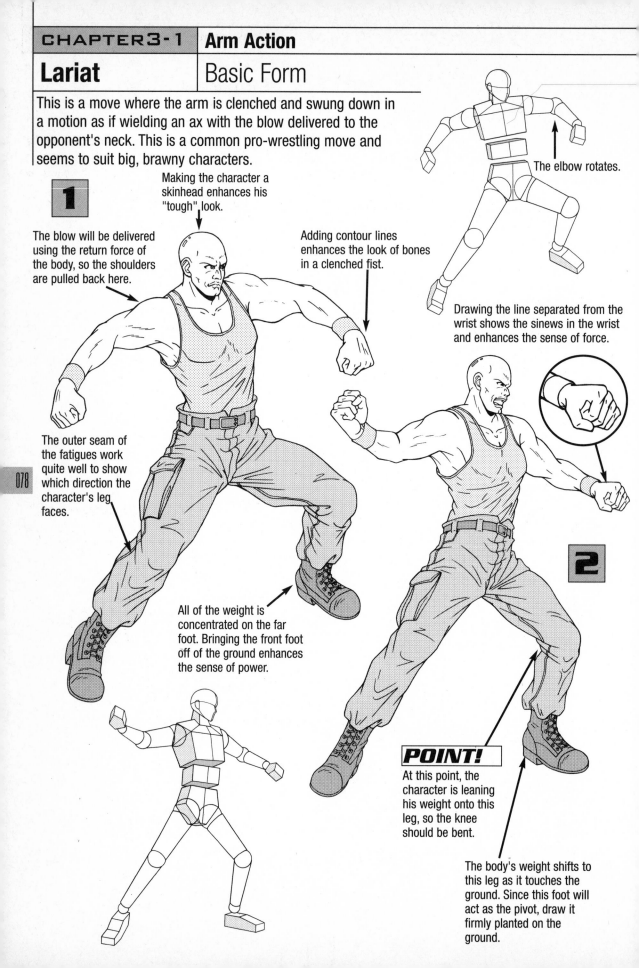

All of the weight is concentrated on the far foot. Bringing the front foot off of the ground enhances the sense of power.

2

POINT!

At this point, the character is leaning his weight onto this leg, so the knee should be bent.

The body's weight shifts to this leg as it touches the ground. Since this foot will act as the pivot, draw it firmly planted on the ground.

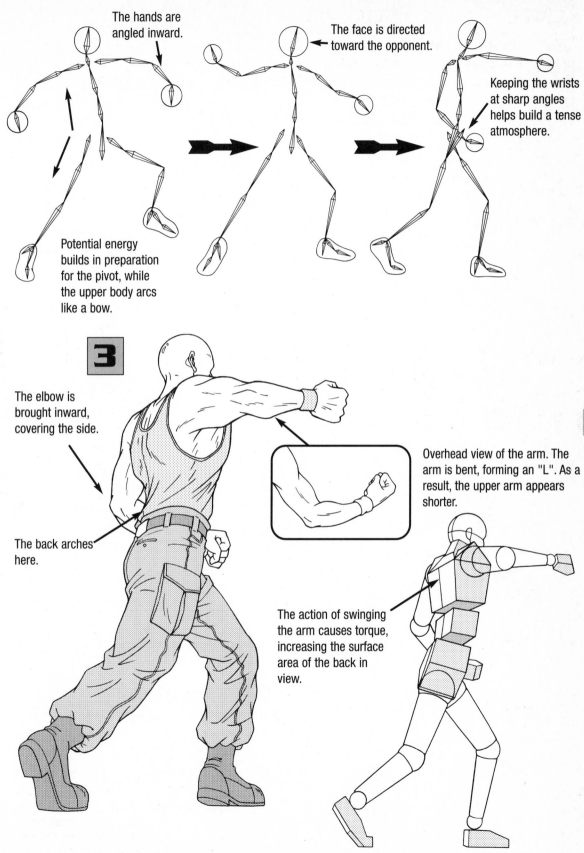

The hands are angled inward.

The face is directed toward the opponent.

Keeping the wrists at sharp angles helps build a tense atmosphere.

Potential energy builds in preparation for the pivot, while the upper body arcs like a bow.

3

The elbow is brought inward, covering the side.

The back arches here.

Overhead view of the arm. The arm is bent, forming an "L". As a result, the upper arm appears shorter.

The action of swinging the arm causes torque, increasing the surface area of the back in view.

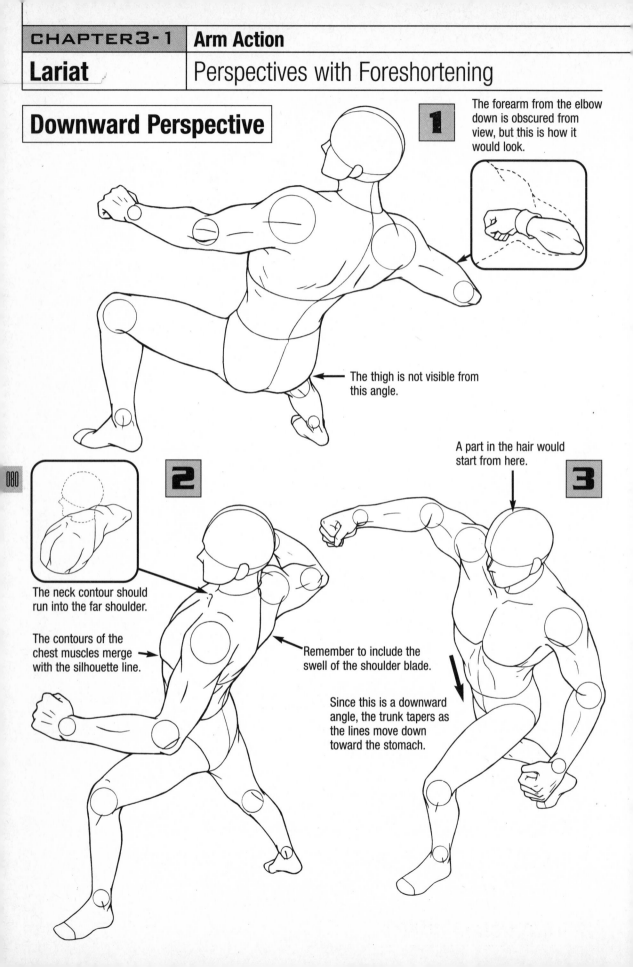

Downward Perspective

1 The forearm from the elbow down is obscured from view, but this is how it would look.

The thigh is not visible from this angle.

2 The neck contour should run into the far shoulder.

The contours of the chest muscles merge with the silhouette line.

Remember to include the swell of the shoulder blade.

3 A part in the hair would start from here.

Since this is a downward angle, the trunk tapers as the lines move down toward the stomach.

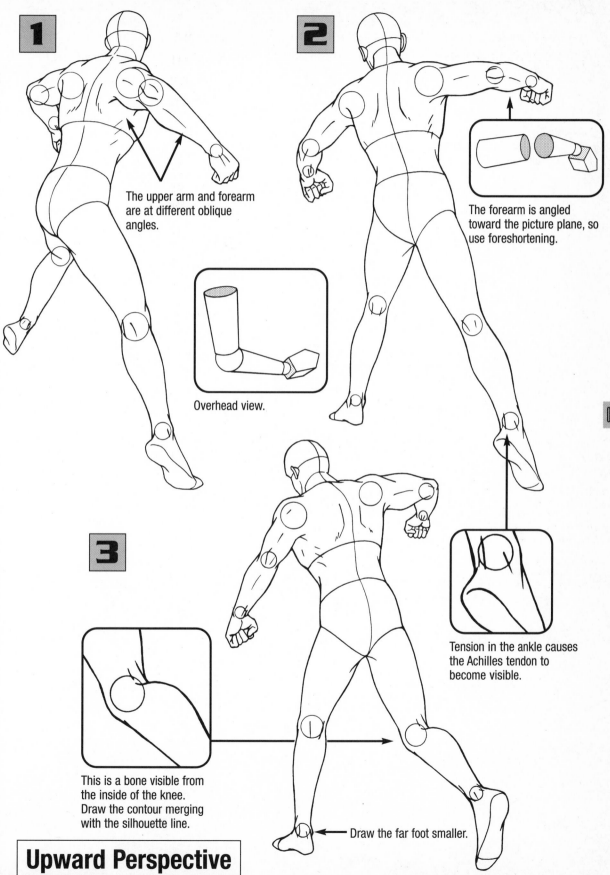

1

The upper arm and forearm are at different oblique angles.

Overhead view.

2

The forearm is angled toward the picture plane, so use foreshortening.

3

This is a bone visible from the inside of the knee. Draw the contour merging with the silhouette line.

Tension in the ankle causes the Achilles tendon to become visible.

Draw the far foot smaller.

Upward Perspective

Elbow Strike | Basic Form

In this move, the elbow is raised, the body rotated, and the blow delivered with the elbow. The reach is shorter than that of a punch, but it is a powerful attack method and makes for a dynamic image.

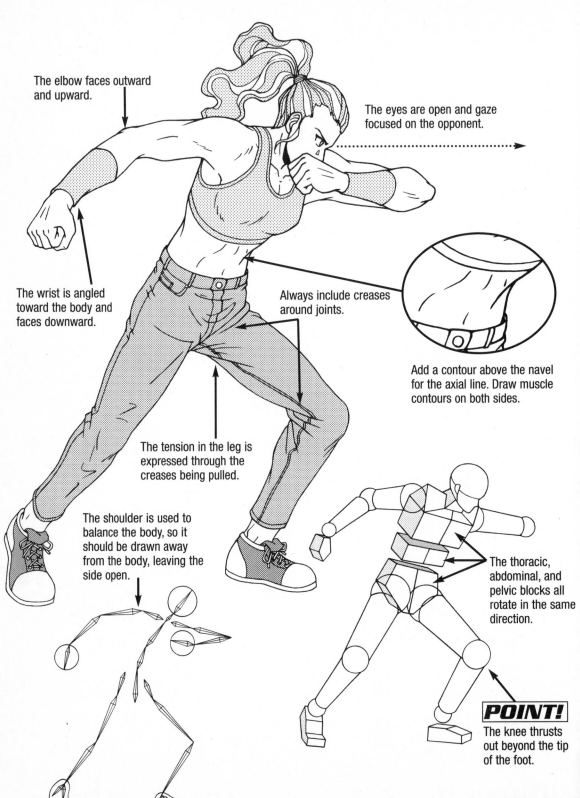

The elbow faces outward and upward.

The eyes are open and gaze focused on the opponent.

The wrist is angled toward the body and faces downward.

Always include creases around joints.

Add a contour above the navel for the axial line. Draw muscle contours on both sides.

The tension in the leg is expressed through the creases being pulled.

The shoulder is used to balance the body, so it should be drawn away from the body, leaving the side open.

The thoracic, abdominal, and pelvic blocks all rotate in the same direction.

POINT!
The knee thrusts out beyond the tip of the foot.

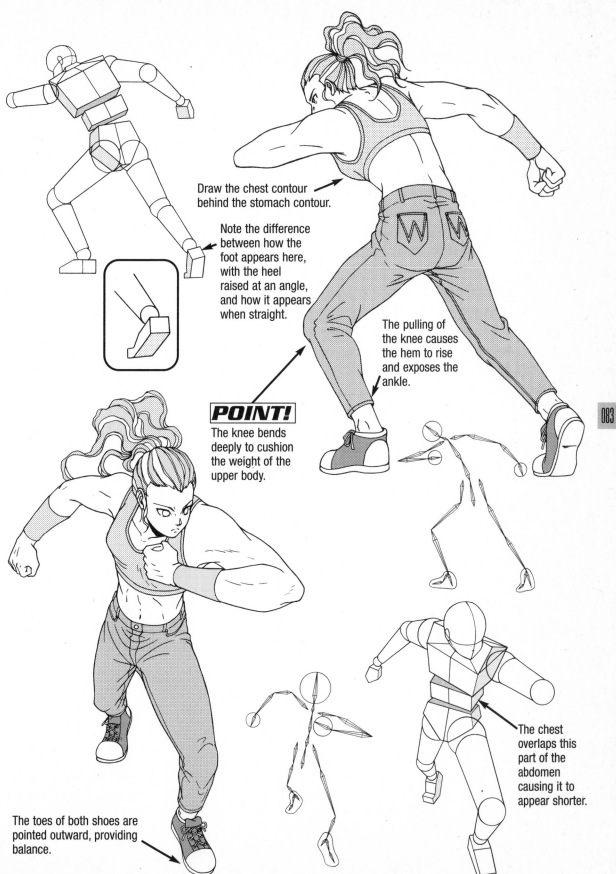

Draw the chest contour behind the stomach contour.

Note the difference between how the foot appears here, with the heel raised at an angle, and how it appears when straight.

The pulling of the knee causes the hem to rise and exposes the ankle.

POINT!
The knee bends deeply to cushion the weight of the upper body.

The chest overlaps this part of the abdomen causing it to appear shorter.

The toes of both shoes are pointed outward, providing balance.

083

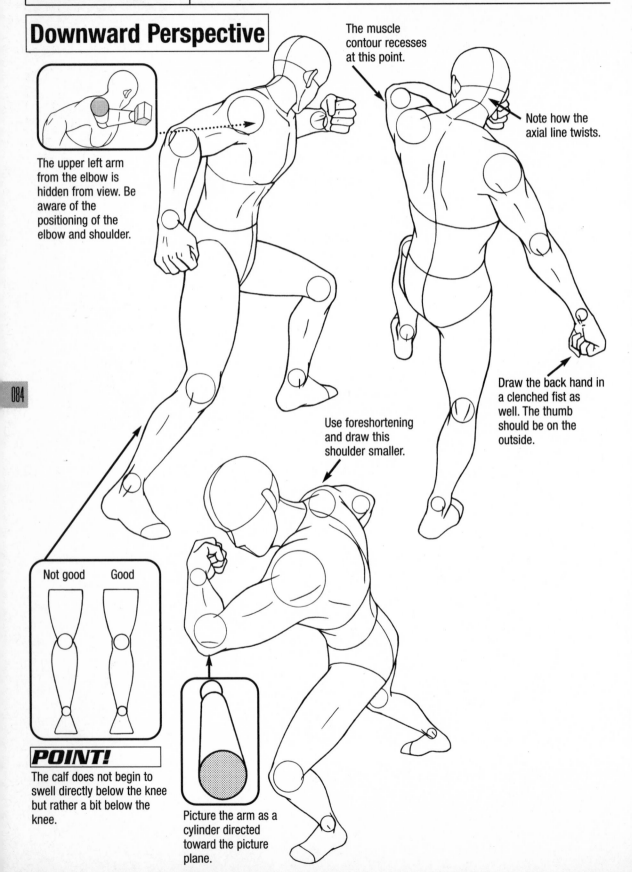

Downward Perspective

The upper left arm from the elbow is hidden from view. Be aware of the positioning of the elbow and shoulder.

The muscle contour recesses at this point.

Note how the axial line twists.

Draw the back hand in a clenched fist as well. The thumb should be on the outside.

Use foreshortening and draw this shoulder smaller.

Not good Good

POINT!
The calf does not begin to swell directly below the knee but rather a bit below the knee.

Picture the arm as a cylinder directed toward the picture plane.

Upward Perspective

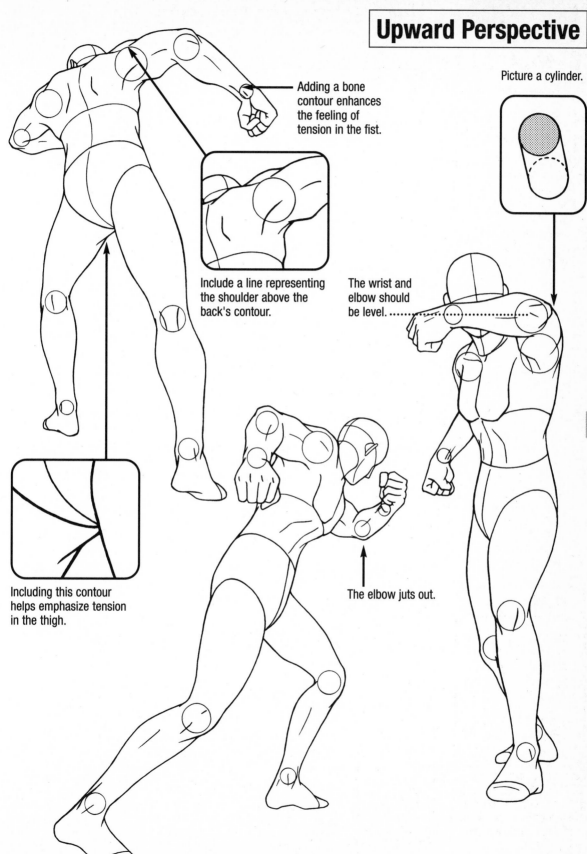

Adding a bone contour enhances the feeling of tension in the fist.

Picture a cylinder.

Include a line representing the shoulder above the back's contour.

The wrist and elbow should be level. ·········

Including this contour helps emphasize tension in the thigh.

The elbow juts out.

Knuckle Hammer | Basic Form

This is a dynamic move executed by clasping the fists over the head and swinging them down, crushing the opponent. Popular in scenes where the opponent is subdued, this move well suits physically large characters.

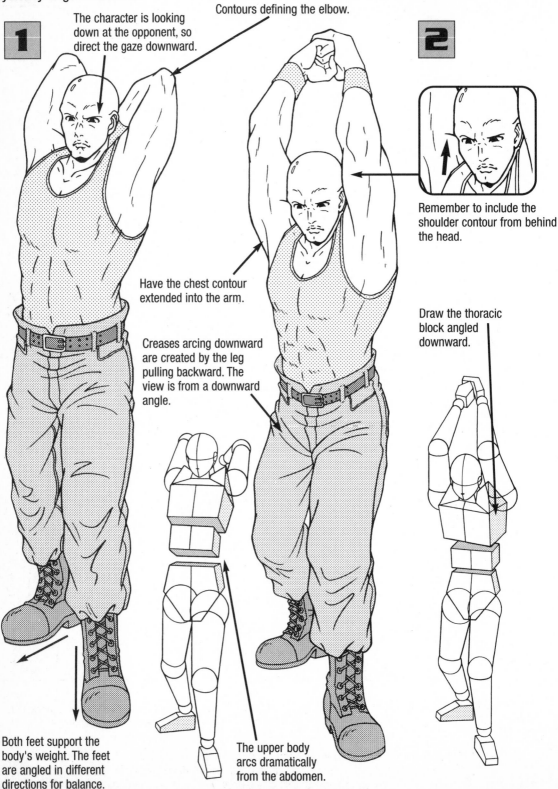

The character is looking down at the opponent, so direct the gaze downward.

Contours defining the elbow.

Remember to include the shoulder contour from behind the head.

Have the chest contour extended into the arm.

Creases arcing downward are created by the leg pulling backward. The view is from a downward angle.

Draw the thoracic block angled downward.

Both feet support the body's weight. The feet are angled in different directions for balance.

The upper body arcs dramatically from the abdomen.

The back arcs rearward, but the head remains in a fixed position, facing forward.

Including this position, which is only seen for a split second during the actual execution, establishes the entire move.

The knees bend sharply to support the body's weight.

The upper surface of the shoulder is visible.

3

This foot maintains the balance.

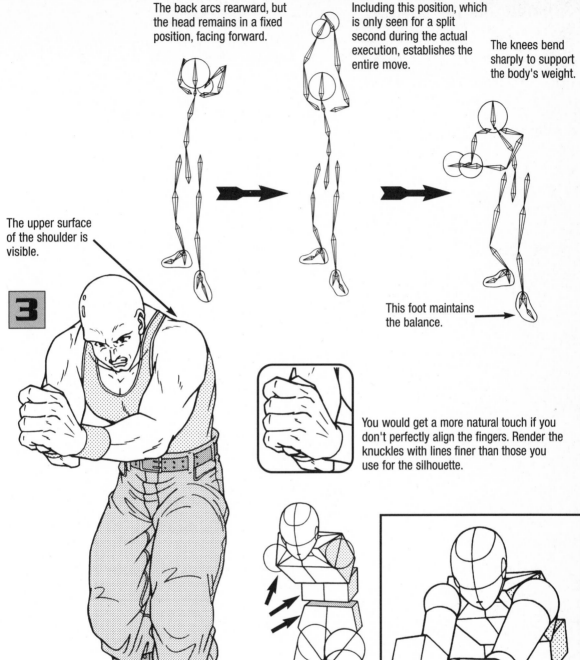

You would get a more natural touch if you don't perfectly align the fingers. Render the knuckles with lines finer than those you use for the silhouette.

Directing the foot outward intensifies the sense of force.

Picture the arm as a cylinder angled toward the picture plane. The right forearm is not visible from the elbow.

Although obscured by the arms, each block forming the upper body increasingly angles downward as the line of view travels up the body.

From an Oblique Angle

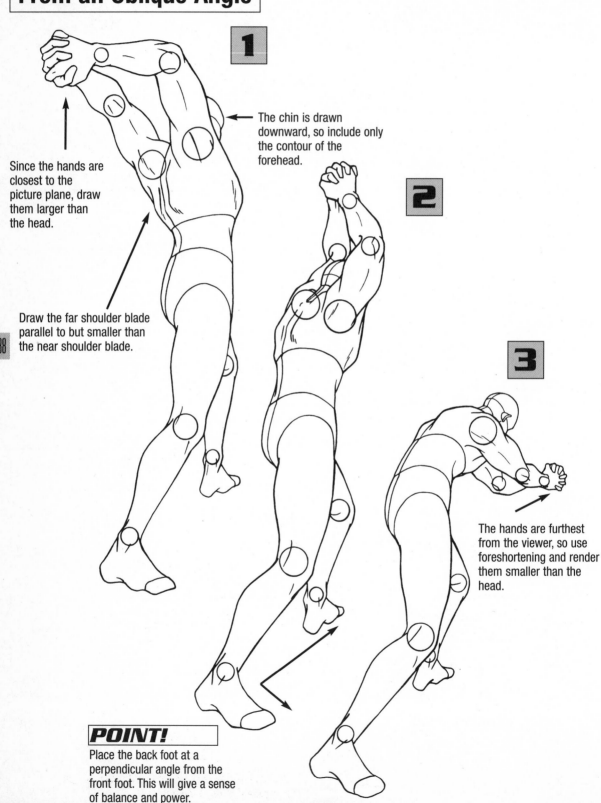

Since the hands are closest to the picture plane, draw them larger than the head.

Draw the far shoulder blade parallel to but smaller than the near shoulder blade.

The chin is drawn downward, so include only the contour of the forehead.

The hands are furthest from the viewer, so use foreshortening and render them smaller than the head.

POINT!
Place the back foot at a perpendicular angle from the front foot. This will give a sense of balance and power.

Side View

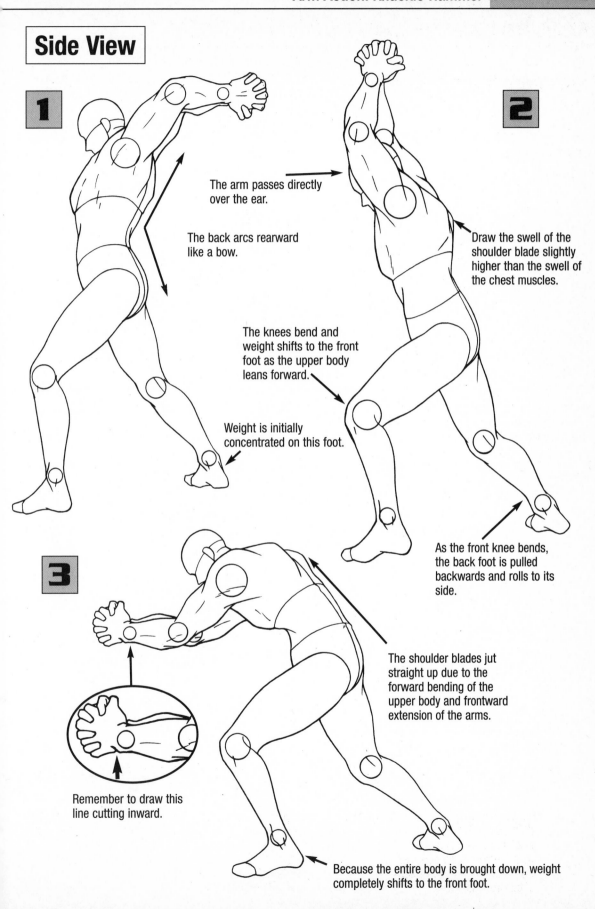

1

The arm passes directly over the ear.

The back arcs rearward like a bow.

2

Draw the swell of the shoulder blade slightly higher than the swell of the chest muscles.

The knees bend and weight shifts to the front foot as the upper body leans forward.

Weight is initially concentrated on this foot.

As the front knee bends, the back foot is pulled backwards and rolls to its side.

3

Remember to draw this line cutting inward.

The shoulder blades jut straight up due to the forward bending of the upper body and frontward extension of the arms.

Because the entire body is brought down, weight completely shifts to the front foot.

089

Upper Cut | Basic Form

This is a punch delivered with an upward blow and is well suited to the more muscular characters. Emphasis on the crouching motion lends drama to the scene, making this effective as a key move.

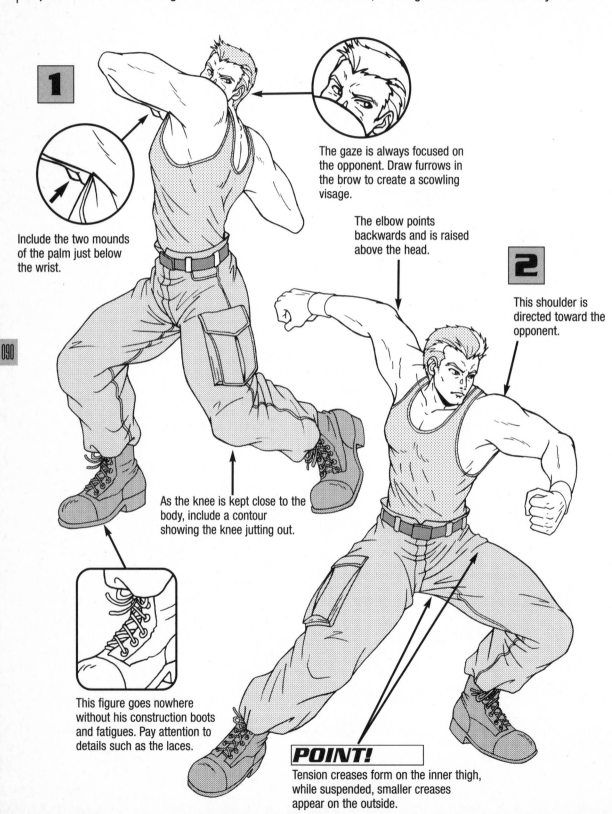

The gaze is always focused on the opponent. Draw furrows in the brow to create a scowling visage.

Include the two mounds of the palm just below the wrist.

The elbow points backwards and is raised above the head.

This shoulder is directed toward the opponent.

As the knee is kept close to the body, include a contour showing the knee jutting out.

This figure goes nowhere without his construction boots and fatigues. Pay attention to details such as the laces.

POINT!

Tension creases form on the inner thigh, while suspended, smaller creases appear on the outside.

090

3

Use a finer line for the elbow contour than for the silhouette.

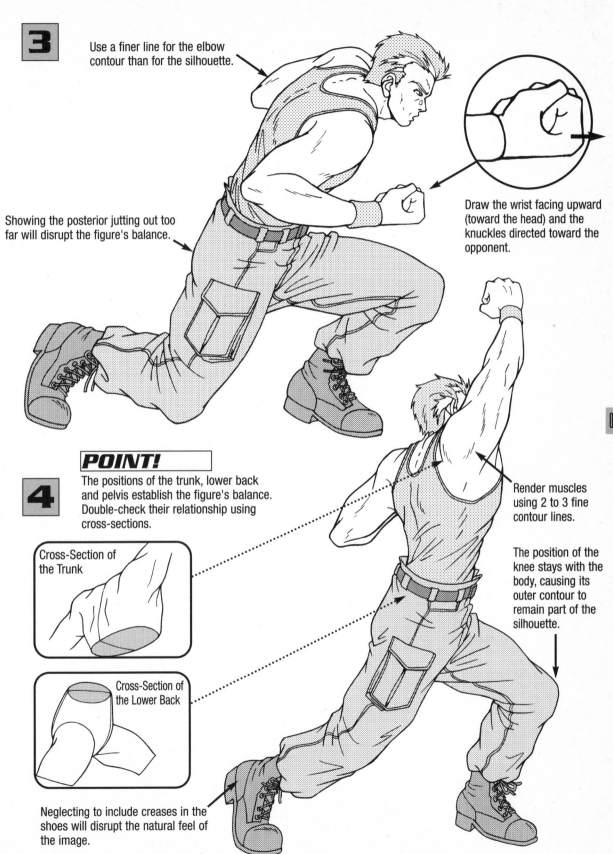

Draw the wrist facing upward (toward the head) and the knuckles directed toward the opponent.

Showing the posterior jutting out too far will disrupt the figure's balance.

POINT!

4

The positions of the trunk, lower back and pelvis establish the figure's balance. Double-check their relationship using cross-sections.

Cross-Section of the Trunk

Cross-Section of the Lower Back

Neglecting to include creases in the shoes will disrupt the natural feel of the image.

Render muscles using 2 to 3 fine contour lines.

The position of the knee stays with the body, causing its outer contour to remain part of the silhouette.

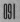

Study positioning using a box figure.

2 The right and left knees face different directions.

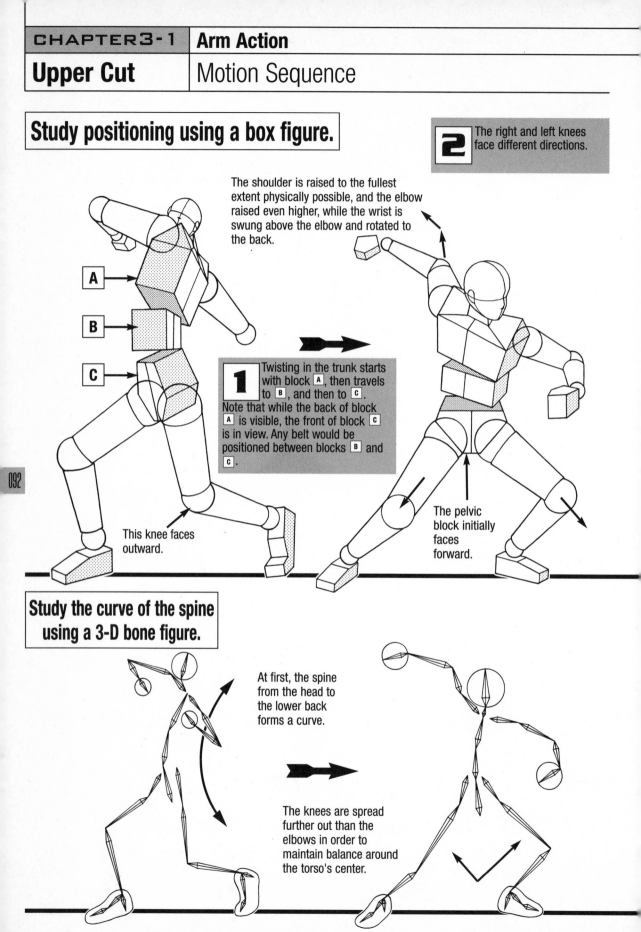

The shoulder is raised to the fullest extent physically possible, and the elbow raised even higher, while the wrist is swung above the elbow and rotated to the back.

A

B

C

1 Twisting in the trunk starts with block A, then travels to B, and then to C. Note that while the back of block A is visible, the front of block C is in view. Any belt would be positioned between blocks B and C.

This knee faces outward.

The pelvic block initially faces forward.

Study the curve of the spine using a 3-D bone figure.

At first, the spine from the head to the lower back forms a curve.

The knees are spread further out than the elbows in order to maintain balance around the torso's center.

092

3 At this point, due to the downward swing of the arm, the order in which the boxes take on torque shifts from the shoulder to the back to the abdomen. The front of the pelvic block remains in view.

4 The figure ends in a position facing the opposite direction of where it started.

The pivot causes the shoulder to be extended further forward than the abdomen.

The fist follows an arc as it swings downward.

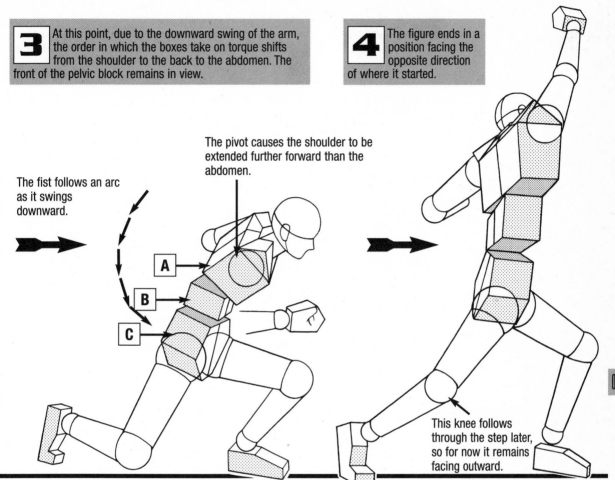

This knee follows through the step later, so for now it remains facing outward.

The spine forms a curve from the neck to the lower back as the figure leans forward.

A long arc forms from the head to the tip of the foot with a raised hand at its apex.

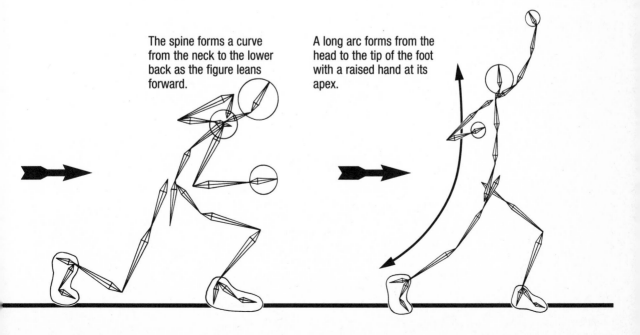

093

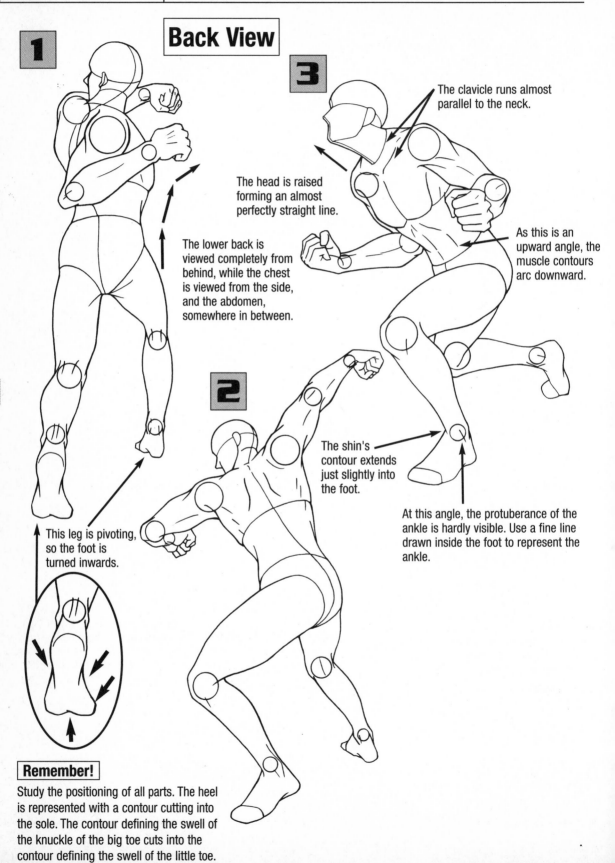

Back View

1

3

The clavicle runs almost parallel to the neck.

The head is raised forming an almost perfectly straight line.

The lower back is viewed completely from behind, while the chest is viewed from the side, and the abdomen, somewhere in between.

As this is an upward angle, the muscle contours arc downward.

2

The shin's contour extends just slightly into the foot.

At this angle, the protuberance of the ankle is hardly visible. Use a fine line drawn inside the foot to represent the ankle.

This leg is pivoting, so the foot is turned inwards.

Remember!
Study the positioning of all parts. The heel is represented with a contour cutting into the sole. The contour defining the swell of the knuckle of the big toe cuts into the contour defining the swell of the little toe.

094

4

Dynamic Perspectives

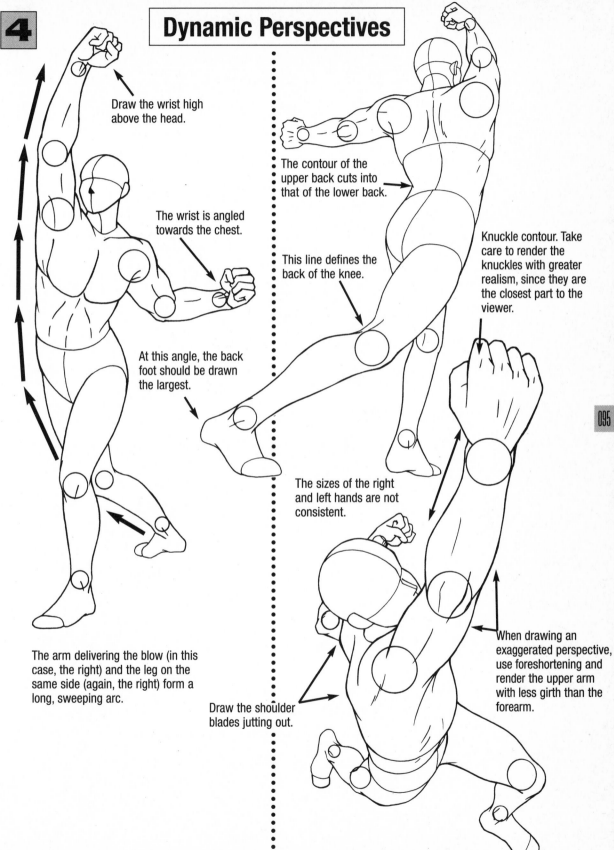

Draw the wrist high above the head.

The wrist is angled towards the chest.

At this angle, the back foot should be drawn the largest.

The contour of the upper back cuts into that of the lower back.

This line defines the back of the knee.

Knuckle contour. Take care to render the knuckles with greater realism, since they are the closest part to the viewer.

The sizes of the right and left hands are not consistent.

The arm delivering the blow (in this case, the right) and the leg on the same side (again, the right) form a long, sweeping arc.

Draw the shoulder blades jutting out.

When drawing an exaggerated perspective, use foreshortening and render the upper arm with less girth than the forearm.

Leg Action

Kicks are designed to deliver severe damage to the opponent. An intrinsic element of drawing kicks is that you have to show the character balanced on one foot. For that reason, kicks are actually more difficult to draw than ultra action scenes. Neglecting to draw the character accurately balanced will cause the figure to look as if it is about to topple over and give your character the impression of being feeble and weak. Pay closer attention to the leg balancing the body than to the leg delivering the blow.

Toe Kick	Basic Form

Effective when the opponent is directly facing the character, for this move, the leg is swung up and the blow delivered with the tip of the foot. Since the move is not elaborate, it can also be used for kicking objects.

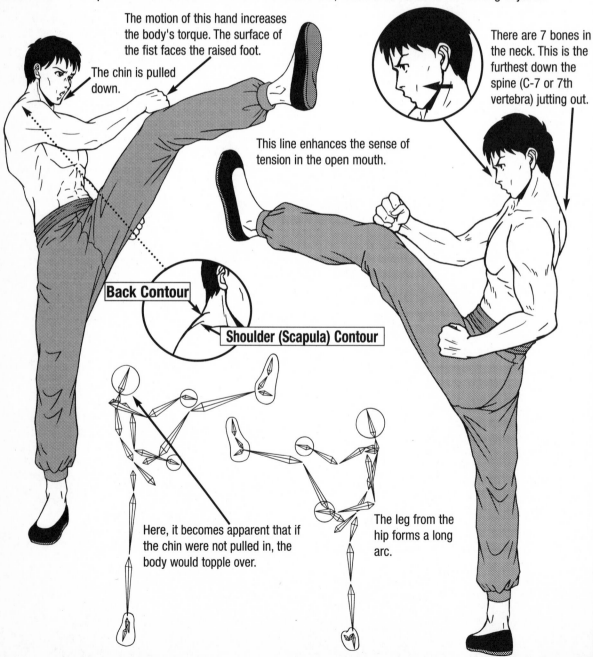

The motion of this hand increases the body's torque. The surface of the fist faces the raised foot.

The chin is pulled down.

There are 7 bones in the neck. This is the furthest down the spine (C-7 or 7th vertebra) jutting out.

This line enhances the sense of tension in the open mouth.

Back Contour

Shoulder (Scapula) Contour

Here, it becomes apparent that if the chin were not pulled in, the body would topple over.

The leg from the hip forms a long arc.

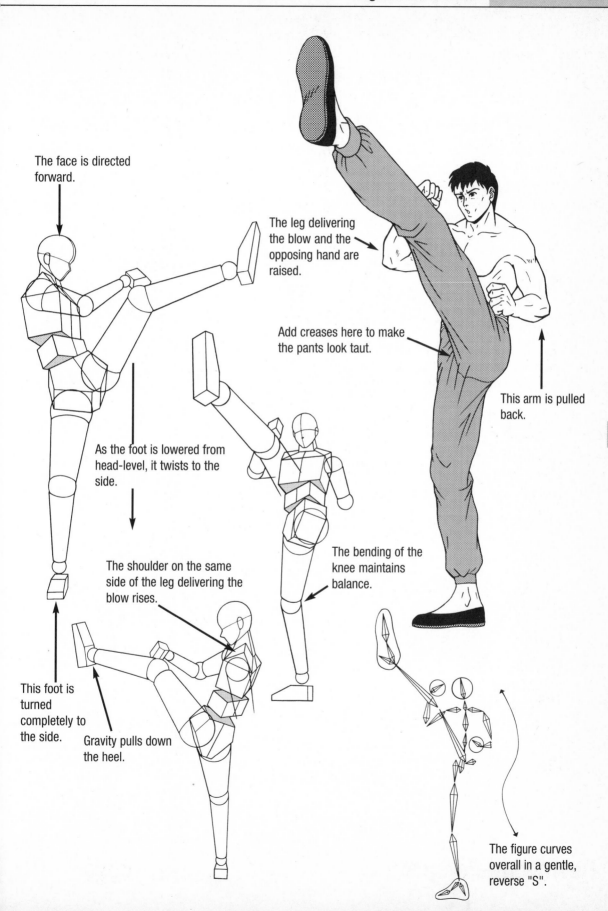

The face is directed forward.

The leg delivering the blow and the opposing hand are raised.

Add creases here to make the pants look taut.

This arm is pulled back.

As the foot is lowered from head-level, it twists to the side.

The shoulder on the same side of the leg delivering the blow rises.

The bending of the knee maintains balance.

This foot is turned completely to the side.

Gravity pulls down the heel.

The figure curves overall in a gentle, reverse "S".

097

Toe Kick | Perspectives with Foreshortening

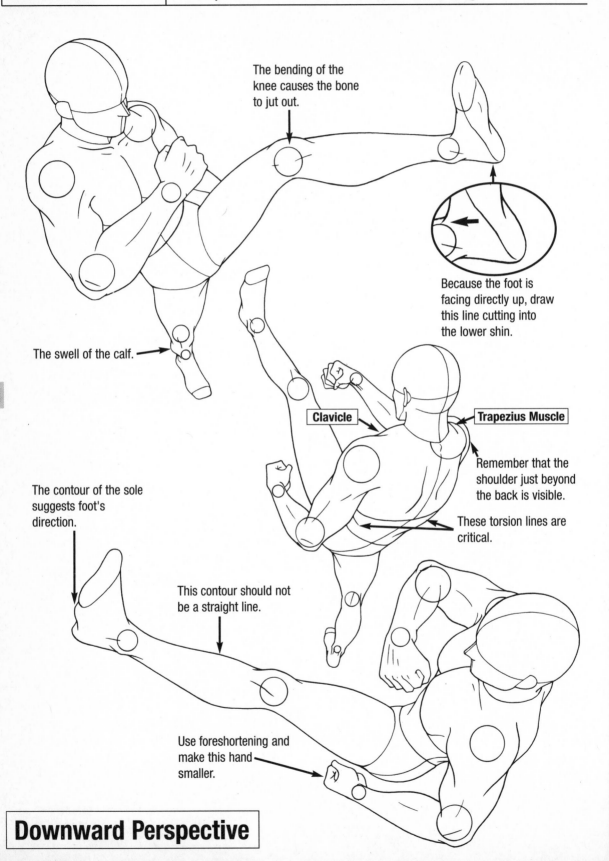

The bending of the knee causes the bone to jut out.

Because the foot is facing directly up, draw this line cutting into the lower shin.

The swell of the calf.

Clavicle

Trapezius Muscle

Remember that the shoulder just beyond the back is visible.

These torsion lines are critical.

The contour of the sole suggests foot's direction.

This contour should not be a straight line.

Use foreshortening and make this hand smaller.

Downward Perspective

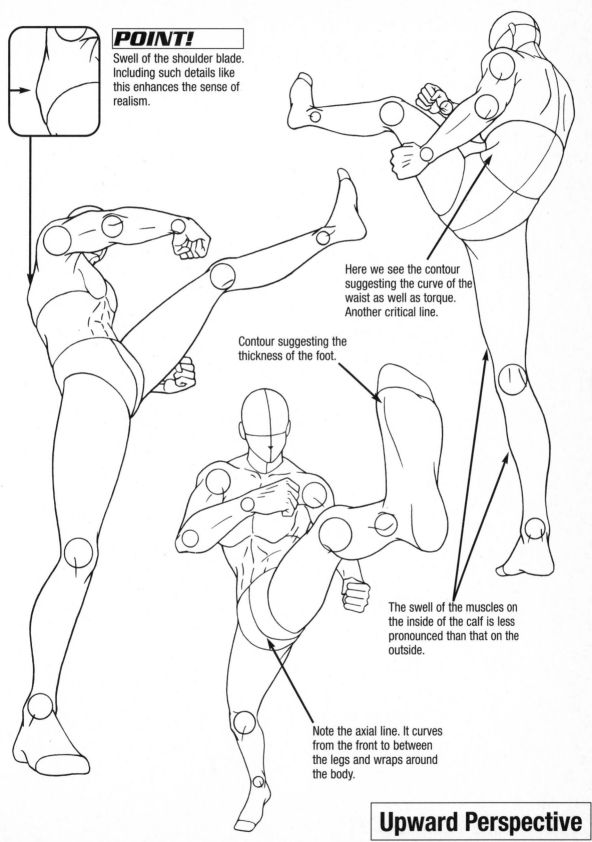

POINT!

Swell of the shoulder blade. Including such details like this enhances the sense of realism.

Here we see the contour suggesting the curve of the waist as well as torque. Another critical line.

Contour suggesting the thickness of the foot.

The swell of the muscles on the inside of the calf is less pronounced than that on the outside.

Note the axial line. It curves from the front to between the legs and wraps around the body.

Upward Perspective

Low Kick | Basic Form

This move is designed to weaken the opponent's position by kicking the lower part of his legs. Although this isn't an intricate move, it is practical and renders damage to the opponent built up gradually through tiny blow after blow. I recommend using the low kick in combination with more elaborate moves.

1

The arm on the same side as the striking leg is pulled back.

Keep the contours of the fist on the straight side to enhance the sense of tension.

The bigger the thigh appears, the greater the torque.

The gaze is directed toward the target of the blow (the opponent's lower leg).

Show the clavicle protruding.

This line defines the spine. Torsion in the trunk allows the spine to come into view up to the waist.

2

Torsion causes the back of the pelvic block to become visible.

The kick is delivered from the upper side of the foot, bringing the heel and the sole into view.

100

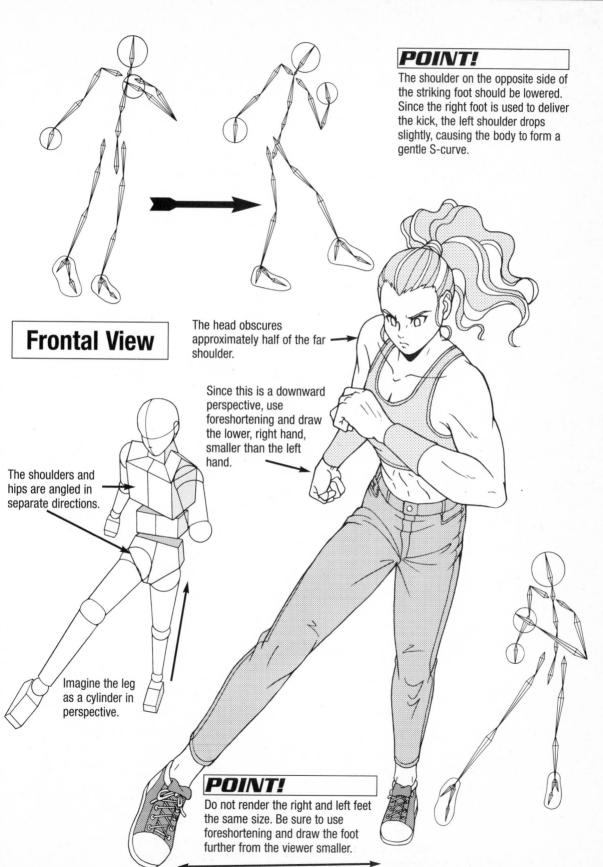

POINT!

The shoulder on the opposite side of the striking foot should be lowered. Since the right foot is used to deliver the kick, the left shoulder drops slightly, causing the body to form a gentle S-curve.

Frontal View

The head obscures approximately half of the far shoulder.

Since this is a downward perspective, use foreshortening and draw the lower, right hand, smaller than the left hand.

The shoulders and hips are angled in separate directions.

Imagine the leg as a cylinder in perspective.

POINT!

Do not render the right and left feet the same size. Be sure to use foreshortening and draw the foot further from the viewer smaller.

Back View

Commonly used as the point of view of a character regarding an ally or of a damsel in distress looking at her rescuer, this perspective is from the back, looking somewhat up.

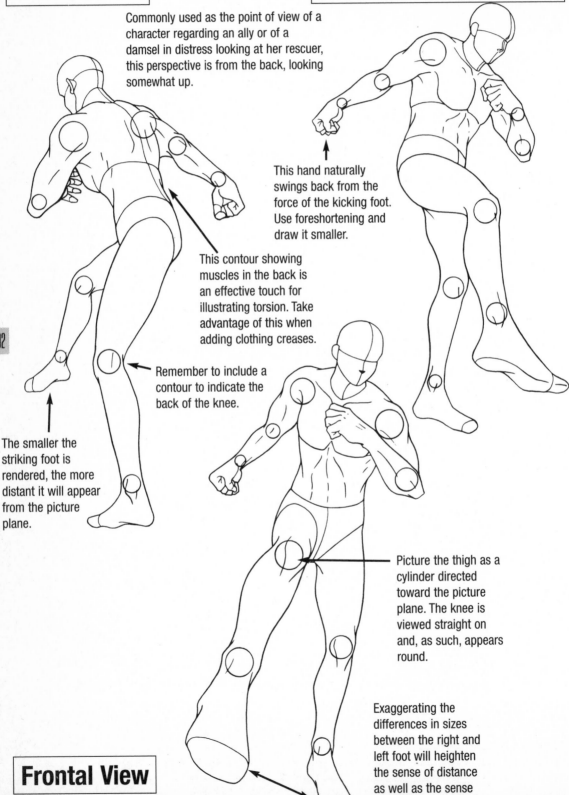

From an Oblique Angle

This hand naturally swings back from the force of the kicking foot. Use foreshortening and draw it smaller.

This contour showing muscles in the back is an effective touch for illustrating torsion. Take advantage of this when adding clothing creases.

Remember to include a contour to indicate the back of the knee.

The smaller the striking foot is rendered, the more distant it will appear from the picture plane.

Picture the thigh as a cylinder directed toward the picture plane. The knee is viewed straight on and, as such, appears round.

Exaggerating the differences in sizes between the right and left foot will heighten the sense of distance as well as the sense of power.

Frontal View

102

Dynamic Upward Perspective

Foreshortening becomes more exaggerated as the perspective approaches the ground.

From this angle, the top of the foot is obscured from view. Exaggerate the thickness of the toes.

Remember to suggest thickness in the toes.

Make the far arm miniscule in comparison.

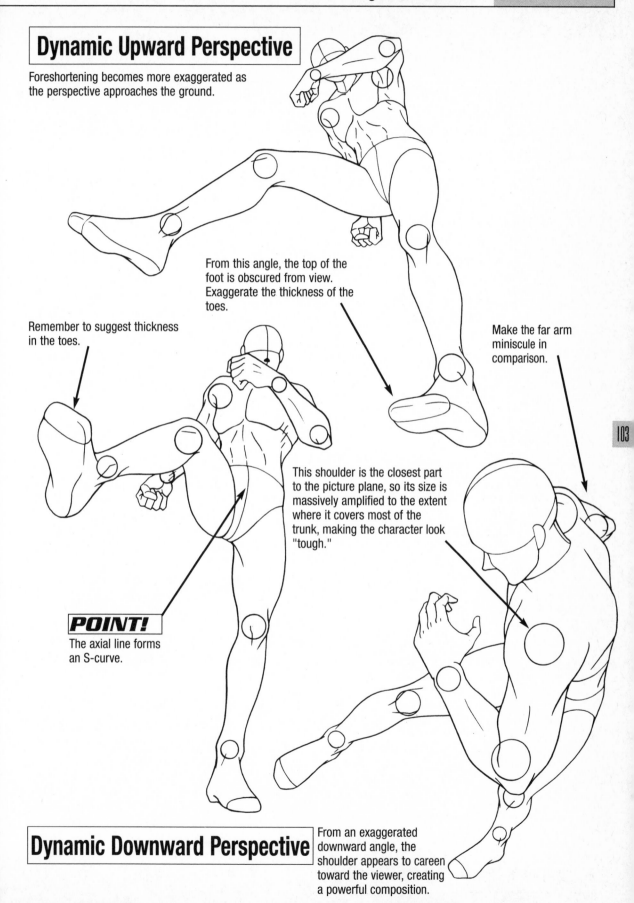

This shoulder is the closest part to the picture plane, so its size is massively amplified to the extent where it covers most of the trunk, making the character look "tough."

POINT!

The axial line forms an S-curve.

103

Dynamic Downward Perspective

From an exaggerated downward angle, the shoulder appears to careen toward the viewer, creating a powerful composition.

Middle Kick | Basic Form

Lower than the high kick (see page 108), the middle kick targets the opponent's abdominal region. This is a multi-purpose move and is adaptable to many types of combat scenes. A true gem, make sure you master it.

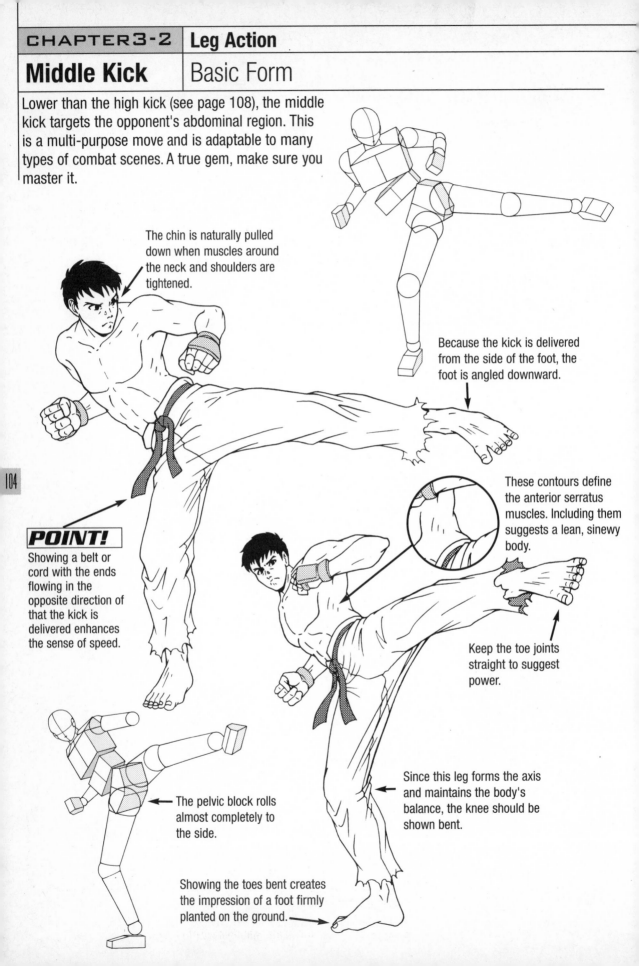

The chin is naturally pulled down when muscles around the neck and shoulders are tightened.

Because the kick is delivered from the side of the foot, the foot is angled downward.

POINT!

Showing a belt or cord with the ends flowing in the opposite direction of that the kick is delivered enhances the sense of speed.

These contours define the anterior serratus muscles. Including them suggests a lean, sinewy body.

Keep the toe joints straight to suggest power.

The pelvic block rolls almost completely to the side.

Since this leg forms the axis and maintains the body's balance, the knee should be shown bent.

Showing the toes bent creates the impression of a foot firmly planted on the ground.

104

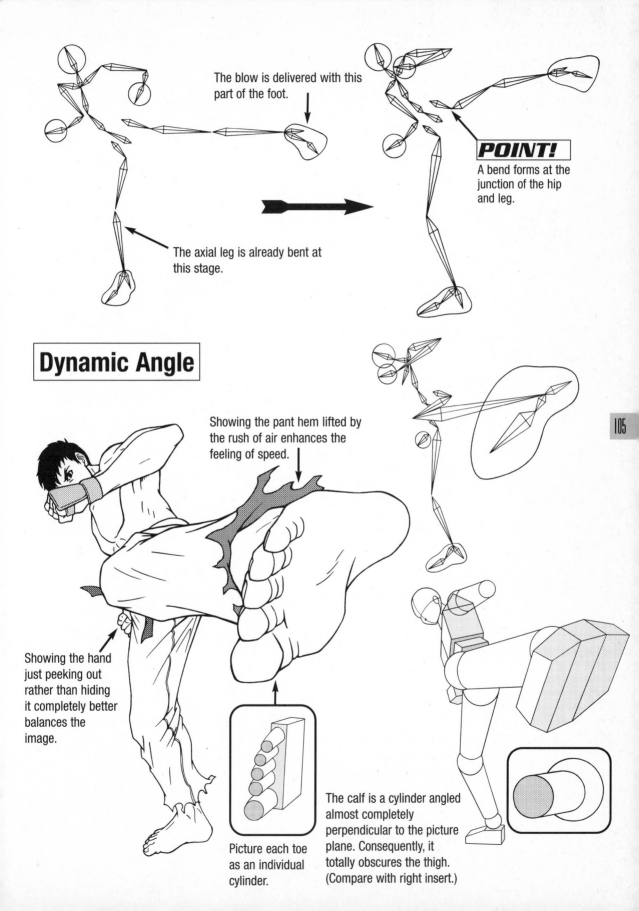

The blow is delivered with this part of the foot.

POINT!

A bend forms at the junction of the hip and leg.

The axial leg is already bent at this stage.

Dynamic Angle

Showing the pant hem lifted by the rush of air enhances the feeling of speed.

Showing the hand just peeking out rather than hiding it completely better balances the image.

Picture each toe as an individual cylinder.

The calf is a cylinder angled almost completely perpendicular to the picture plane. Consequently, it totally obscures the thigh. (Compare with right insert.)

From the Back

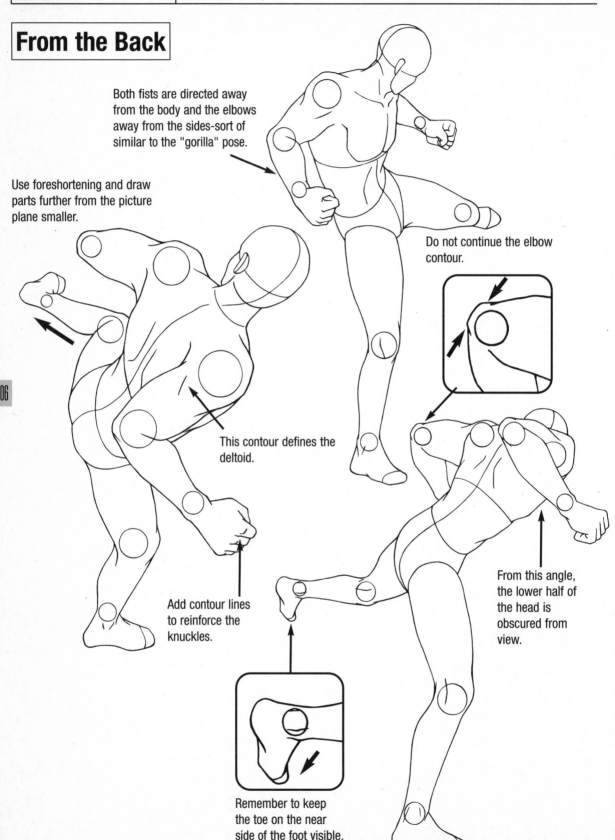

Both fists are directed away from the body and the elbows away from the sides-sort of similar to the "gorilla" pose.

Use foreshortening and draw parts further from the picture plane smaller.

Do not continue the elbow contour.

This contour defines the deltoid.

Add contour lines to reinforce the knuckles.

From this angle, the lower half of the head is obscured from view.

Remember to keep the toe on the near side of the foot visible.

106

Dynamic Upward Perspective

POINT!

These angles will test your skills in drawing the hand. Be sure to master drawing the hand from both above and below.

From above

From below

Remember to include the right upper arm, which is still visible from the far side of the back.

The protrusion of the shoulder blades becomes exaggerated due to the arms pulled backward.

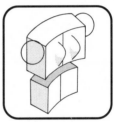

Normal State

With the Arms Pulled Back

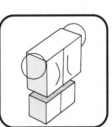

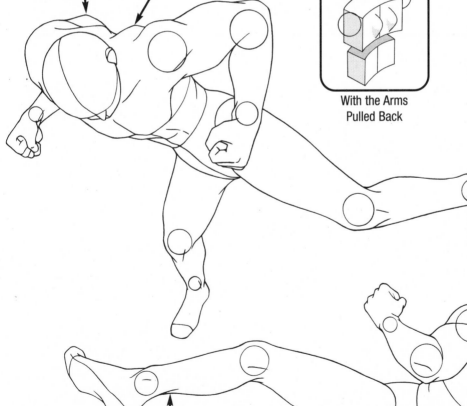

Contour defining the Achilles tendon. This is useful for suggesting tension in the leg.

This contour should be curved.

Dynamic Downward Perspective

107

High Kick | Basic Form

This is a common move used in any number of situations and consists of a high kick delivered from the side. There are many examples of this move used in animated karate, tae kwon do, and other martial art scenes floating available for you to use for reference.

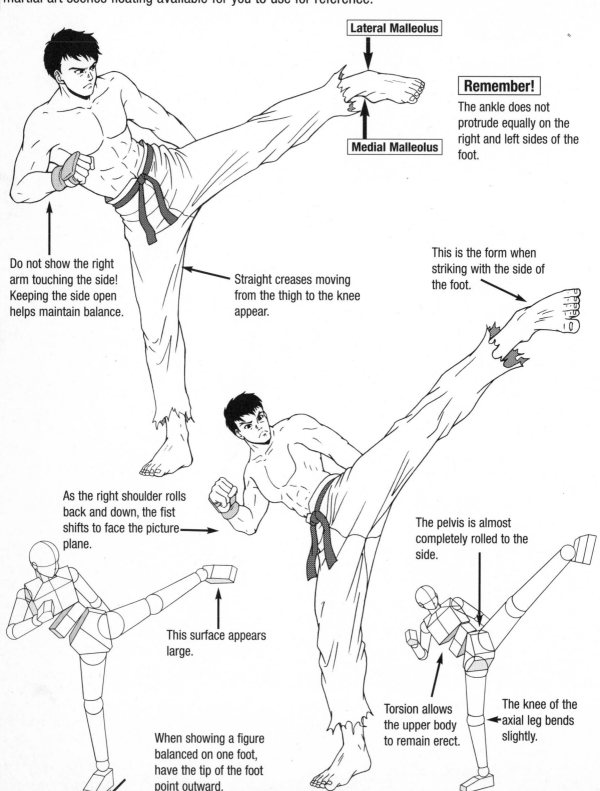

Lateral Malleolus

Medial Malleolus

Remember!
The ankle does not protrude equally on the right and left sides of the foot.

Do not show the right arm touching the side! Keeping the side open helps maintain balance.

Straight creases moving from the thigh to the knee appear.

This is the form when striking with the side of the foot.

As the right shoulder rolls back and down, the fist shifts to face the picture plane.

This surface appears large.

The pelvis is almost completely rolled to the side.

When showing a figure balanced on one foot, have the tip of the foot point outward.

Torsion allows the upper body to remain erect.

The knee of the axial leg bends slightly.

108

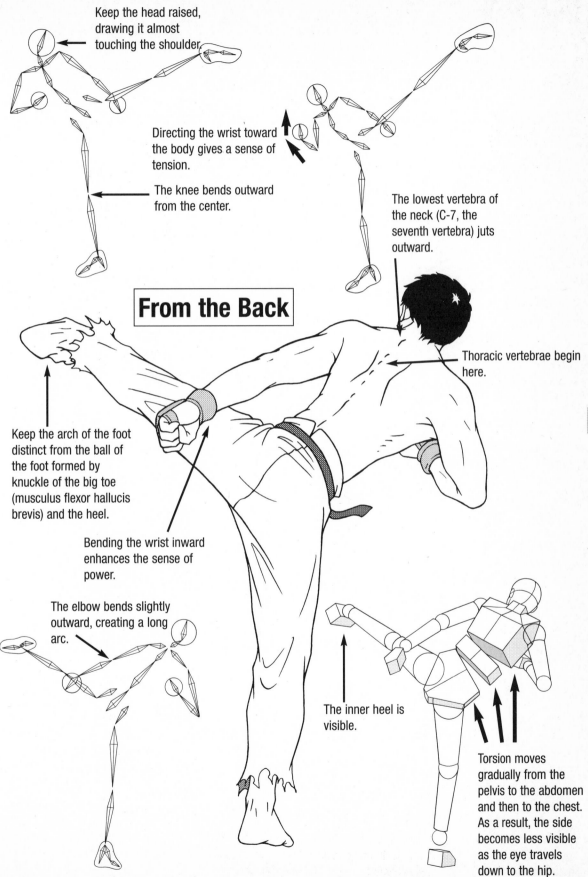

Keep the head raised, drawing it almost touching the shoulder.

Directing the wrist toward the body gives a sense of tension.

The knee bends outward from the center.

The lowest vertebra of the neck (C-7, the seventh vertebra) juts outward.

From the Back

Thoracic vertebrae begin here.

Keep the arch of the foot distinct from the ball of the foot formed by knuckle of the big toe (musculus flexor hallucis brevis) and the heel.

Bending the wrist inward enhances the sense of power.

The elbow bends slightly outward, creating a long arc.

The inner heel is visible.

Torsion moves gradually from the pelvis to the abdomen and then to the chest. As a result, the side becomes less visible as the eye travels down to the hip.

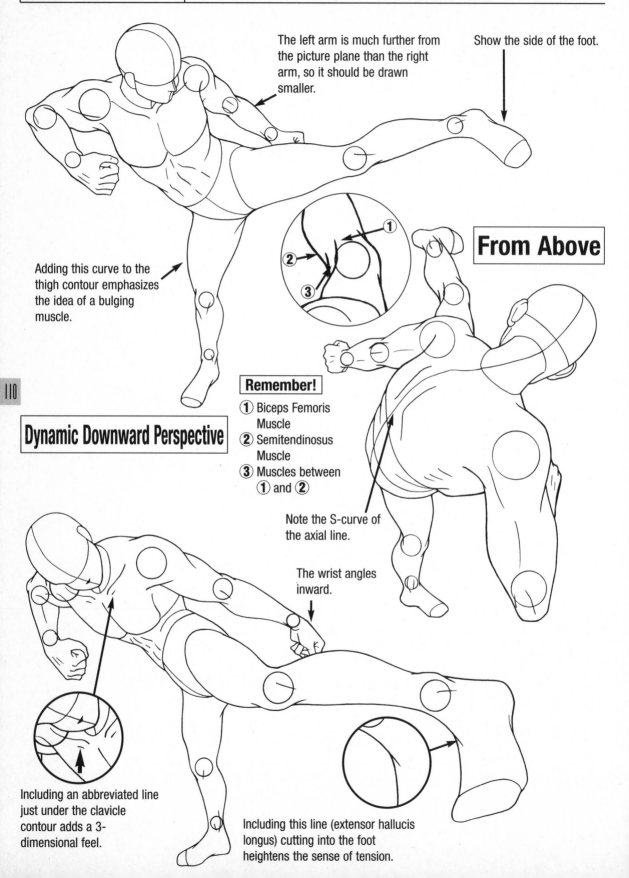

The left arm is much further from the picture plane than the right arm, so it should be drawn smaller.

Show the side of the foot.

From Above

Adding this curve to the thigh contour emphasizes the idea of a bulging muscle.

Dynamic Downward Perspective

Remember!
① Biceps Femoris Muscle
② Semitendinosus Muscle
③ Muscles between ① and ②

Note the S-curve of the axial line.

The wrist angles inward.

Including an abbreviated line just under the clavicle contour adds a 3-dimensional feel.

Including this line (extensor hallucis longus) cutting into the foot heightens the sense of tension.

Dynamic Upward Perspective

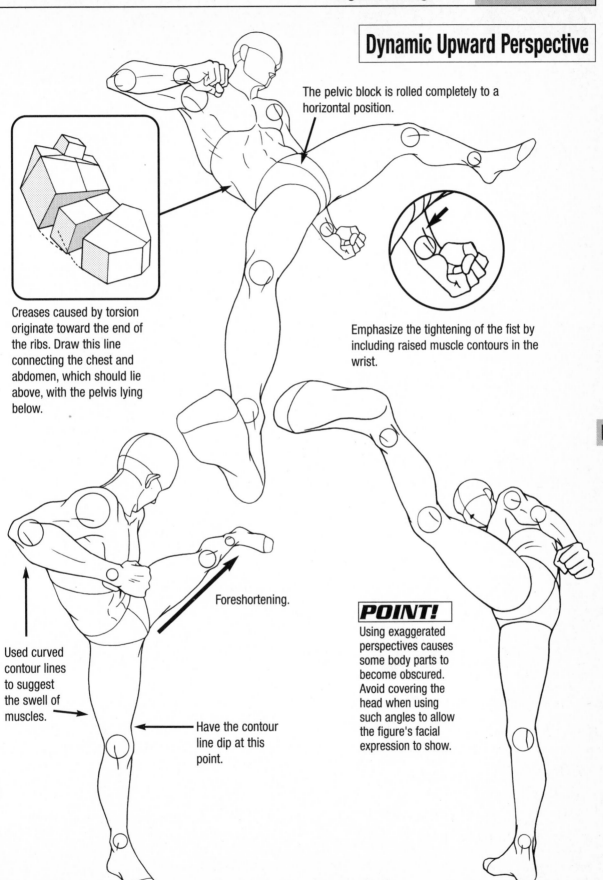

The pelvic block is rolled completely to a horizontal position.

Creases caused by torsion originate toward the end of the ribs. Draw this line connecting the chest and abdomen, which should lie above, with the pelvis lying below.

Emphasize the tightening of the fist by including raised muscle contours in the wrist.

Used curved contour lines to suggest the swell of muscles.

Foreshortening.

Have the contour line dip at this point.

POINT!

Using exaggerated perspectives causes some body parts to become obscured. Avoid covering the head when using such angles to allow the figure's facial expression to show.

Combat Kick | Basic Form

For this move, the entire weight of the body is balanced on one foot, and kick delivered to the opponent with incredible force. This move is perfect for use with villains, making it seem inappropriate for female characters.

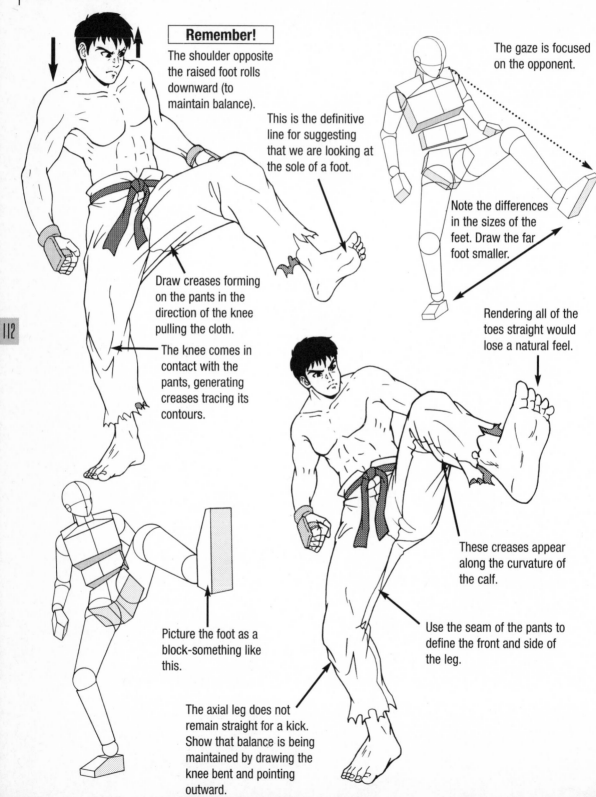

Remember!
The shoulder opposite the raised foot rolls downward (to maintain balance).

This is the definitive line for suggesting that we are looking at the sole of a foot.

The gaze is focused on the opponent.

Note the differences in the sizes of the feet. Draw the far foot smaller.

Draw creases forming on the pants in the direction of the knee pulling the cloth.

The knee comes in contact with the pants, generating creases tracing its contours.

Rendering all of the toes straight would lose a natural feel.

112

These creases appear along the curvature of the calf.

Picture the foot as a block-something like this.

Use the seam of the pants to define the front and side of the leg.

The axial leg does not remain straight for a kick. Show that balance is being maintained by drawing the knee bent and pointing outward.

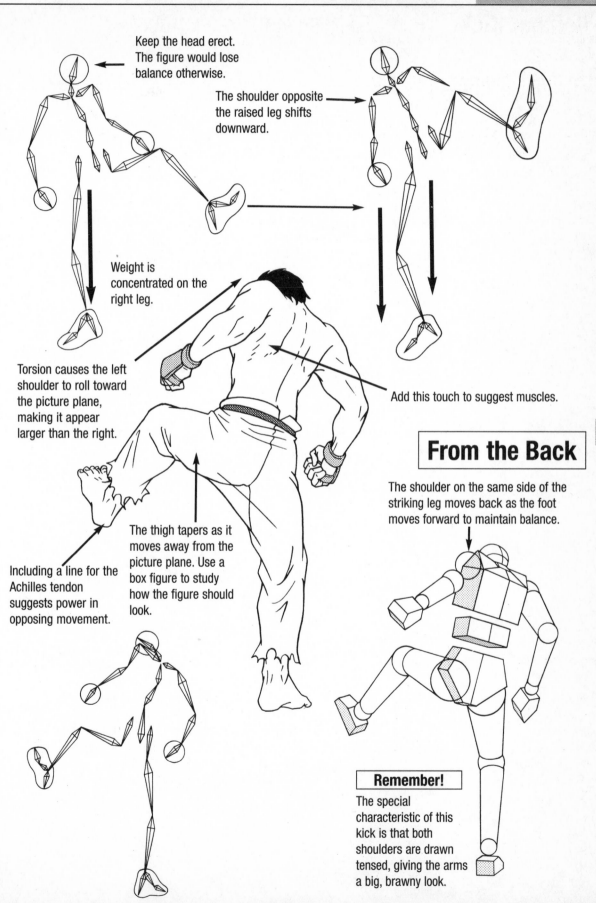

Keep the head erect. The figure would lose balance otherwise.

The shoulder opposite the raised leg shifts downward.

Weight is concentrated on the right leg.

Torsion causes the left shoulder to roll toward the picture plane, making it appear larger than the right.

Add this touch to suggest muscles.

Including a line for the Achilles tendon suggests power in opposing movement.

The thigh tapers as it moves away from the picture plane. Use a box figure to study how the figure should look.

From the Back

The shoulder on the same side of the striking leg moves back as the foot moves forward to maintain balance.

113

Remember!

The special characteristic of this kick is that both shoulders are drawn tensed, giving the arms a big, brawny look.

Dynamic Downward Perspective

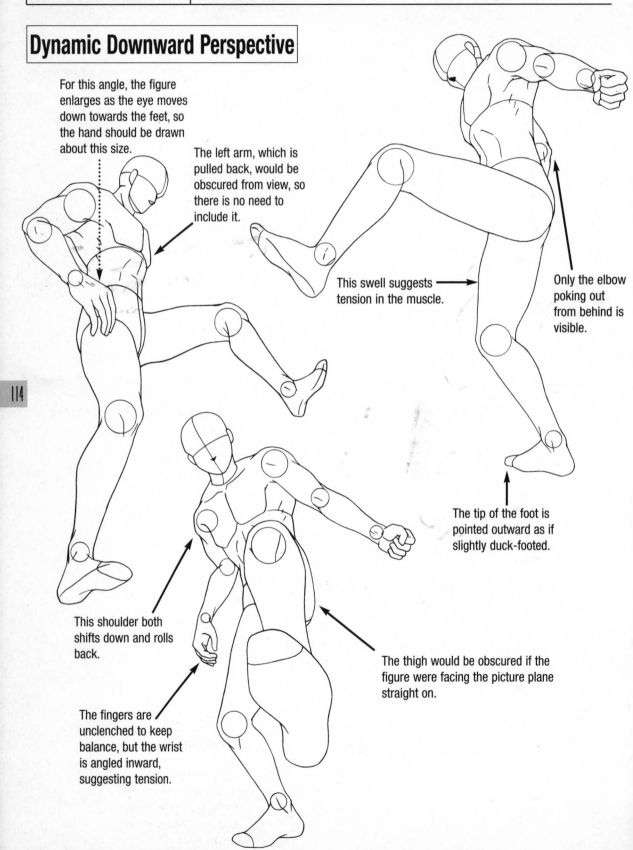

For this angle, the figure enlarges as the eye moves down towards the feet, so the hand should be drawn about this size.

The left arm, which is pulled back, would be obscured from view, so there is no need to include it.

This swell suggests tension in the muscle.

Only the elbow poking out from behind is visible.

The tip of the foot is pointed outward as if slightly duck-footed.

This shoulder both shifts down and rolls back.

The thigh would be obscured if the figure were facing the picture plane straight on.

The fingers are unclenched to keep balance, but the wrist is angled inward, suggesting tension.

114

Dynamic Downward Perspective

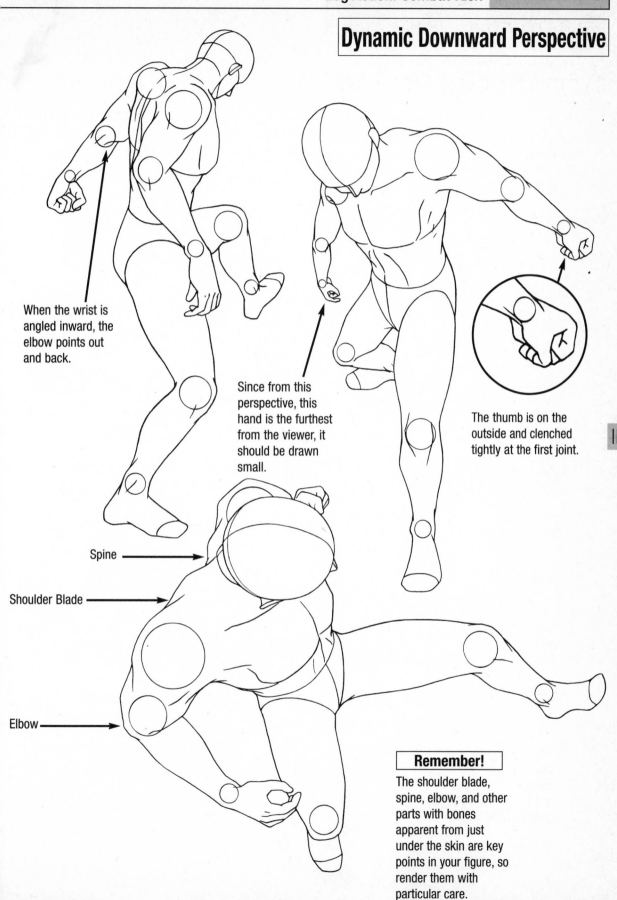

When the wrist is angled inward, the elbow points out and back.

Since from this perspective, this hand is the furthest from the viewer, it should be drawn small.

The thumb is on the outside and clenched tightly at the first joint.

Spine

Shoulder Blade

Elbow

Remember!

The shoulder blade, spine, elbow, and other parts with bones apparent from just under the skin are key points in your figure, so render them with particular care.

115

Up Kick | Basic Form

This move is executed by jumping up in front and to the side of the opponent, letting the kick fly. The damage delivered by this kick is not as severe as that of the jump kick, but it is a great move to finish off minor opponents and works well with small, light female characters.

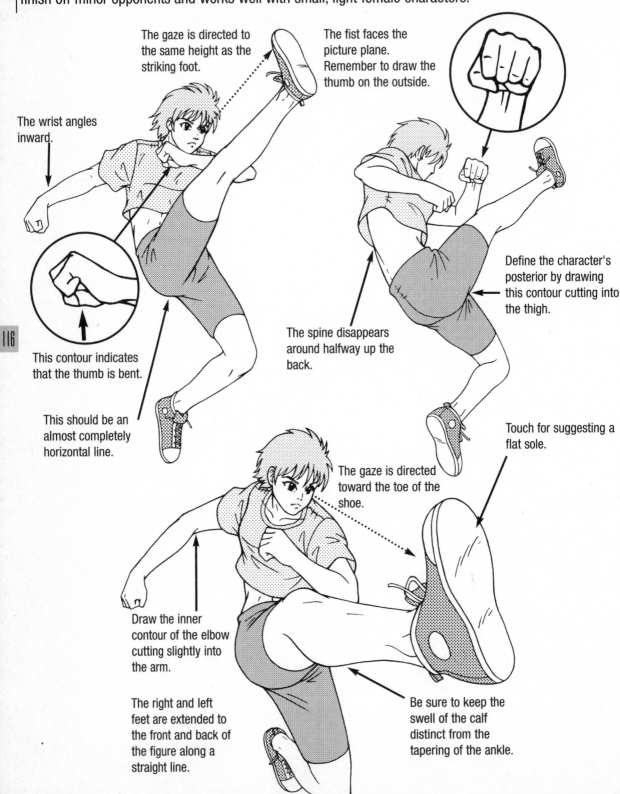

The gaze is directed to the same height as the striking foot.

The fist faces the picture plane. Remember to draw the thumb on the outside.

The wrist angles inward.

This contour indicates that the thumb is bent.

This should be an almost completely horizontal line.

The spine disappears around halfway up the back.

Define the character's posterior by drawing this contour cutting into the thigh.

Touch for suggesting a flat sole.

The gaze is directed toward the toe of the shoe.

Draw the inner contour of the elbow cutting slightly into the arm.

The right and left feet are extended to the front and back of the figure along a straight line.

Be sure to keep the swell of the calf distinct from the tapering of the ankle.

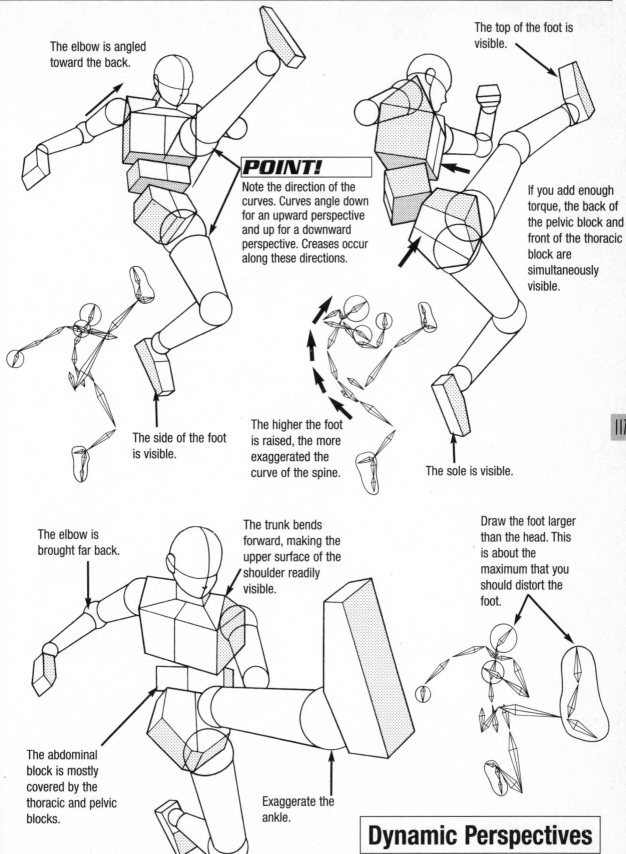

The elbow is angled toward the back.

The top of the foot is visible.

POINT!

Note the direction of the curves. Curves angle down for an upward perspective and up for a downward perspective. Creases occur along these directions.

If you add enough torque, the back of the pelvic block and front of the thoracic block are simultaneously visible.

The side of the foot is visible.

The higher the foot is raised, the more exaggerated the curve of the spine.

The sole is visible.

The elbow is brought far back.

The trunk bends forward, making the upper surface of the shoulder readily visible.

Draw the foot larger than the head. This is about the maximum that you should distort the foot.

The abdominal block is mostly covered by the thoracic and pelvic blocks.

Exaggerate the ankle.

Dynamic Perspectives

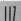

Up Kick | Perspectives with Foreshortening

Dynamic Upward Perspectives

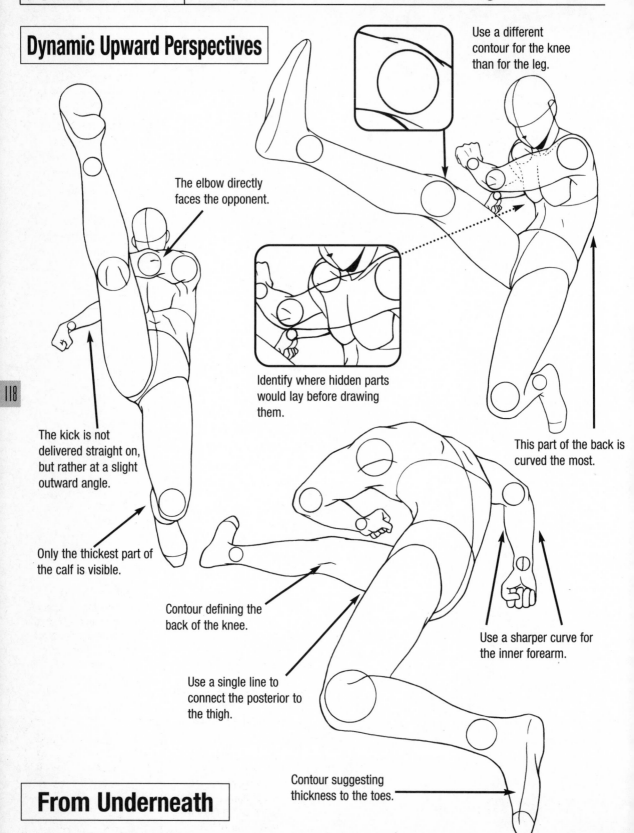

Use a different contour for the knee than for the leg.

The elbow directly faces the opponent.

Identify where hidden parts would lay before drawing them.

The kick is not delivered straight on, but rather at a slight outward angle.

Only the thickest part of the calf is visible.

This part of the back is curved the most.

Contour defining the back of the knee.

Use a single line to connect the posterior to the thigh.

Use a sharper curve for the inner forearm.

Contour suggesting thickness to the toes.

From Underneath

118

Dynamic Downward Perspective

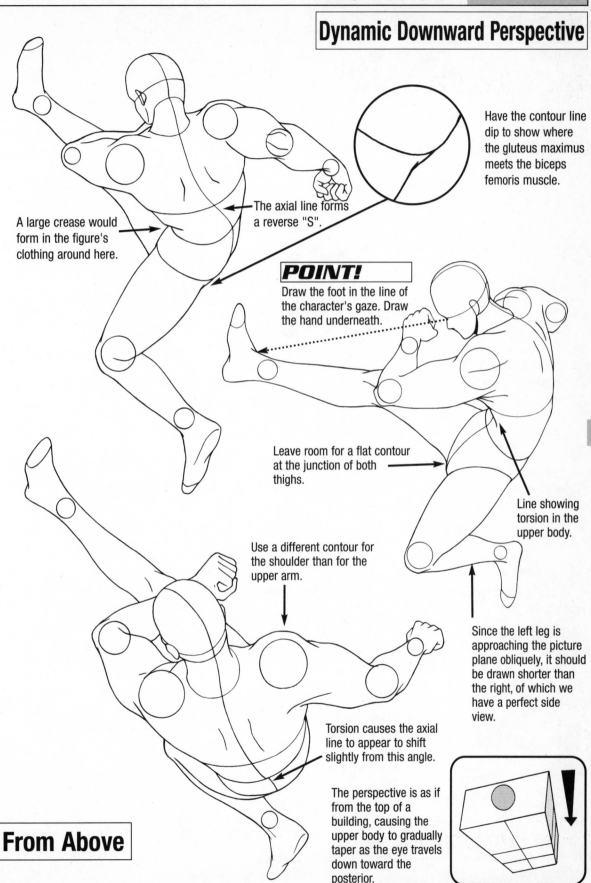

Have the contour line dip to show where the gluteus maximus meets the biceps femoris muscle.

A large crease would form in the figure's clothing around here.

The axial line forms a reverse "S".

POINT!
Draw the foot in the line of the character's gaze. Draw the hand underneath.

Leave room for a flat contour at the junction of both thighs.

Line showing torsion in the upper body.

Use a different contour for the shoulder than for the upper arm.

Since the left leg is approaching the picture plane obliquely, it should be drawn shorter than the right, of which we have a perfect side view.

Torsion causes the axial line to appear to shift slightly from this angle.

The perspective is as if from the top of a building, causing the upper body to gradually taper as the eye travels down toward the posterior.

From Above

Knee Kick | Basic Form

For this kick, the blow is delivered by jumping up and striking the opponent with the knee. This is not necessarily a practical move, but showing the character float above the opponent's head with this type of jump move will give your image a little panache.

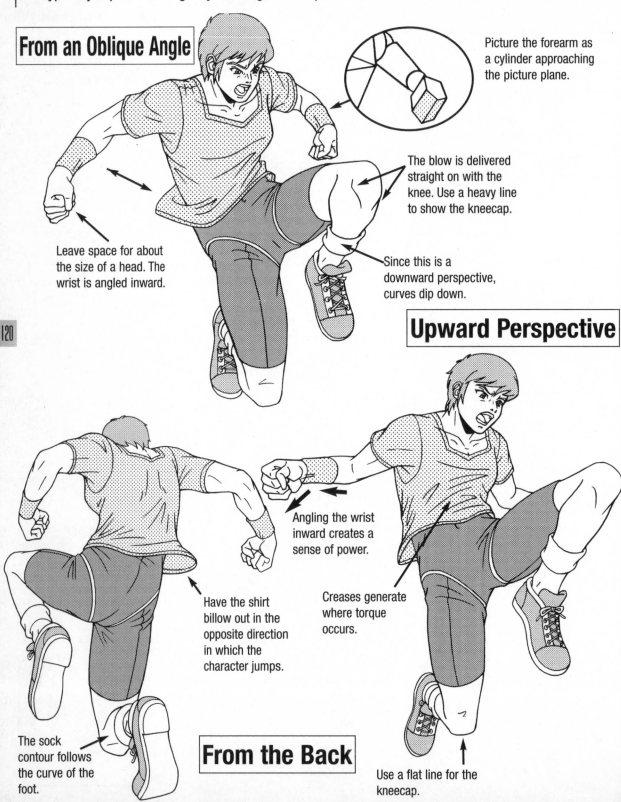

From an Oblique Angle

Picture the forearm as a cylinder approaching the picture plane.

The blow is delivered straight on with the knee. Use a heavy line to show the kneecap.

Leave space for about the size of a head. The wrist is angled inward.

Since this is a downward perspective, curves dip down.

Upward Perspective

Angling the wrist inward creates a sense of power.

Have the shirt billow out in the opposite direction in which the character jumps.

Creases generate where torque occurs.

The sock contour follows the curve of the foot.

From the Back

Use a flat line for the kneecap.

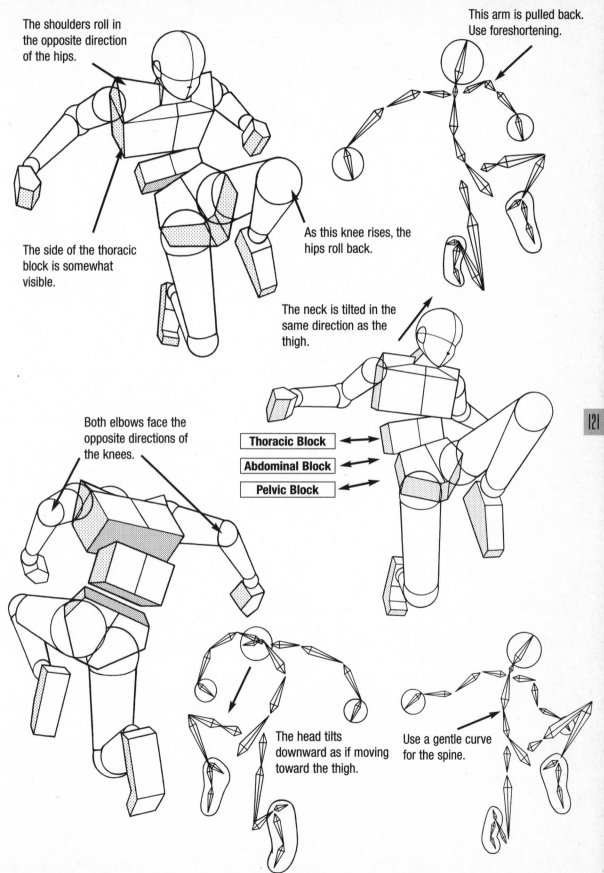

The shoulders roll in the opposite direction of the hips.

This arm is pulled back. Use foreshortening.

The side of the thoracic block is somewhat visible.

As this knee rises, the hips roll back.

The neck is tilted in the same direction as the thigh.

Both elbows face the opposite directions of the knees.

Thoracic Block ◄──►

Abdominal Block ◄──►

Pelvic Block ◄──►

The head tilts downward as if moving toward the thigh.

Use a gentle curve for the spine.

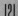

Moment before the Kick

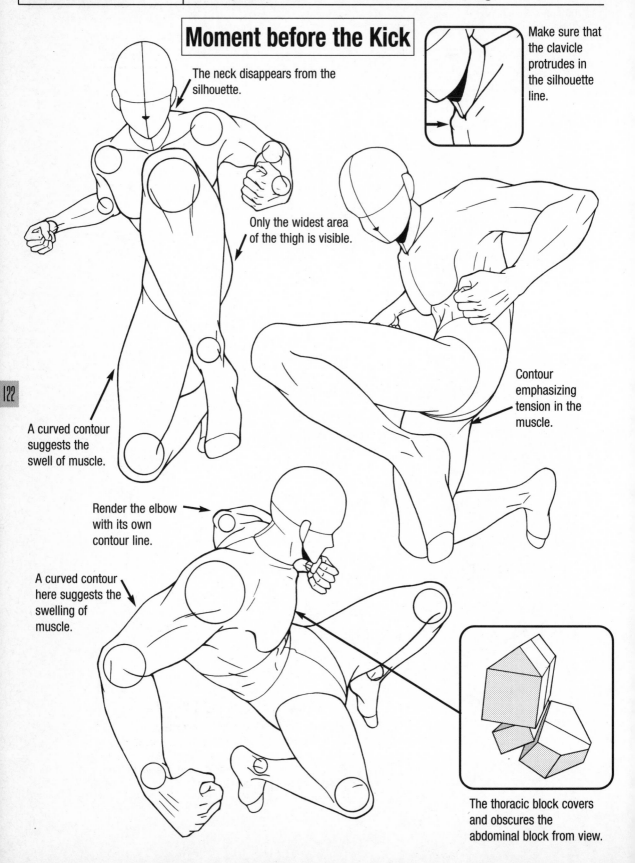

The neck disappears from the silhouette.

Make sure that the clavicle protrudes in the silhouette line.

Only the widest area of the thigh is visible.

Contour emphasizing tension in the muscle.

A curved contour suggests the swell of muscle.

Render the elbow with its own contour line.

A curved contour here suggests the swelling of muscle.

The thoracic block covers and obscures the abdominal block from view.

Moment Kick Is Delivered

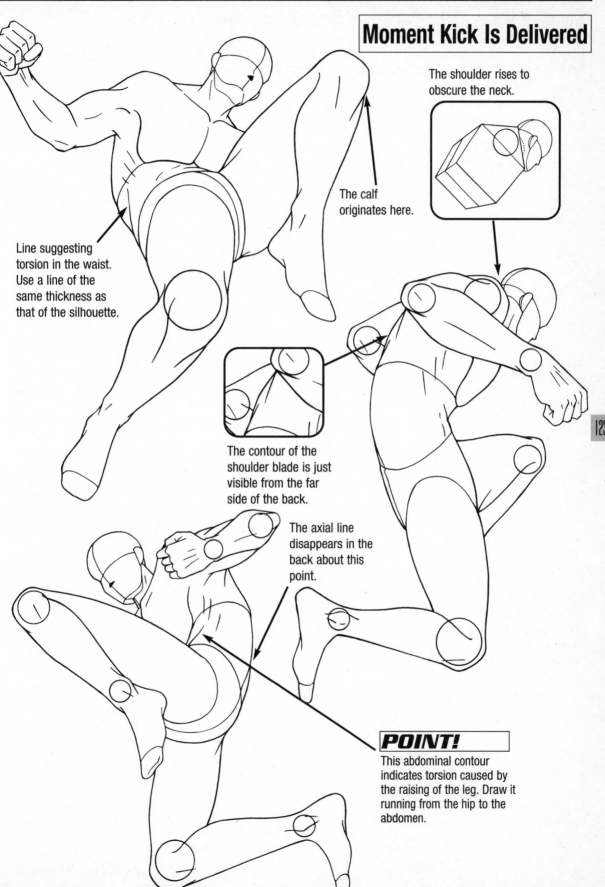

The shoulder rises to obscure the neck.

The calf originates here.

Line suggesting torsion in the waist. Use a line of the same thickness as that of the silhouette.

The contour of the shoulder blade is just visible from the far side of the back.

The axial line disappears in the back about this point.

POINT!

This abdominal contour indicates torsion caused by the raising of the leg. Draw it running from the hip to the abdomen.

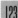

Jumping Knee Kick | Basic Form

This move is executed by jumping in front and to the side of the opponent, delivering the blow with the knee, striking the chin or other vulnerable body areas. Quite an impressive sight, don't you think?

Remember!.

The "gripping air" look. The hand does not always have to be in a fist to show tension. The key point here is to show all three joints bending to have the fingers curl.

The head is down, causing the shoulder to obscure the face from the cheek and below.

Have the lower back's contour cut into the waist around this point.

124

The back contour originates here (around the hip).

The toes of the shoes are pointed while jumping.

Draw the far shoe toe just peeking out from beyond the leg smaller than that of the near shoe.

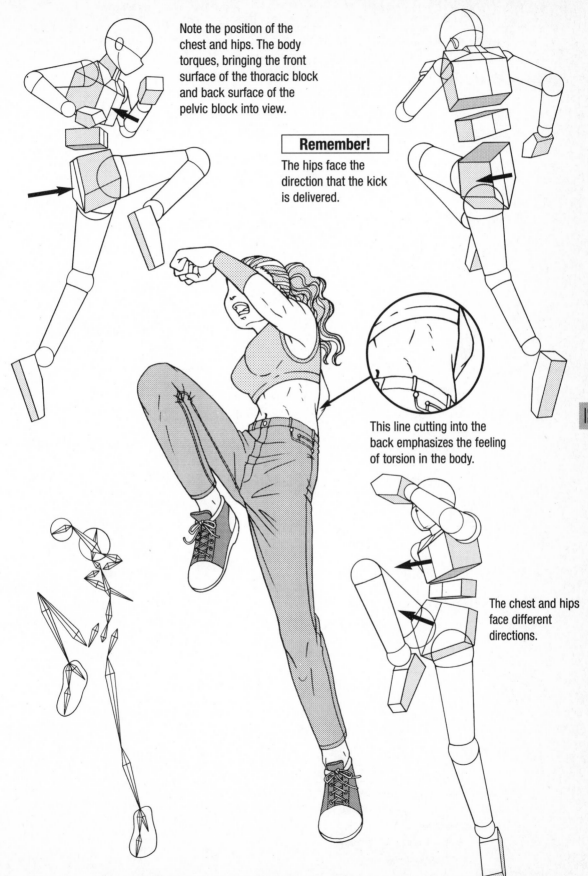

Note the position of the chest and hips. The body torques, bringing the front surface of the thoracic block and back surface of the pelvic block into view.

Remember!

The hips face the direction that the kick is delivered.

This line cutting into the back emphasizes the feeling of torsion in the body.

The chest and hips face different directions.

125

Upward Perspective and Underneath View

Picture a cylinder angled almost perfectly away from the picture plane.

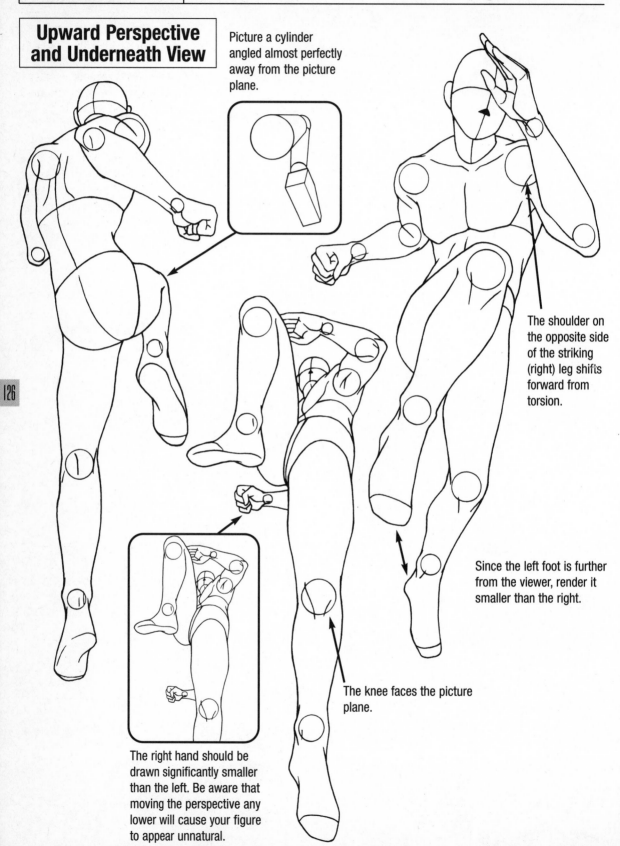

The shoulder on the opposite side of the striking (right) leg shifts forward from torsion.

Since the left foot is further from the viewer, render it smaller than the right.

The knee faces the picture plane.

The right hand should be drawn significantly smaller than the left. Be aware that moving the perspective any lower will cause your figure to appear unnatural.

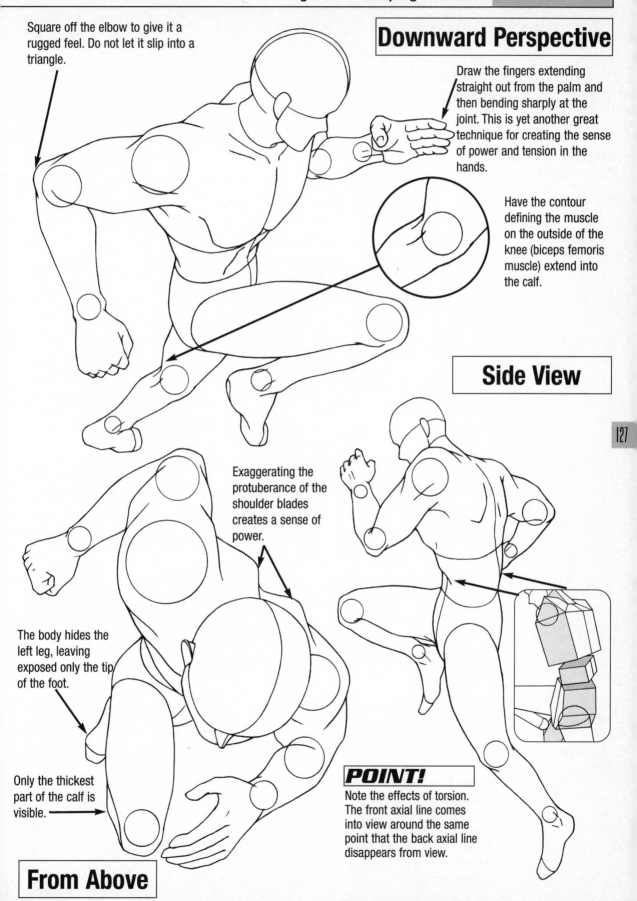

Square off the elbow to give it a rugged feel. Do not let it slip into a triangle.

Downward Perspective

Draw the fingers extending straight out from the palm and then bending sharply at the joint. This is yet another great technique for creating the sense of power and tension in the hands.

Have the contour defining the muscle on the outside of the knee (biceps femoris muscle) extend into the calf.

Side View

Exaggerating the protuberance of the shoulder blades creates a sense of power.

The body hides the left leg, leaving exposed only the tip of the foot.

Only the thickest part of the calf is visible.

From Above

POINT!

Note the effects of torsion. The front axial line comes into view around the same point that the back axial line disappears from view.

Roundhouse | Basic Form

This is a powerful kick, dispensed using the force of the body rotating. This move requires a good sense of balance. Since it allows the combatant using the move to attack all sides, it can be adapted to scenes showing one character mowing down multiple enemies.

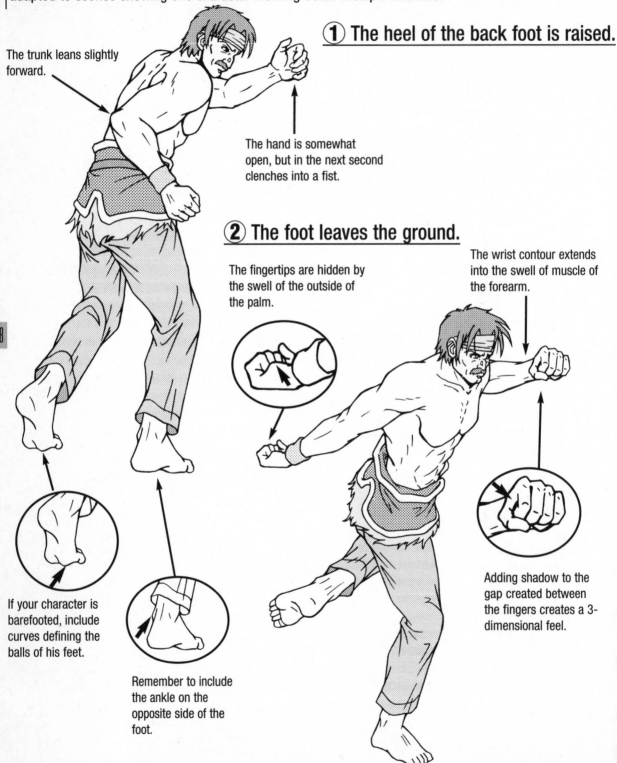

The trunk leans slightly forward.

The hand is somewhat open, but in the next second clenches into a fist.

① The heel of the back foot is raised.

② The foot leaves the ground.

The fingertips are hidden by the swell of the outside of the palm.

The wrist contour extends into the swell of muscle of the forearm.

If your character is barefooted, include curves defining the balls of his feet.

Remember to include the ankle on the opposite side of the foot.

Adding shadow to the gap created between the fingers creates a 3-dimensional feel.

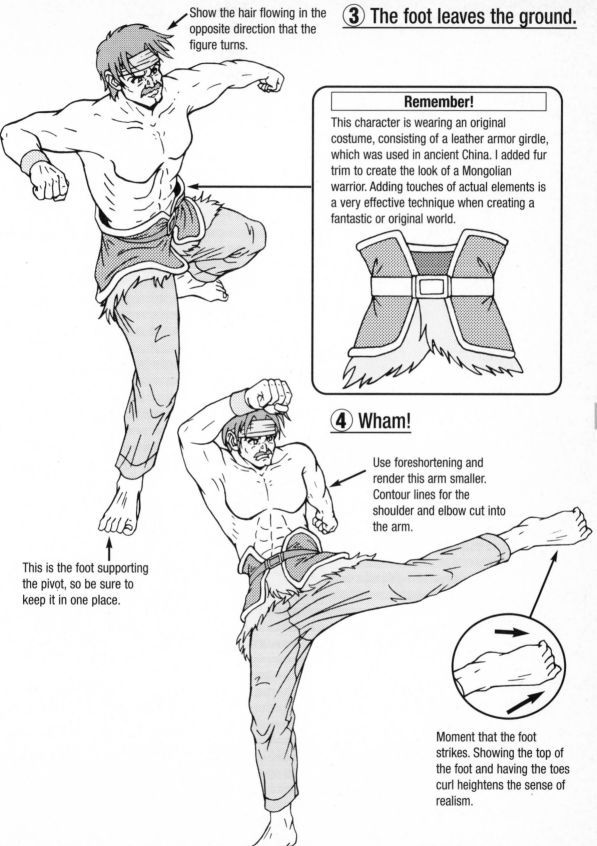

Show the hair flowing in the opposite direction that the figure turns.

③ The foot leaves the ground.

Remember!

This character is wearing an original costume, consisting of a leather armor girdle, which was used in ancient China. I added fur trim to create the look of a Mongolian warrior. Adding touches of actual elements is a very effective technique when creating a fantastic or original world.

④ Wham!

Use foreshortening and render this arm smaller. Contour lines for the shoulder and elbow cut into the arm.

This is the foot supporting the pivot, so be sure to keep it in one place.

Moment that the foot strikes. Showing the top of the foot and having the toes curl heightens the sense of realism.

129

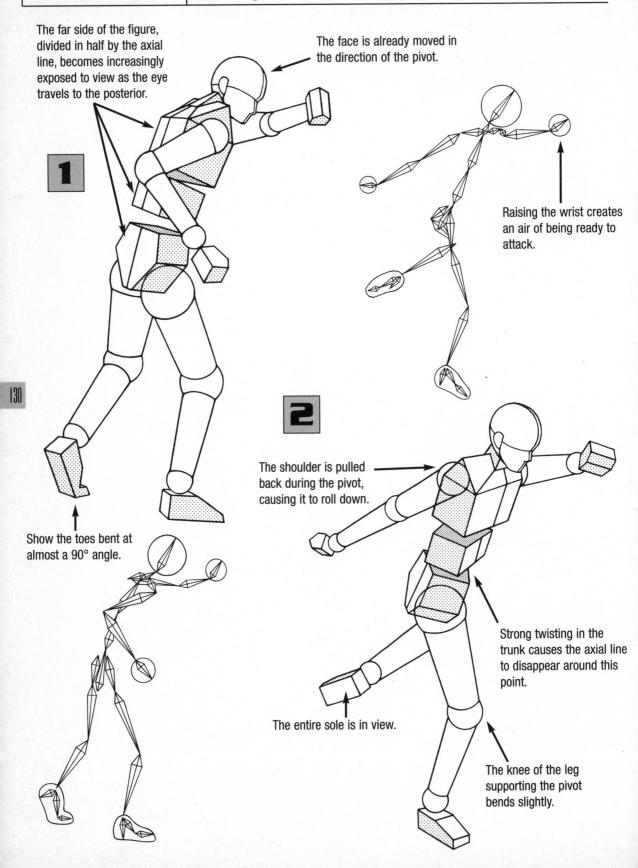

The far side of the figure, divided in half by the axial line, becomes increasingly exposed to view as the eye travels to the posterior.

The face is already moved in the direction of the pivot.

1

Raising the wrist creates an air of being ready to attack.

Show the toes bent at almost a 90° angle.

2

The shoulder is pulled back during the pivot, causing it to roll down.

Strong twisting in the trunk causes the axial line to disappear around this point.

The entire sole is in view.

The knee of the leg supporting the pivot bends slightly.

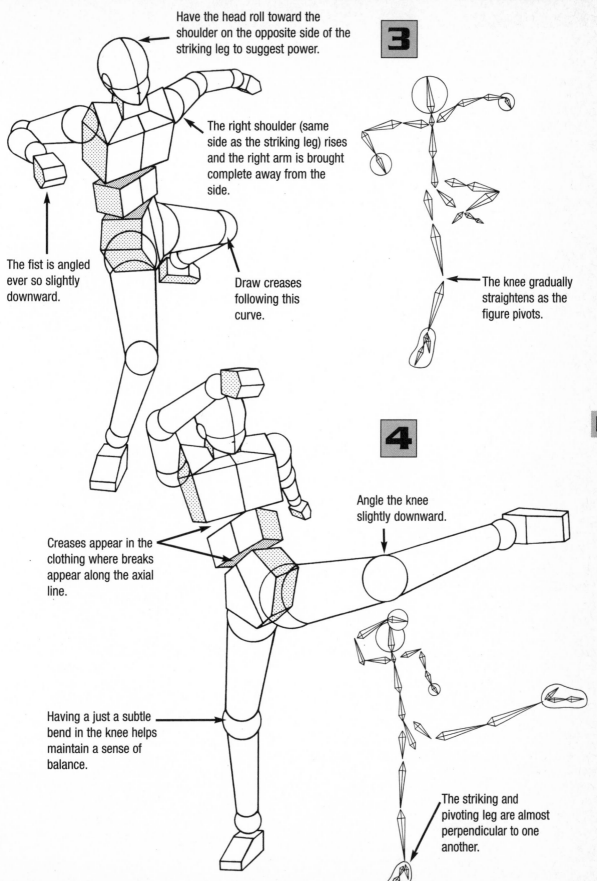

3

Have the head roll toward the shoulder on the opposite side of the striking leg to suggest power.

The right shoulder (same side as the striking leg) rises and the right arm is brought complete away from the side.

The fist is angled ever so slightly downward.

Draw creases following this curve.

The knee gradually straightens as the figure pivots.

4

Creases appear in the clothing where breaks appear along the axial line.

Angle the knee slightly downward.

Having a just a subtle bend in the knee helps maintain a sense of balance.

The striking and pivoting leg are almost perpendicular to one another.

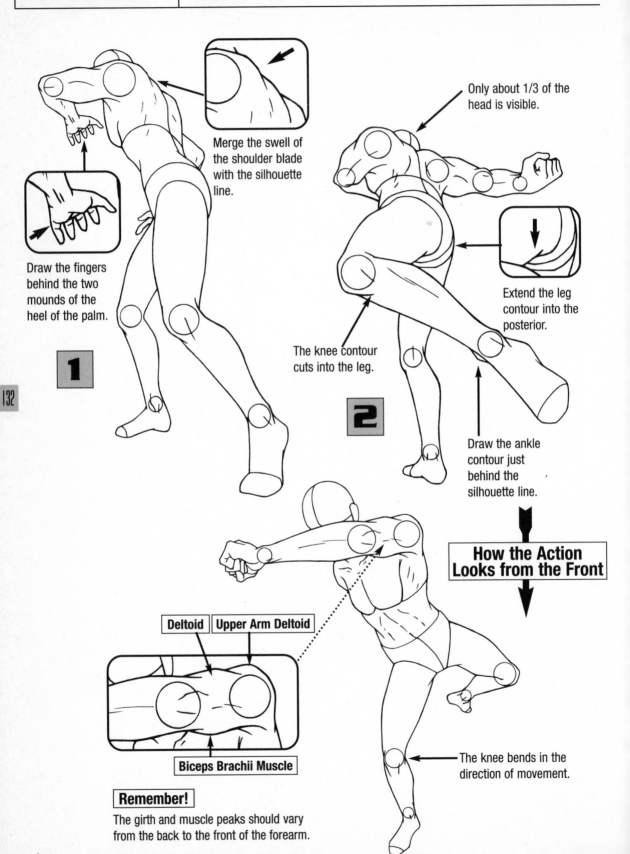

Merge the swell of the shoulder blade with the silhouette line.

Draw the fingers behind the two mounds of the heel of the palm.

1

Only about 1/3 of the head is visible.

The knee contour cuts into the leg.

Extend the leg contour into the posterior.

2

Draw the ankle contour just behind the silhouette line.

How the Action Looks from the Front

| Deltoid | Upper Arm Deltoid |

Biceps Brachii Muscle

The knee bends in the direction of movement.

Remember!
The girth and muscle peaks should vary from the back to the front of the forearm.

132

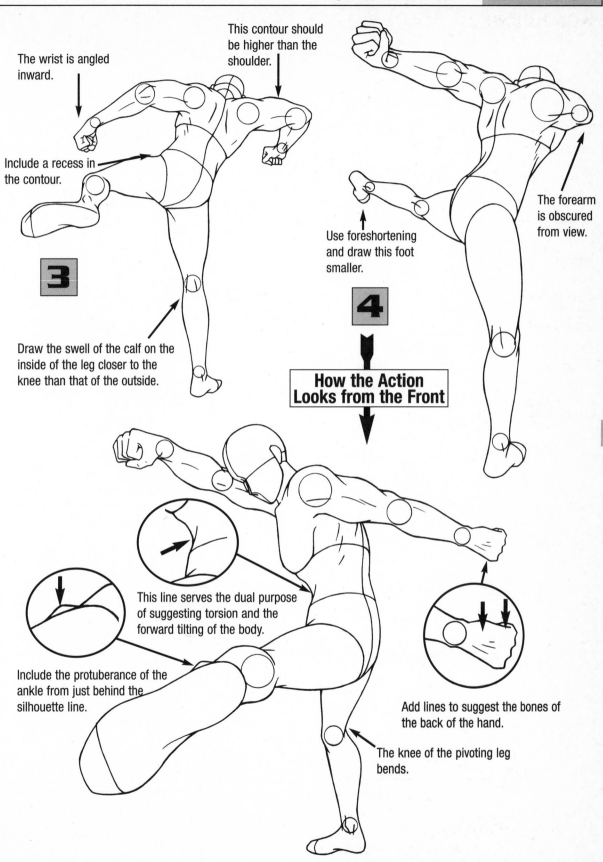

The wrist is angled inward.

This contour should be higher than the shoulder.

Include a recess in the contour.

The forearm is obscured from view.

Use foreshortening and draw this foot smaller.

3

Draw the swell of the calf on the inside of the leg closer to the knee than that of the outside.

4

How the Action Looks from the Front

This line serves the dual purpose of suggesting torsion and the forward tilting of the body.

Include the protuberance of the ankle from just behind the silhouette line.

Add lines to suggest the bones of the back of the hand.

The knee of the pivoting leg bends.

133

Back Roundhouse | Basic Form

For this kick, the character starts with her back facing the opponent, does a half-spin, using its force to deliver the blow. This move can be used in a scene where the hero notices an enemy creeping up from behind.

1

2

The side of the figure and the back of the head simultaneously face the picture plane.

The gaze is focused on the opponent.

Creases follow lines of torsion in the trunk.

This elbow touches the body.

Because it is the force of this arm being swung that creates torsion in the body, the elbow is brought away from the body.

134

The figure moves into the kick here. The heel is pointed in the direction of the pivot.

The chest and pelvic blocks are angled in opposing directions.

The knee is tilted inward.

The heel of the pivoting foot is planted firmly on the ground.

The striking leg is pointed in the opposite direction of the target.

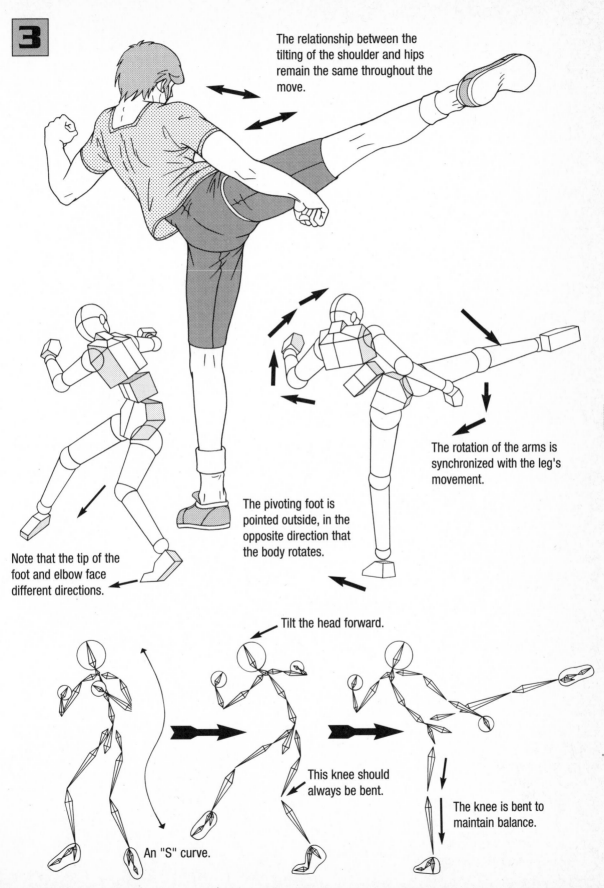

3

The relationship between the tilting of the shoulder and hips remain the same throughout the move.

The rotation of the arms is synchronized with the leg's movement.

The pivoting foot is pointed outside, in the opposite direction that the body rotates.

Note that the tip of the foot and elbow face different directions.

Tilt the head forward.

This knee should always be bent.

The knee is bent to maintain balance.

An "S" curve.

Back View

1

The head is almost completely hidden from the body tilting forward.

The face is directed toward the target.

2

This contour suggesting torsion is a key point.

When drawing the knee at a sharp bend, take care that the posterior does not extend out further than the heel.

3

The chin is pulled down sharply.

POINT!

Imagine the foot composed of 3 parts: the heel, the body, and the toe.

POINT!

An illustration from page 135 and one second later. Note that the knee straightens almost perfectly.

136

Use foreshortening to intensify the image

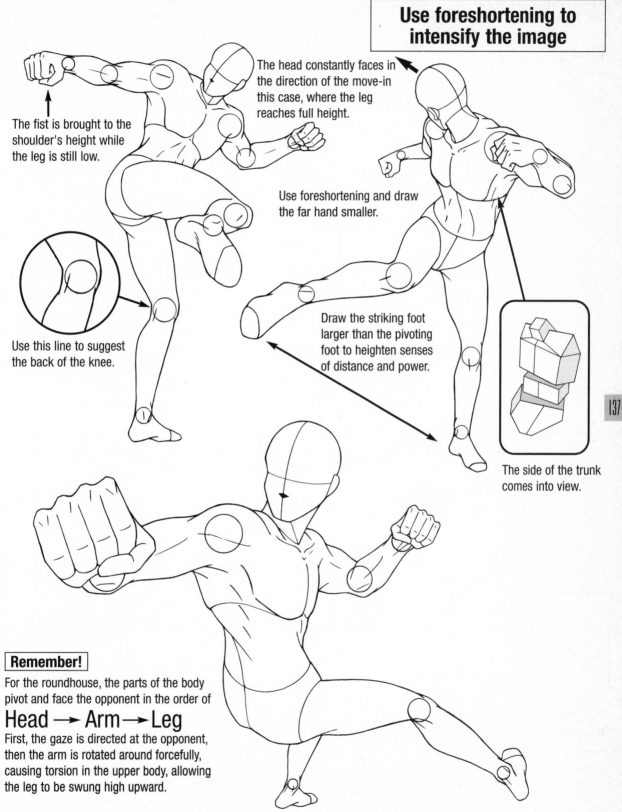

The head constantly faces in the direction of the move-in this case, where the leg reaches full height.

The fist is brought to the shoulder's height while the leg is still low.

Use foreshortening and draw the far hand smaller.

Use this line to suggest the back of the knee.

Draw the striking foot larger than the pivoting foot to heighten senses of distance and power.

The side of the trunk comes into view.

| Remember! |

For the roundhouse, the parts of the body pivot and face the opponent in the order of

Head → Arm → Leg

First, the gaze is directed at the opponent, then the arm is rotated around forcefully, causing torsion in the upper body, allowing the leg to be swung high upward.

137

Ax Kick | Basic Form

Introduced to the general public through K-1 (a popular martial arts tournament), this kick is executed by raising the foot high above the head and smashing the heel down on the opponent. With the chest, legs, and posterior all facing in different directions, the body is full of contortions, making this move very difficult to draw.

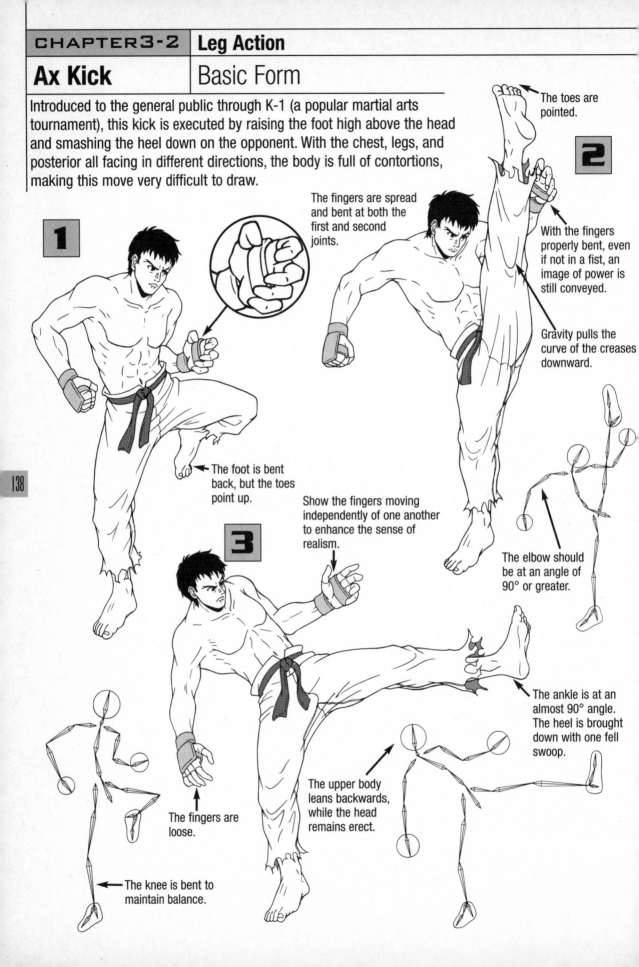

1

The fingers are spread and bent at both the first and second joints.

← The foot is bent back, but the toes point up.

2

The toes are pointed.

With the fingers properly bent, even if not in a fist, an image of power is still conveyed.

Gravity pulls the curve of the creases downward.

The elbow should be at an angle of 90° or greater.

3

Show the fingers moving independently of one another to enhance the sense of realism.

The fingers are loose.

← The knee is bent to maintain balance.

The upper body leans backwards, while the head remains erect.

The ankle is at an almost 90° angle. The heel is brought down with one fell swoop.

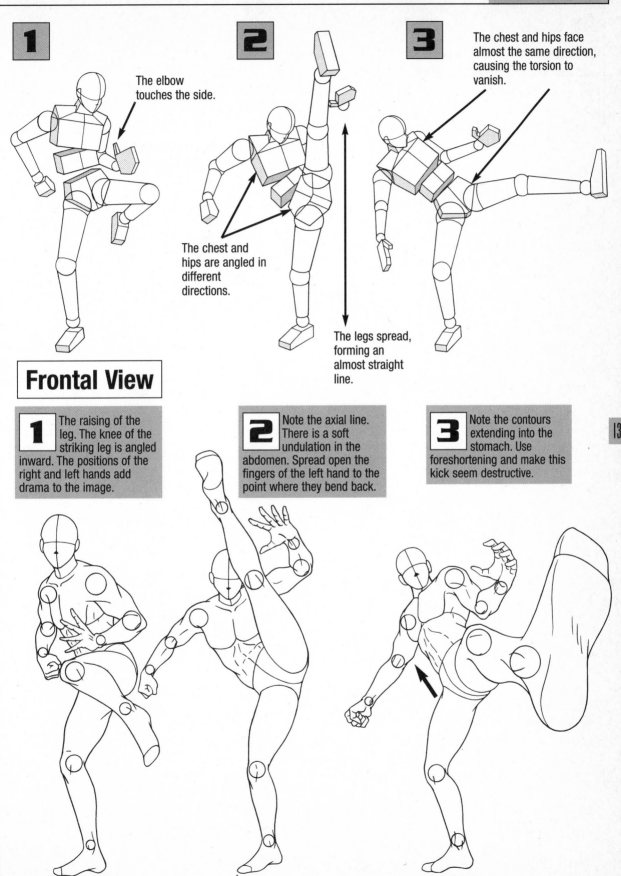

1 The elbow touches the side.

2 The chest and hips are angled in different directions.

The legs spread, forming an almost straight line.

3 The chest and hips face almost the same direction, causing the torsion to vanish.

Frontal View

1 The raising of the leg. The knee of the striking leg is angled inward. The positions of the right and left hands add drama to the image.

2 Note the axial line. There is a soft undulation in the abdomen. Spread open the fingers of the left hand to the point where they bend back.

3 Note the contours extending into the stomach. Use foreshortening and make this kick seem destructive.

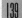

Ax Kick | Back View

Rendering this move from behind is no easy task, but it is an impressive feat to be able to draw it. Start by tracing and move up from there.

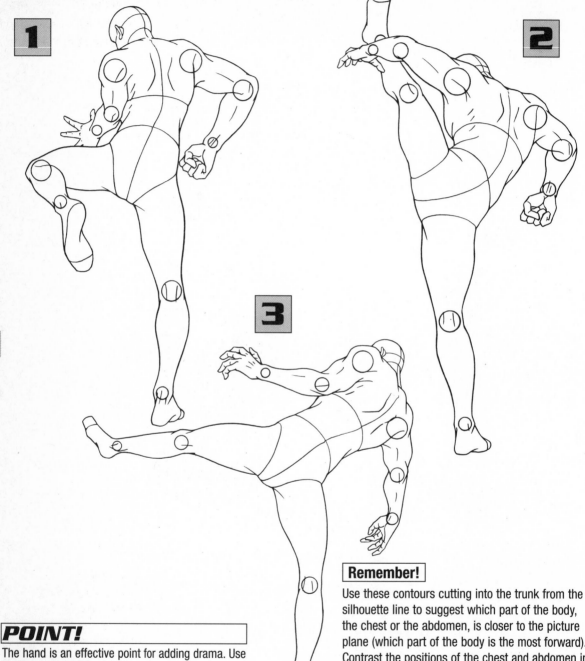

1

2

3

POINT!

The hand is an effective point for adding drama. Use the hands to portray a feeling that matches the figure's movement.

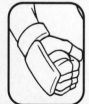 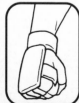 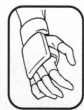

Remember!

Use these contours cutting into the trunk from the silhouette line to suggest which part of the body, the chest or the abdomen, is closer to the picture plane (which part of the body is the most forward). Contrast the positions of the chest and abdomen in illustrations (2) and (3) from page 139.

 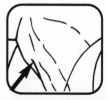

The chest is closer. | The abdomen is closer.

Crash Course, Part 3

Drawing by Megumi Matsumoto, Saitama Prefecture

Let's see what this character looks like as a box figure. With the facial expression gone, the overall pose of the figure has nothing left to convey.

Having both the arm and leg on the same side of the body extended like this draws too much attention visually on the screen or page.

For this third work, Ms. Matsumoto has created a cute character clad in a uniform of original design. Ms. Matsumoto put effort into skillfully positioning both the creases as well as the hands, producing quite a satisfactory image, indeed. She shows adept rendering of the head and body, but the character's pose still needs some work.

I felt the sleeves of the blazer would be too distracting when the drawing was colored, so I opted for a vest instead.

I shifted the figure's weight to the left foot and used the right foot to add an element of playfulness.

Give some thought to the right and left compositional balance.

The feet seem somewhat small compared to the overall figure.

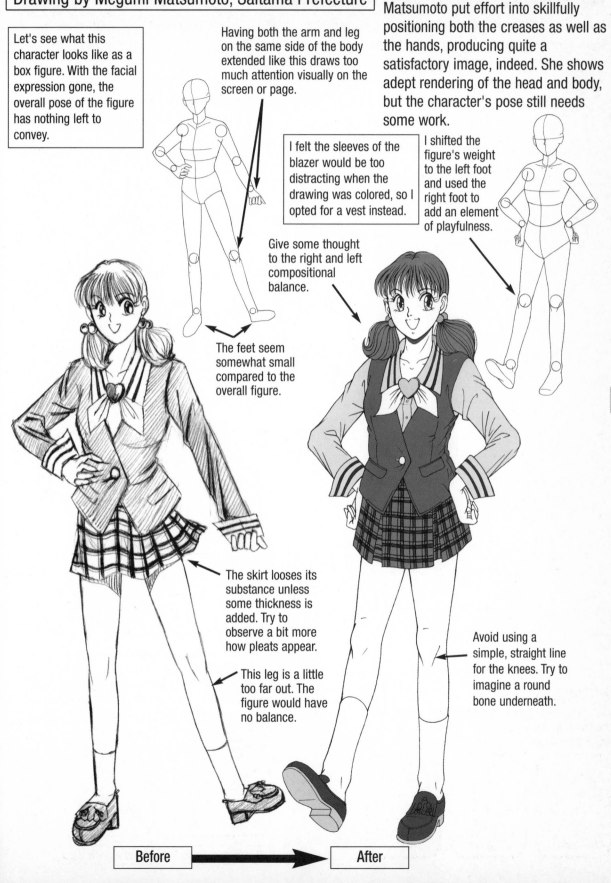

The skirt looses its substance unless some thickness is added. Try to observe a bit more how pleats appear.

This leg is a little too far out. The figure would have no balance.

Avoid using a simple, straight line for the knees. Try to imagine a round bone underneath.

Before ➡ After

Ultra Action

These are razzle-dazzle moves frequently drawn in physically impossible positions and movements and with flamboyant use of distorted features. These usually constitute the highlight of an action scene, and are used for passionate scenes or story climaxes. The key to these moves is skillfully balancing the hands and feet and properly rendering torsion in the body.

Jump Punch	Basic Form

In this move, a strike is delivered to the opponent's head while in mid-air. Since it is a fantastic move, it tends to appear chiefly in game animation.

① Leading Up to the Punch

Exaggerating the twisting of this line is very effective visually.

Drawing the wrist firmly angled inward gives suggests power.

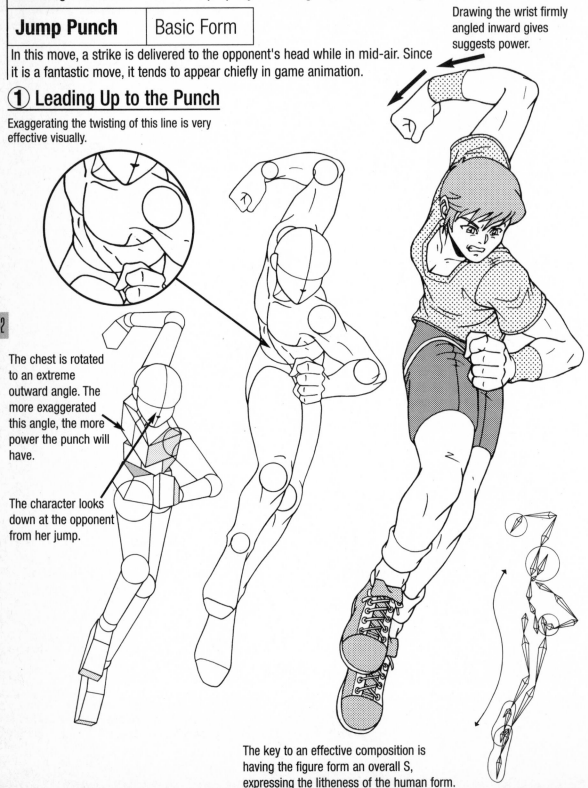

The chest is rotated to an extreme outward angle. The more exaggerated this angle, the more power the punch will have.

The character looks down at the opponent from her jump.

The key to an effective composition is having the figure form an overall S, expressing the litheness of the human form.

② Moment of the Strike

The shoulder pulls the clothing creases. Draw the creases trailing back from the shoulder.

The trunk above the waist bends sharply.

Bend the figure at the waist as much as possible to generate the impression of a powerful punch.

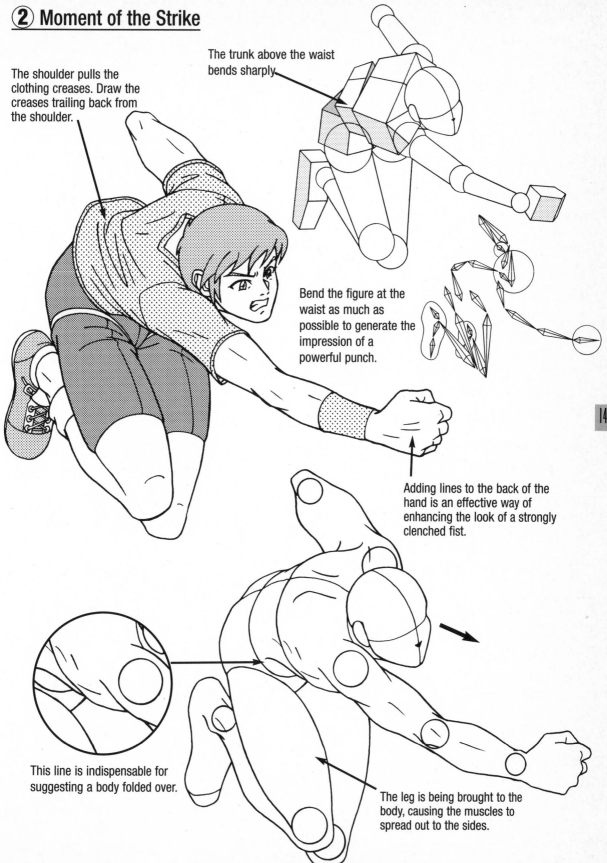

Adding lines to the back of the hand is an effective way of enhancing the look of a strongly clenched fist.

This line is indispensable for suggesting a body folded over.

The leg is being brought to the body, causing the muscles to spread out to the sides.

143

Jump Punch | Moment of the Strike

Remember to show the hand opposite the fist delivering the strike tightened as well.

POINT!

As the neck is turned to directly gaze at the opponent, the head is viewed from an upward angle. This allows a view of the underside of the chin, not visible from the commonly used profile view.

A gentle curve is created from the head to the foot.

Contour indicating curve in the abdomen.

The leg rises with the hips.

The hands and feet are tucked inward as the abdomen torques.

Bring the leg on the same side as the striking fist close to the body.

144

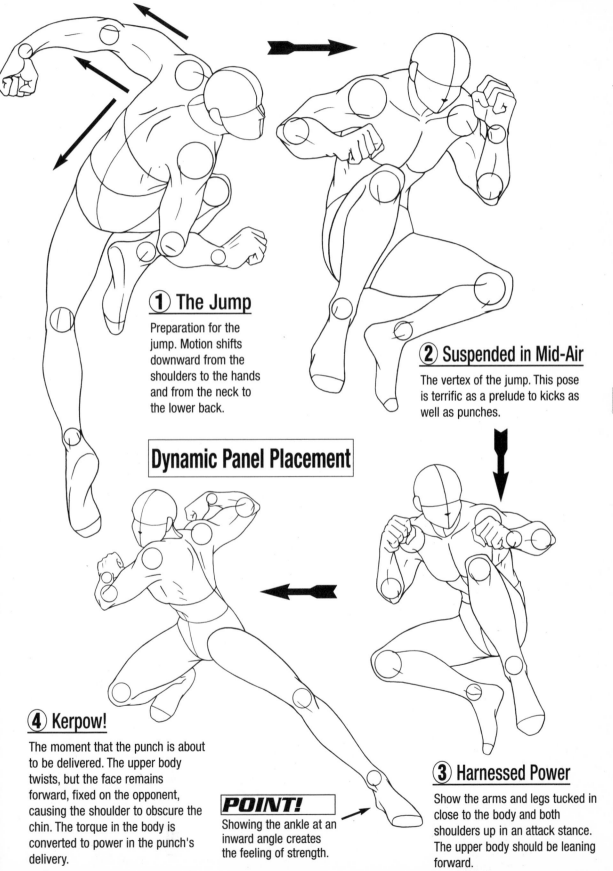

① The Jump

Preparation for the jump. Motion shifts downward from the shoulders to the hands and from the neck to the lower back.

② Suspended in Mid-Air

The vertex of the jump. This pose is terrific as a prelude to kicks as well as punches.

Dynamic Panel Placement

④ Kerpow!

The moment that the punch is about to be delivered. The upper body twists, but the face remains forward, fixed on the opponent, causing the shoulder to obscure the chin. The torque in the body is converted to power in the punch's delivery.

POINT!

Showing the ankle at an inward angle creates the feeling of strength.

③ Harnessed Power

Show the arms and legs tucked in close to the body and both shoulders up in an attack stance. The upper body should be leaning forward.

145

Back Flip Kick | Basic Form

This kick concludes with an aerial back flip after delivering the blow and is somewhat reminiscent of an overhead kick in soccer. This dazzling move is great for use in key action points.

① The lower back is tucked in.

POINT!

Angling the wrists inward suggests tension.

A graceful arc is formed from the head to the tip of the foot.

② The Jump

Showing the hair flowing enhances the sense of speed.

Show the elbows at approximately the same level, tucked in toward the chest.

The elbows are spread out and back.

Show both knees bending and the lower back tucked in.

The wrists are still angled inward at this point.

Show the toe pointed to suggest force in the movement.

This jump involves flipping straight backward, so there should be no torsion in the side view.

POINT!

The leg delivering the kick is pulled back, and the knee in a deep bend.

146

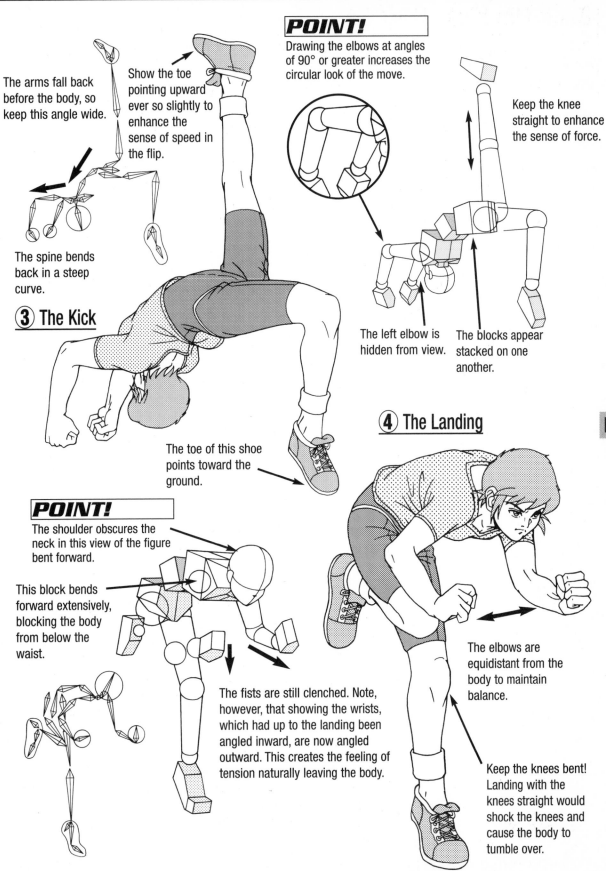

The arms fall back before the body, so keep this angle wide.

Show the toe pointing upward ever so slightly to enhance the sense of speed in the flip.

Drawing the elbows at angles of 90° or greater increases the circular look of the move.

Keep the knee straight to enhance the sense of force.

The spine bends back in a steep curve.

③ **The Kick**

The left elbow is hidden from view.

The blocks appear stacked on one another.

④ **The Landing**

147

The toe of this shoe points toward the ground.

POINT!

The shoulder obscures the neck in this view of the figure bent forward.

This block bends forward extensively, blocking the body from below the waist.

The fists are still clenched. Note, however, that showing the wrists, which had up to the landing been angled inward, are now angled outward. This creates the feeling of tension naturally leaving the body.

The elbows are equidistant from the body to maintain balance.

Keep the knees bent! Landing with the knees straight would shock the knees and cause the body to tumble over.

Back Flip Kick | New Angles

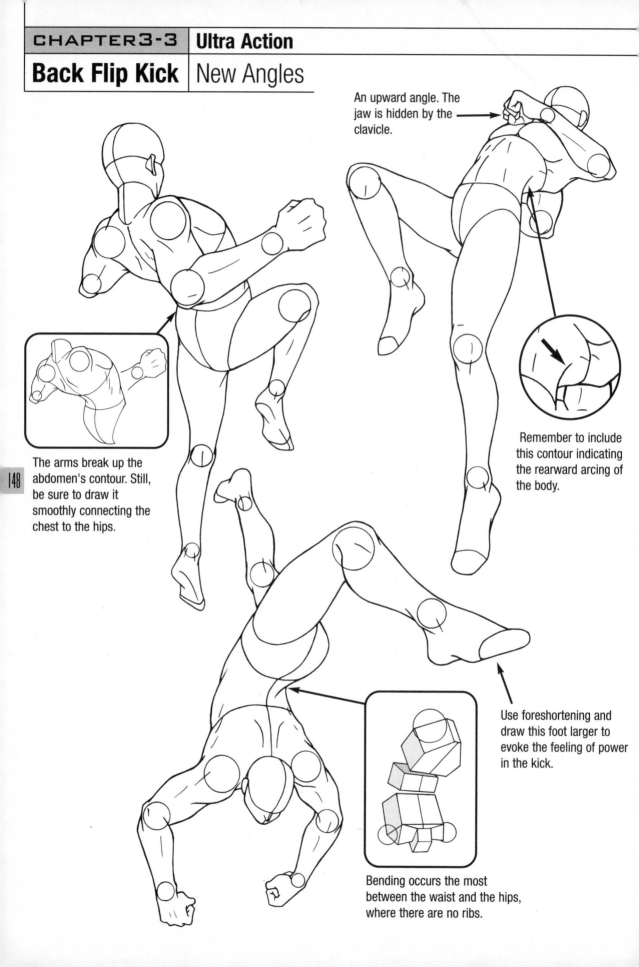

An upward angle. The jaw is hidden by the clavicle.

Remember to include this contour indicating the rearward arcing of the body.

The arms break up the abdomen's contour. Still, be sure to draw it smoothly connecting the chest to the hips.

148

Use foreshortening and draw this foot larger to evoke the feeling of power in the kick.

Bending occurs the most between the waist and the hips, where there are no ribs.

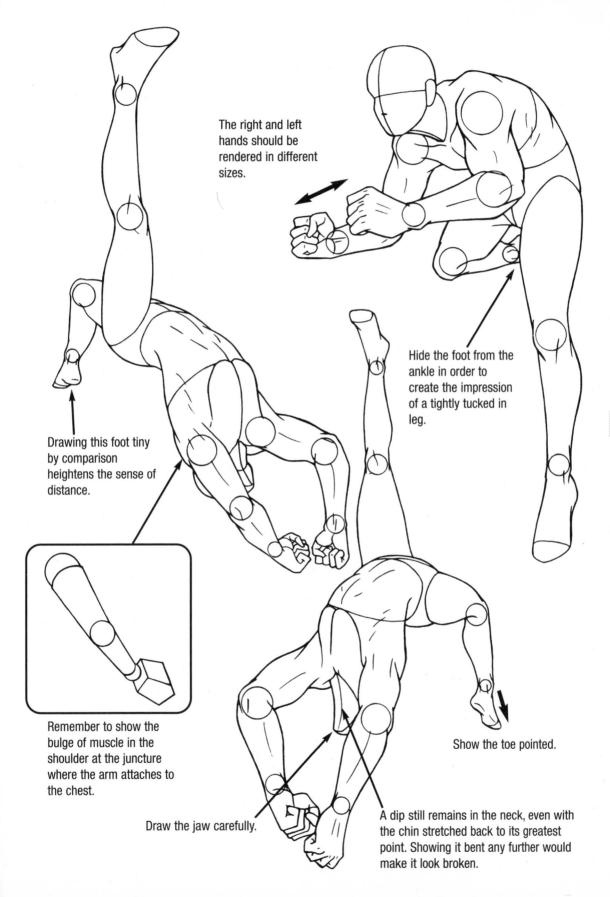

The right and left hands should be rendered in different sizes.

Hide the foot from the ankle in order to create the impression of a tightly tucked in leg.

149

Drawing this foot tiny by comparison heightens the sense of distance.

Remember to show the bulge of muscle in the shoulder at the juncture where the arm attaches to the chest.

Draw the jaw carefully.

Show the toe pointed.

A dip still remains in the neck, even with the chin stretched back to its greatest point. Showing it bent any further would make it look broken.

Foot Sweep | Basic Form

For this move, the feet are swept out from a crouched position at the feet of the opponent. The goal here is to topple the opponent, more than to inflict damage.

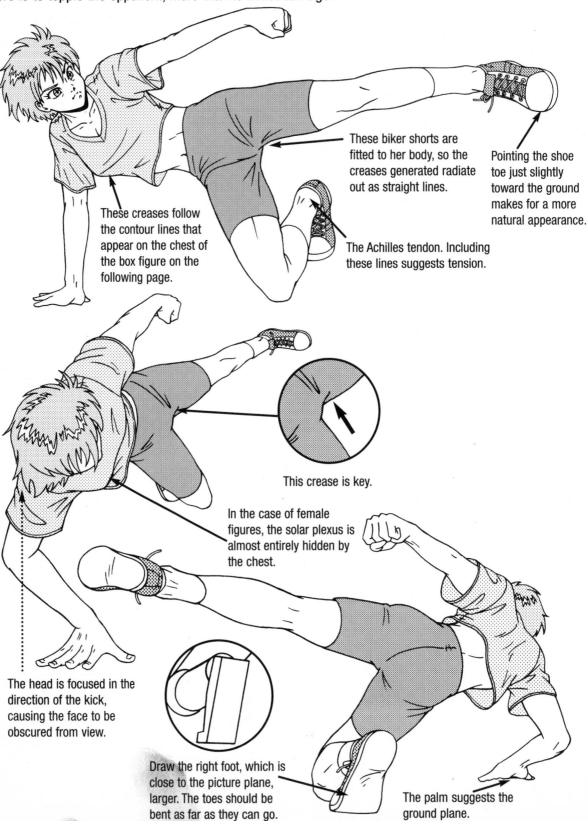

These biker shorts are fitted to her body, so the creases generated radiate out as straight lines.

Pointing the shoe toe just slightly toward the ground makes for a more natural appearance.

These creases follow the contour lines that appear on the chest of the box figure on the following page.

The Achilles tendon. Including these lines suggests tension.

This crease is key.

In the case of female figures, the solar plexus is almost entirely hidden by the chest.

The head is focused in the direction of the kick, causing the face to be obscured from view.

Draw the right foot, which is close to the picture plane, larger. The toes should be bent as far as they can go.

The palm suggests the ground plane.

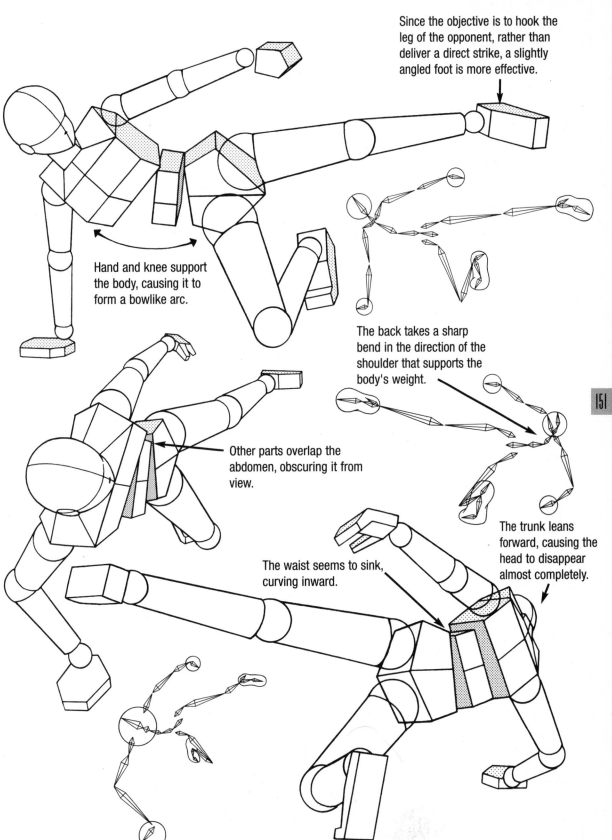

Since the objective is to hook the leg of the opponent, rather than deliver a direct strike, a slightly angled foot is more effective.

Hand and knee support the body, causing it to form a bowlike arc.

The back takes a sharp bend in the direction of the shoulder that supports the body's weight.

Other parts overlap the abdomen, obscuring it from view.

The trunk leans forward, causing the head to disappear almost completely.

The waist seems to sink, curving inward.

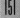

Upward Perspective

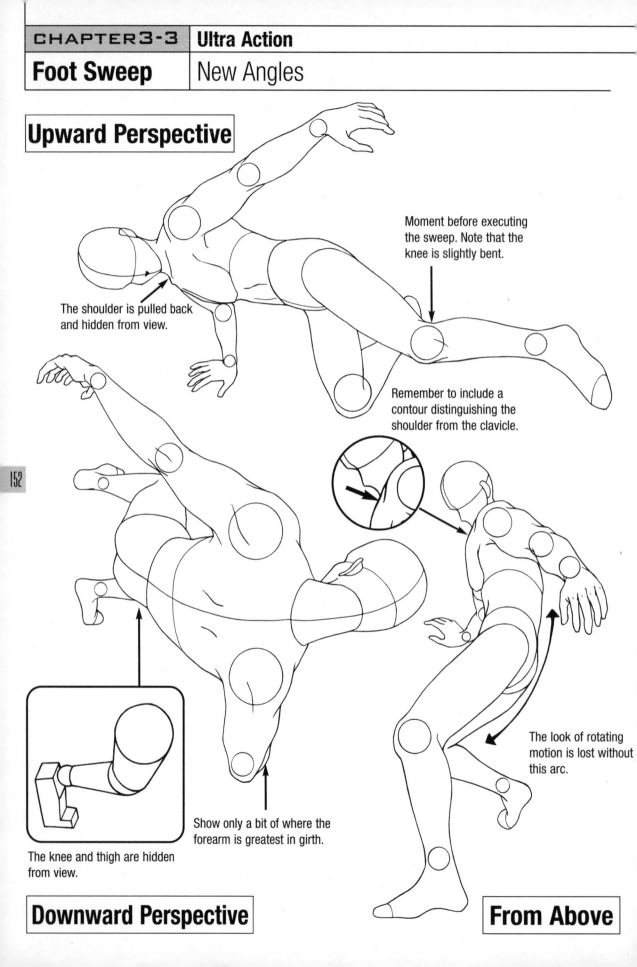

Moment before executing the sweep. Note that the knee is slightly bent.

The shoulder is pulled back and hidden from view.

Remember to include a contour distinguishing the shoulder from the clavicle.

152

The knee and thigh are hidden from view.

Show only a bit of where the forearm is greatest in girth.

The look of rotating motion is lost without this arc.

Downward Perspective

From Above

Extreme Foreshortening

Drawing the near arm larger is an effective means of enhancing the sense of closeness.

The posterior obscures the thigh.

This little line suggests depth to the body.

This vertical line in the wrist is an effective touch for indicating in which direction the arm faces.

Since the hips actually jut out more than the leg, show just a little of the hip.

The right hand and head are equidistant from the picture plane and should be drawn proportionally.

153

The body hides the shoulder from view. Because the hand is almost directly under the chest, if a different angle were used, it would be obscured, and balance would be lost.

Adding this line to suggest the shoulder blade gives the impression of bending forward.

Sliding | Basic Form

This is a move typically used in soccer and baseball. In animated films and games it often appears as a move where one character runs and slides to sweep at another character's feet.

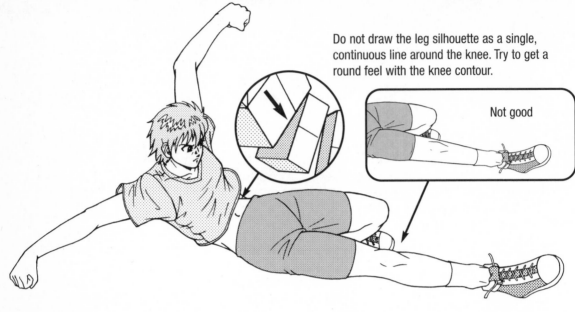

Do not draw the leg silhouette as a single, continuous line around the knee. Try to get a round feel with the knee contour.

Not good

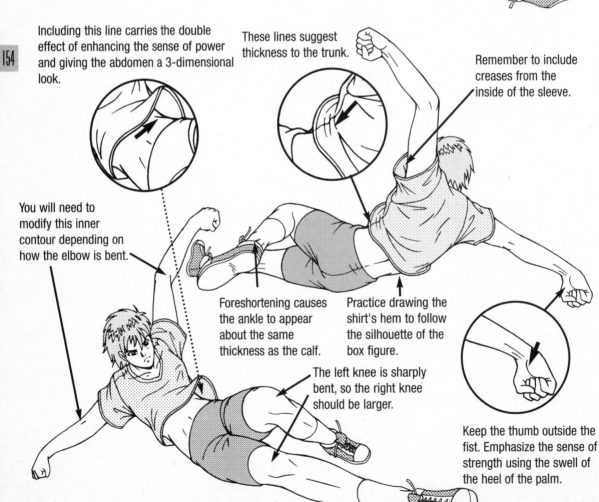

Including this line carries the double effect of enhancing the sense of power and giving the abdomen a 3-dimensional look.

These lines suggest thickness to the trunk.

Remember to include creases from the inside of the sleeve.

You will need to modify this inner contour depending on how the elbow is bent.

Foreshortening causes the ankle to appear about the same thickness as the calf.

Practice drawing the shirt's hem to follow the silhouette of the box figure.

The left knee is sharply bent, so the right knee should be larger.

Keep the thumb outside the fist. Emphasize the sense of strength using the swell of the heel of the palm.

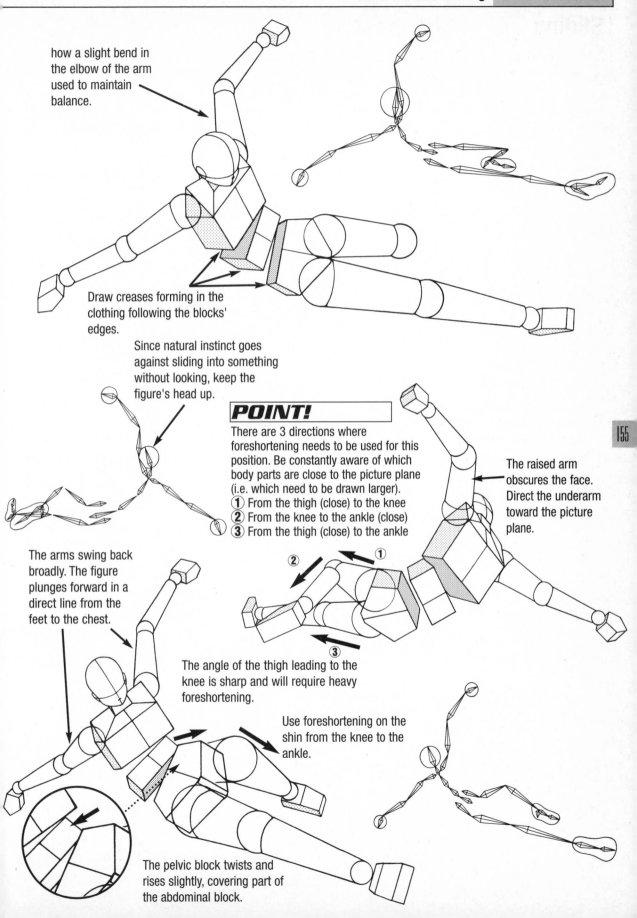

how a slight bend in the elbow of the arm used to maintain balance.

Draw creases forming in the clothing following the blocks' edges.

Since natural instinct goes against sliding into something without looking, keep the figure's head up.

POINT!

There are 3 directions where foreshortening needs to be used for this position. Be constantly aware of which body parts are close to the picture plane (i.e. which need to be drawn larger).

① From the thigh (close) to the knee
② From the knee to the ankle (close)
③ From the thigh (close) to the ankle

The raised arm obscures the face. Direct the underarm toward the picture plane.

The arms swing back broadly. The figure plunges forward in a direct line from the feet to the chest.

The angle of the thigh leading to the knee is sharp and will require heavy foreshortening.

Use foreshortening on the shin from the knee to the ankle.

The pelvic block twists and rises slightly, covering part of the abdominal block.

Downward Perspective

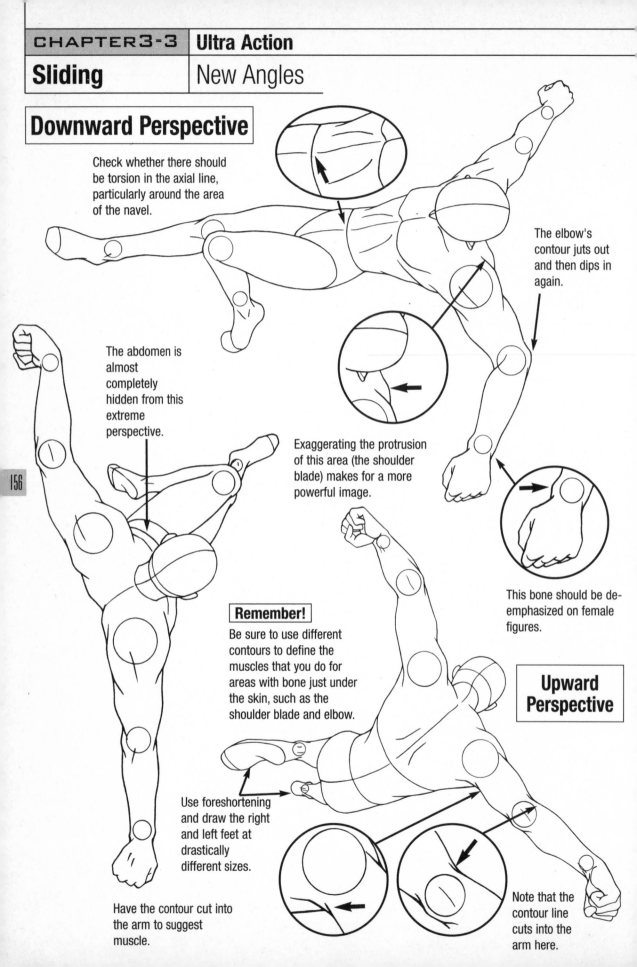

Check whether there should be torsion in the axial line, particularly around the area of the navel.

The abdomen is almost completely hidden from this extreme perspective.

The elbow's contour juts out and then dips in again.

Exaggerating the protrusion of this area (the shoulder blade) makes for a more powerful image.

This bone should be de-emphasized on female figures.

Remember!

Be sure to use different contours to define the muscles that you do for areas with bone just under the skin, such as the shoulder blade and elbow.

Upward Perspective

Use foreshortening and draw the right and left feet at drastically different sizes.

Have the contour cut into the arm to suggest muscle.

Note that the contour line cuts into the arm here.

Extreme Foreshortening

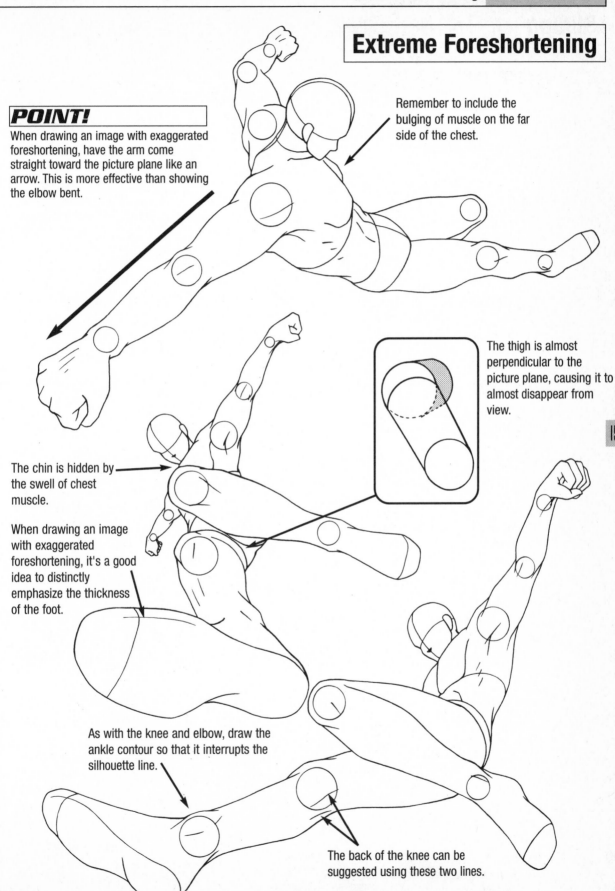

POINT!

When drawing an image with exaggerated foreshortening, have the arm come straight toward the picture plane like an arrow. This is more effective than showing the elbow bent.

Remember to include the bulging of muscle on the far side of the chest.

The chin is hidden by the swell of chest muscle.

When drawing an image with exaggerated foreshortening, it's a good idea to distinctly emphasize the thickness of the foot.

The thigh is almost perpendicular to the picture plane, causing it to almost disappear from view.

As with the knee and elbow, draw the ankle contour so that it interrupts the silhouette line.

The back of the knee can be suggested using these two lines.

157

Jump Kick | Basic Form

Great for use as a highlight where one character sends the other flying with an impressive kick, this move is executed by running and using the force generated to propel into a forward jump, delivering the blow to the opponent's chest or face.

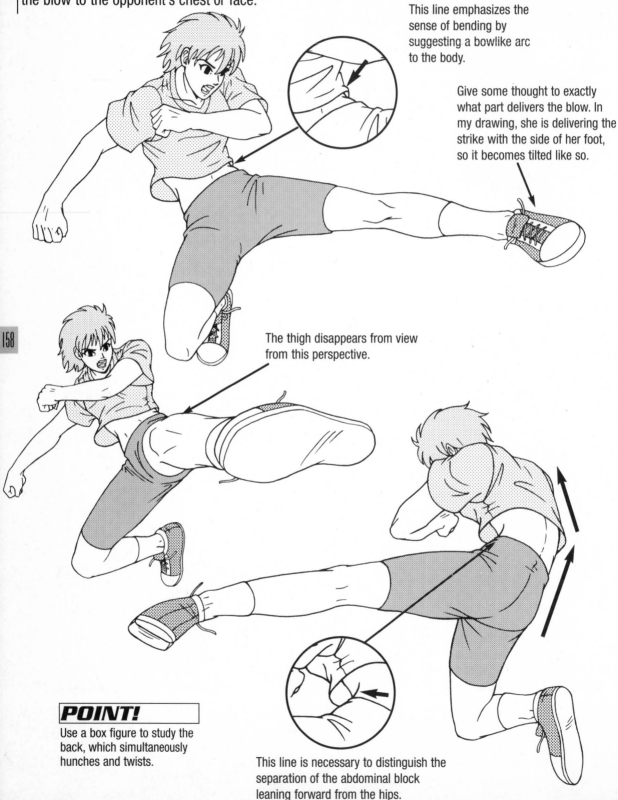

This line emphasizes the sense of bending by suggesting a bowlike arc to the body.

Give some thought to exactly what part delivers the blow. In my drawing, she is delivering the strike with the side of her foot, so it becomes tilted like so.

The thigh disappears from view from this perspective.

158

POINT!

Use a box figure to study the back, which simultaneously hunches and twists.

This line is necessary to distinguish the separation of the abdominal block leaning forward from the hips.

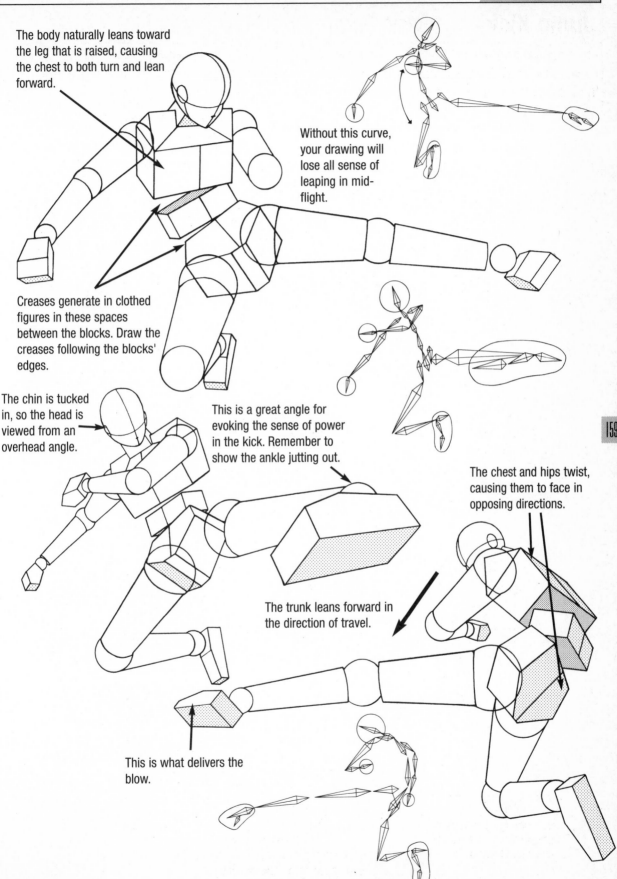

The body naturally leans toward the leg that is raised, causing the chest to both turn and lean forward.

Without this curve, your drawing will lose all sense of leaping in mid-flight.

Creases generate in clothed figures in these spaces between the blocks. Draw the creases following the blocks' edges.

The chin is tucked in, so the head is viewed from an overhead angle.

This is a great angle for evoking the sense of power in the kick. Remember to show the ankle jutting out.

The chest and hips twist, causing them to face in opposing directions.

The trunk leans forward in the direction of travel.

This is what delivers the blow.

Jump Kick | Perspectives with Foreshortening

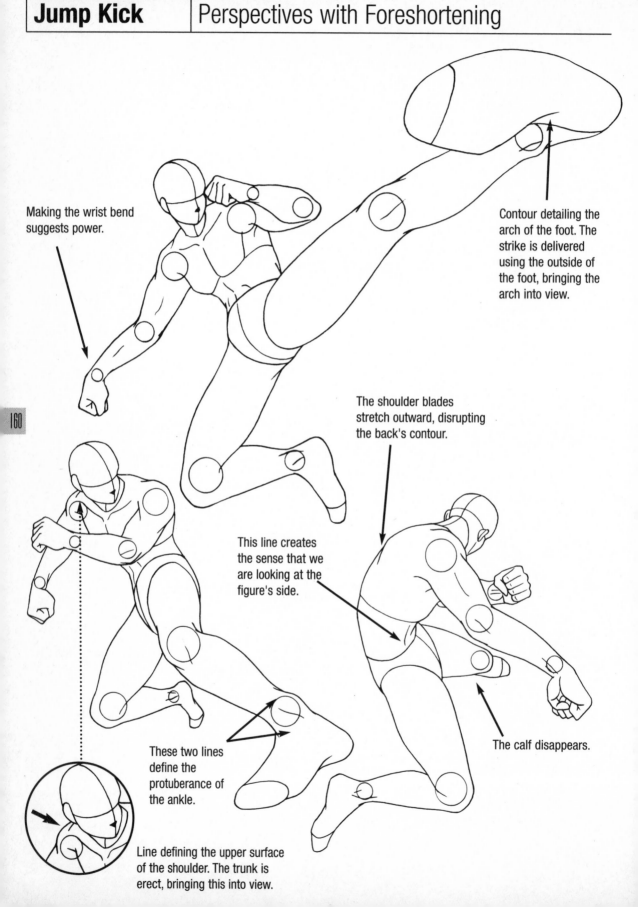

Making the wrist bend suggests power.

Contour detailing the arch of the foot. The strike is delivered using the outside of the foot, bringing the arch into view.

The shoulder blades stretch outward, disrupting the back's contour.

This line creates the sense that we are looking at the figure's side.

The calf disappears.

These two lines define the protuberance of the ankle.

Line defining the upper surface of the shoulder. The trunk is erect, bringing this into view.

160

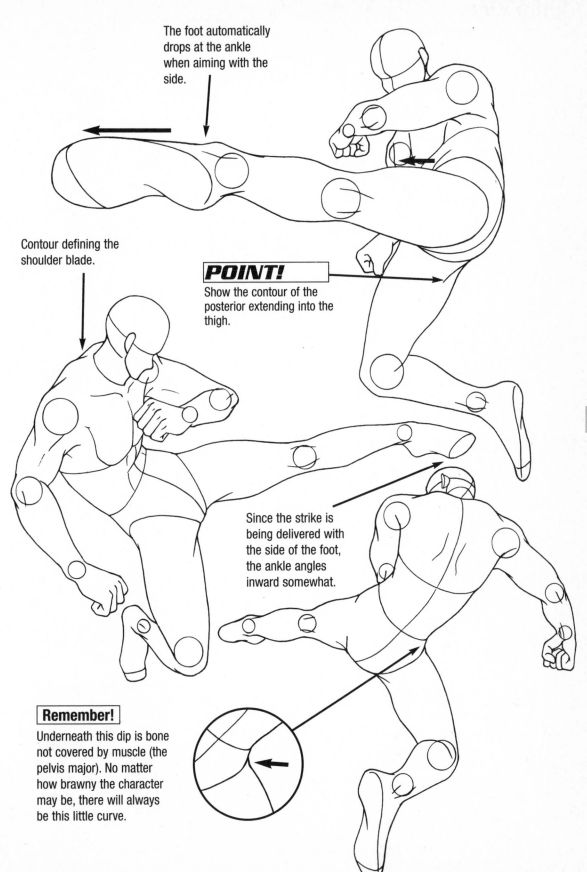

The foot automatically drops at the ankle when aiming with the side.

Contour defining the shoulder blade.

POINT!
Show the contour of the posterior extending into the thigh.

Since the strike is being delivered with the side of the foot, the ankle angles inward somewhat.

Remember!
Underneath this dip is bone not covered by muscle (the pelvis major). No matter how brawny the character may be, there will always be this little curve.

161

Advice from a Young Creator

Chihiro Inoue

Chihiro Inoue was raised in Shizuoka Prefecture and graduated from a technical school with a degree in graphics. At present, Ms. Inoue works as a game graphics designer for that video game company responsible for producing a certain game, well known by everyone under the sun.

There is a multitude of sophisticated games out there now. I keep an eye on these games while I work on my own projects, which are games using 16-color graphics. 16 colors may not seem like a lot, but I'm having a great time working with them.

While my official job description is that of game graphics designer, there is such an immense diversity in the types of jobs out there involved in drawing, it is impossible to decide what you want to do.

I'd like to work for a sign maker. The idea of painting a huge sign seems to me a lot of fun, but I hear that it is actually no easy feat.

Still, what I want to do is to draw, since that's what gives me pleasure. I sometimes just stand off to the side and enjoy watching others work. For the artist or creator, seeing someone there enjoying his or her work is more rewarding than having someone offer sympathy and understanding for the effort put into it.

Personally, I feel that entertaining others requires that you be aware of the host of fun stuff already available in this world. But, at the same time, it also requires physical stamina and a certain amount of brainpower in order to create a bit of amusement that never before existed.

For myself, I plan to continue to practice creating day by day, but I also plan to play hard and never to miss a meal.

A Look at the Professional Workplace: Q & A

Hot professionals active in producing animated films and games provide us with straightforward and candid answers about working in the field. In this volume, we feature an interview with Eiko Tanaka, president and matriarch of Studio 4°C, lead by the illustrious director of Akira, Koji Morimoto, and which boasts only the cream of the crop of Japan's current creators.

Studio 4°C

• About Studio 4°C

Q: Hardly any information, such as which artists work with Studio 4°C or what projects are underway, ever make it to the general public. What sort of company is Studio 4°C?

A: Studio 4°C would probably best be described as an "atelier."

Typically, there is a system involved in animation production. Animation for television, theater, and OVA [*Original Video Animation: animation marketed directly as a home video*] each have their own systems and the work involved is set accordingly. The workflow involved in production is already in place, and the staff necessary is brought in and plunked into the position allotted. Thus, this production process followed by these companies allows them to meet their deadlines (laugh). However, [*in our case*] it seems to me rather that most projects are planned from the initial stage of deciding what sort of thing to create and what sort of team is needed to produce it, and then recruiting this team. We don't limit the duties of capable team members to just "this." Rather, our attitude is more like, "Well, since you are capable of this, this, and this, why don't you do it?" We are more of an "atelier" where the team makeup and workflow are tailored to a particular project, which we are interested in producing, and we have fun in the process of producing the project.

Q: A number of artists work for Studio 4°C, but do you have permanent, in-house artists?

A: Many of our production and animation staff and the vast majority of our CD staff are permanent. Creative staff (directors, character designers, etc.) tend to be more fluid.

Q: What led you to create 4°C?

A: I used to be a member of the *Tonari no Totoro* [*a.k.a. My Neighbor Totoro*] production team (Studio GHIBLI). I had been building a team to work on the Totoro project, but about the time that the project was wrapping up, I was asked to help out the Akira project, which was in danger of falling behind in its release (laugh). At that time, since we had finished our part in *Hotaru no Haka* [*a.k.a. Grave of the Fireflies*] (the production of both *Tonari no Totoro* and *Hotaru no haka* finished about the same time), I invited the team to switch over to the *Akira* studio to help out. Then, when *Akira* ended, the *Majo no Takkyubin* [*a.k.a. Kiki's Delivery Service*] project started, so I called everyone again to work on that (grin).

So, this was how the teams were formed to work on the *Majo no Takkyubin*, *Tonari no Totoro*, *Akira*, and *Hotaru no Haka*. Under GHIBLI's system, the team would break up once a specific project was over. In other words, all of these people absolutely overflowing with talent would split apart [*just because the project was over*].

However, at that time there weren't that many projects around targeted at the theaters, and it wasn't particularly easy to be accepted by a studio. In my case, after *Majo no takkyubin* finished, I had three ulcers started (laugh) and had to stay home and recover. It was while I was home recovering that I received a phone call from Koji Morimoto, *Akira's* animation director and Yoshiharu Sato, *Totoro's* animation director saying they had no one to work with and asking me to start a studio for them. I told them I was sick of being overworked, but they just bounced right back with "We want a harem," "We want a place where we can meet babes." (laugh) That was the general tone. A feeling of camaraderie had naturally developed between us.

The first thing we did after we got everyone together and started the new company was go driving with Ozawa (this volume's author) (laugh). Come December, we would get together to make *nabe* [*a Japanese style of stew*]. Everyone would bring something to eat, and we would stay up until morning telling UFO stories. We didn't interfere with each other's work, but just did what interested us. Despite Morimoto and Sato's request for "a place to meet babes," we ended up building a studio of mostly of guys, so they were complaining, "What's up? There's no one but guys here!" (laugh)

Q: What sorts of people make up your staff?

A: I've come now to understand what Morimoto and Sato meant by "harem," in that the studio is made of up people one would want to spend time with. When you're busy, you end up absolutely exhausted and pulling all-nighters. When everyone is in a crunch like that, colleagues who can share your troubles and toils are those who see things from the same creative direction that you do. That's why we work well together and can bond into an effective team. This sort of psychology still prevails at the Studio. When things heat up, no one goes home for a week. We work until we crash, and then we wake up and work until we crash, and so on, and so on (laugh). Basically, we aren't there together working under a system, but rather as a team assembled to work on something creative that interests us all. In that respect, we do our best to keep the staff limited. Also, we put together our projects at the individual feature level. We still don't carry out regular recruiting activities. If we could develop rules or a system that suited Studio 4°C, then perhaps we would expand the company,

A Look at the Professional Workplace: Q & A

The bright and energetic Eiko Tanaka, president and matriarch of Studio 4°C.

but that doesn't seem likely.

Q: The quality of Studio 4°C's work is extremely sophisticated. What is Studio 4°C's own particular modus operandi?

A: Everyone in this industry has talent. Everyone has the capability of producing a high-quality work. It's just hard to get an opportunity to show off this talent.

The anime industry today pretty much revolves on an amount of money that would just barely cover living expenses. For example, local production costs for TV series today run around the same that they did 20 years earlier. This amount has to be enough to both feed the staff as well as cover the production of the episode. Which means that, for example that the episode can't be finished unless a minimum of 3,000 cells is made to fill a 22-minute time slot. So, this means that the project order that comes to us is for 3,000 cells. The time required for the project in terms of labor costs takes approximately three months spanning from the scenario stage to the finished package. Who is going to do what during this time period has to be clearly defined. Ideally, we'd be given more time and allowed more cells to do a good job on the project, but if we're told that the budget only covers 3,000 cells, then that's all we can make. And remember, we are working at rates identical to those paid 20 years ago.

At Studio 4°C we seek to produce projects that don't have such time "constraints." For example, the other day we produced 800 cells for a 25-second segment of *Eikyu Kazoku* [*Eternal Family*] (53-segment series). In other words, this means 32 cells of animation per second. Going back to the TV series I was just talking about where 3,000 cells are used for a 22-minute episode, this translates to a dismal 2 to 3 cells per second. The look of the final product is totally different. But, since the budgets of individual products are calculated according to the number of cells, these projects end up costing about the same (laugh).

Q: Are there a lot of "eccentric personalities" amongst animators?

A: People who are creative have talent that has basically been well substantiated. If you were to evaluate this talent, you wouldn't call it "eccentric" but wonderful. In the context of the corporate makeup, these individuals might seem "eccentric," but such people need an environment that allows them to show off their talents. When we consider it from this light, they don't seem "eccentric" at all. If there is a kernel within the ideas that such a person expresses that leads to creating something, then that person has reason. The real issue is whether or not the

environment is one in which production can take place. There are some animators with hygienic issues, but once they come to us, they become spick-and-span (laugh). Some of these guys come with cruddy black fingernails and terminal sleep head, but generally, in the span of one month, they trim their hair and wash their clothes. You have to wonder why. It's not as if we pass judgment over them (smile).

Q: Why don't you actively recruit to increase Studio 4°C's size?

A: The question is whether we can maintain interpersonal relationships at the Studio to which every team member will approve if we expand (smile). The larger we become, the more difficult it becomes to ensure that the rules and the system function properly. At our current size, the company is able to function based on mutual trust. If we were the same size as other companies, we would probably have already folded. With the framework we have now, if Koji Morimoto were to say, "We might not make the deadline," everyone would turn on full steam for the final week, taking 30 minute naps, not going out for meals, but just snacking on chocolate, and doing everything possible to get the project out. This is something everyone tacitly understands. We each do whatever is within our capabilities. Once the director completes his part, everyone jumps in and finishes up whatever is left. The team acts as a single unit. We are the optimal machine. We may appear eccentric to the general public, but isn't that always the case? (laugh)

Q: Were the similar atmospheres seen in Studio 4°C's works, such as the dim lighting and unusual use of color, intentional?

A: That's likely a reaction resulting from the switch occurring in the industry from cell to digital animation. Colors were extremely limited, so this is an unleashing. With paint, not even 1000 different pigments are used on a cinematic piece. If you were to distinguish between the different pigments used on one feature, even if special hues were used, they still wouldn't amount to more than 1000 or 1200. Paints entail lining little jars up on a desk, and only about 100 pigments can fit on one desk. And then you are supposed to open each one of these jars to apply the paint. You just try using 1000 colors! (laugh) Your desk would be overflowing with little jars, so you wouldn't be able to recolor anything. However, now we have 36,000 pigments (the number of pigments available through computer animation). We're like kids in a candy store (laugh), using up all of the colors we can get our hands on. Creating a low-lighting screen image entirely with pigments is not something possible with paints. All that you can use are the darker colors gradients of the primary colors, right? That's why we were

Each cell is scanned individually to create a moving image.

so eager to switch to CG.

Even lighting used to be a technologically complex affair with limits to the photography platform and creating effects using the cells, and especially with optical composition (the optical combination of individually photographed materials on a single film). Even if you thought you were considering the prospect, people around you would complain, "Don't get involved over your head." Now, since this is such a breeze with a 3-D PathMap, people are saying, "Look at how easy this is!" (laugh)

Now we have this digital toy, making all of these wild things possible, so we just can't help but try them out (laugh).

So, if you wanted to make a colorful film in garish colors to create a bright, cheerful world, you could do this digitally as well, because it allows you to select both the pigments and lighting according to your needs or target image. If the image is highly stylized, we can ignore lighting, while if it's supposed to be realistic or look like it was created with film, then we can focus on lighting.

Q: When those outside of the Studio 4°C team participate, is it because they are people who associate with members of the team on a daily basis, or is it that you saw their work, appreciated it, and thought you'd like them to do work for Studio 4°C?

A: Both. It's this scent that just draws everyone together. There are those on the outside who want to try something new. We, on the other hand, are looking for someone out of the ordinary who wants to try something new. We end up naturally drawn to one another.

Q: Do you ever reject an individual? Do you have something specific you are looking for?

A: I wonder. Basically, we don't refuse anyone, but there are people we just don't get along with. This is rare though, but we did have one such person come by the other day.

Q: Is there anyone you just can't work with as a team?

A: Well, if there is someone who doesn't act responsible toward his or her own work, then you will not want to work with that person anymore. Studio members tend to form teams with whomever they want for each project. Everyone, production, animation, CD, constantly has his or her feelers out for who is doing what kind of work. If you turn out something irresponsible, then no one will want to work with you, and you'll be kicked out the next time a new team is formed. But, irresponsible workers don't seem to care anyway (laugh). If you tell them, "Thanks to you, we have to do a

retake," they just come back with, "I'm tired. I need a break." (laugh) But then, they find themselves without any more work.

• About recent projects

Q: Has *Digital Juice* been finished yet?

A: Some people have finished, but some are still working (laugh). Since this is a DVD-related project, each artist is allotted 3 minutes, so we had to get about 10 artists together.

We initially thought we'd be done with this before the end of the year, but we'd like to continue working on this project. Currently, about 5 episodes are almost complete in terms of animation, and they have appeared in the Yubari Film Festival.

We don't see as many experimental films lately, do we? We wanted to use this project to play around and see what we could produce digitally. So, we are going to keep going with it a little longer (laugh).

Q: Why did you opt for experimental films?

A: There are any number of people in this world who have something they want to make. However, they require the proper budget, know-how, technical skill, staff, and the like. A single, 3-minute feature costs about Yen 12 to 18 million. If creators are offered this budget, they are going to be happy, because essentially, an experimental work is one where they can prolong the project and fill it with detail.

In the case of Studio 4°C, we work on several projects simultaneously, so we do have free time in between projects. We try to use this free time to work on short, experimental films.

Q: Let's talk about Metropolis.

A: That's an incredible piece. We feel honored to have been allowed to participate in the 3-D parts as well. When we saw the animatic (still frames of the work in progress), our reaction was "Japan sure can produce phenomenal stuff." (laugh) Look out Disney! (laugh). Well, Osamu Tezuka was conscious of Disney when he created the "Tezuka Osamu world." It was, after all, the staff of Madhouse, who assisted Tezuka Osamu in creating *Metropolis*.

• Computers and Animation

Q: When did Studio 4°C start using computer-generated animation?

An animator so concentrated on his work,
he doesn't seem to notice the camera.

A: About when we were working on *Memories: Kanojo no Omoide* [*a.k.a. Memories*] of which Otomo (Katsuhiro) wrote the original and executive directed the film. I think the first to suggest it was Koji Morimoto. There is a scene at the end of *Memories* where there is a space jungle concentrated at this magnetic field, and moving into the center of the jungle, there appears an immense rotating rose. It would have been unbelievably difficult to create that rose manually, which is why we discussed generating it digitally. We visited studios that were producing video games at the time and asked them, "How do you do it?" And, they came back with, "Wouldn't it be faster if you just bought your own system, since your going to do the animation yourself anyway?" And, that's how we came to install our own computers. Since this is animation for a movie, the production time involved is extensive, which means if we were to outsource it, the production costs would be huge.

So, we bought the latest, greatest machine out there. It was a Mac Quadra. Since we said that we would produce the film with Mac, we received Apple's cooperation. We still have the original machine, which we treat with reverence (laugh): it has a "Don't touch!" sign stuck to it. We ultimately bought three machines and then started recruiting staff (laugh). This was before any one had thought of producing a film digitally, so we were pretty much learning by trial and error. It was fun though.

I wonder if I should mention this. Well...the salesperson who came to sell us the Macs had this excited twinkle in his eye and asked us, "What are you going to use them for?" and we answered, "Animation," and then he responded, "Let me help!" So, then we asked him, "But don't you have your sales to attend to?" and he said, "I'll just quit." (laugh) Anyway, he told us, "I've really wanted to do this. There is some great software in here." Plus, he insisted that since he was a salesperson, he was extremely knowledgeable about the computer and software (laugh). So, we thought of all the potential staff we could hire, who could be better than this guy with the twinkle in his eye who insists he wants to do animation more than anything. He is currently the CG Director for *Steamboy*.

Q: Now, do you draw the images directly on a tablet (a computer graphics tool).

A: No, we draw them by hand and scan them up to the stage where we get the images moving.

Q: Are those who can't draw using a pencil still unable to produce artwork with CG? Do you have a trial drawing test?

A: Since we don't actively recruit, we don't have a trial test. However, when we do the occasional hire, we ask the candidate to produce a cube. Recently, this has seemed a pretty valid way to go. Those who can't draw this just can't conceptually grasp movement. These people can handle work in two dimensions but just can't conceive of how things change over time. Consequently, it's better if we don't take on people who can't draw a cube, even if the position is just for production and not involved with animation. It's only a cube, but even so, if they don't have a sense of 3-dimensions strong enough to jot it down, realize, "Oh, it must be curved here" and adjust the image, then they can't work. If they have this basic sense, they can study afterwards how a human moves. After that it's a question of the individual. No one knows how to work the computer off the bat. It's the same for everyone at first, whether you are going to work in 2-D or 3-D.

• Perception of the Animator

Q: Is an animator a craftsperson?

A: At Studio 4°C, everyone is a craftsperson. Everyone works in the spirit of a true craftsperson. A true craftsperson puts his heart and soul into the work.

Q: People tend to see the Studio 4°C team members as being "instinctive" rather than craftspersons.

A: I disagree. In truth, about *1%* of what we do is inspiration and the other *99%* is exertion. Inspiration is important. We place great importance on it, since we feel animators would be sunk without it (laugh). But, you can't produce a film solely on inspiration. Everyone has ideas. For every million people, there are thousands of millions of ideas. Everyone gets inspirations. Infants get inspirations. Of course, they would never be able to put this to film.

Q: You have worked with a wide variety of artists. What makes a great animator?

A: Katsuhiro Otomo is full of ideas, but he also has the ability to coalesce and congeal them. It doesn't just end in inspiration for him. With most people, it does just end there without ever really forming into anything. The ability to produce a piece that is convincing and see it through to a film with energy-that is wonderful. While this is partly evident of genius, it is also evident of exceptional effort. Everyone has natural inspirations. However, those who create have the ability to shoulder the responsibility of shaping their idea and seeing it through to fruition.

That is why those who create are able to turn their ideas into a finished piece and have it viewed by others. Most people give up, making up excuses like, "Oh, this is impossible!" or "I need a rest," or just "I give up." Those who create don't give up.

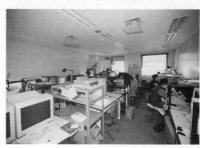

A workroom so tidy and orderly, one would never know it to be an animation studio. Digital animation takes place in a workroom with dim lighting.

That's how Hayao Miyazaki is. He never stops until the end. He's persistent (laugh). After *Totoro's* first cut, when we were all back at the Studio, Miyazaki said, "With the way it ends now, the cat bus is active but not Totoro. I came up with an idea to have the movie end with *Totoro* more active. It should only take about 15 cuts." We all moaned, "Miyazaki, give it up!" (laugh) That's being particular about your work. That's the ability to demand a thorough and finished product. When you first feel an inspiration, you are convinced your idea will inevitably come to full bloom. But then the moment you draw it to paper, you begin to think, "This isn't quite what I imagined." Then once the character, *genga* [*original drawings in a scene representing the main or "key" poses in an action*], and movement are finished, you think to yourself, "This isn't quite right." In the end, on a scale of *100%*, only about *10%* comes out the way you expected. Even if you're lucky, only *50-60%* will come out the way you had imagined. But, you take this and do all that you can, which results in endless retakes (laugh). I feel that a truly great animator is one who doesn't become fed up with the finished product, but who sees it through all the way to the end.

But, people in a creative environment are generally this way. They stick with the project, and even if at the very, very, very end, someone says, "Let's do a retake," they say, "Ok."

Q: We'd like to have your candid views on erotic animation.

A: Even if we do produce an erotic piece, I wouldn't like for it to be something of a generally lascivious nature. However, it is important to give into the erotic impulse, just like the impulse to eat and to sleep. At the same time, if this is to be portrayed as an act of love, then the whole thing should be drawn in detail without the blurring of genitalia. Thus, while this may be different from what is considered "erotic," it may arouse sexual desires in some viewers. Erotic scenes are essential to painting the image of a "lustful being," and I feel having it makes the animation more interesting.

Q: I wonder if there is a work the members of Studio 4°C discuss as exceptional. What I mean is, is there a movie, animated or otherwise, that you feel shouldn't be missed?

A: Morimoto likes *Eraserhead*, Tanaka tends to go for movies like *Terminator 2* or *Aliens*. I wonder if these are appropriate? (laugh)

You shouldn't just rely on the impression you get through information you find on the Internet. It seems like the practice of going to the cinema and learning through experiencing the film is disappearing. Don't be satisfied with just renting from the video store. It doesn't matter if what you see in the cinema is the blockbuster of the day, just that you go. Then you are enclosed in a pitch-black environment for two hours. That's crucial. You are in an otherworldly environment, confronted one on one with the movie. This allows you to enter the movie. There may be times when you aren't totally absorbed, but there are also times when the film moves you deeply.

For example, if it's *Eraserhead* you want to see, you hunt everywhere for a cinema where it is playing, perhaps going even as far as some cinema in the boondocks of Hokkaido (laugh), so that you can say, "I saw it. David Lynch's director's cut!" These words are the ultimate for the creator. It is critical that you see the work one on one in an environment where senses of tension and of actually being there can't be disturbed. Not in an environment that you create, such as your own room, but in a forced space that you enter. That's where a movie should be viewed.

Q: Is there a particular work in Japanese animation that you feel stands out?

A: A work of animation that would seem difficult to top? Well, I thought *Koneko no Rakugaki* [*Kitten's Scribblings*] was highly entertaining (laugh). Yasuji Mori, the work's director, was the master of animation at the time that I first joined the industry. I thought that he was just some old coot (laugh), but he was Hayao Miyazaki's teacher. He is truly a nice man. He is trim and small, but he is great at arm wrestling (laugh). The feature consists of this kitten drawing graffiti nonstop. Mori is such a fantastic director, that even the kitten's doodles are adorable. If you watch this work, you'll feel to your bones that we have this thing called animation, because drawing pictures is such incredible fun. This is a must-see for all prospective animators (smile).

When Katsuhiro Otomo said that he wanted to do *Taiho no Machi* [*Memories Episode 3: Cannon Fodder*] in a single cut, I thought "This is just like *Koneko no rakugaki*." I felt motivated to do that piece as a finale to the old era before the new age of digital animation, even though I knew it would be difficult.

Q: Could you just leave the readers with one final bit of advice?

A: Don't ever quit. Believe that you, yourself, have wonderful talents, be diligent, and don't give up. Remember, some people don't come into their own until they reach 60, 70 years of age. There are artists who started drawing once they turned 70 and who have produced extremely wonderful illustrated books. So, don't give up-no matter how old you are. Whatever it is that you like, that you want to do, please, develop it.